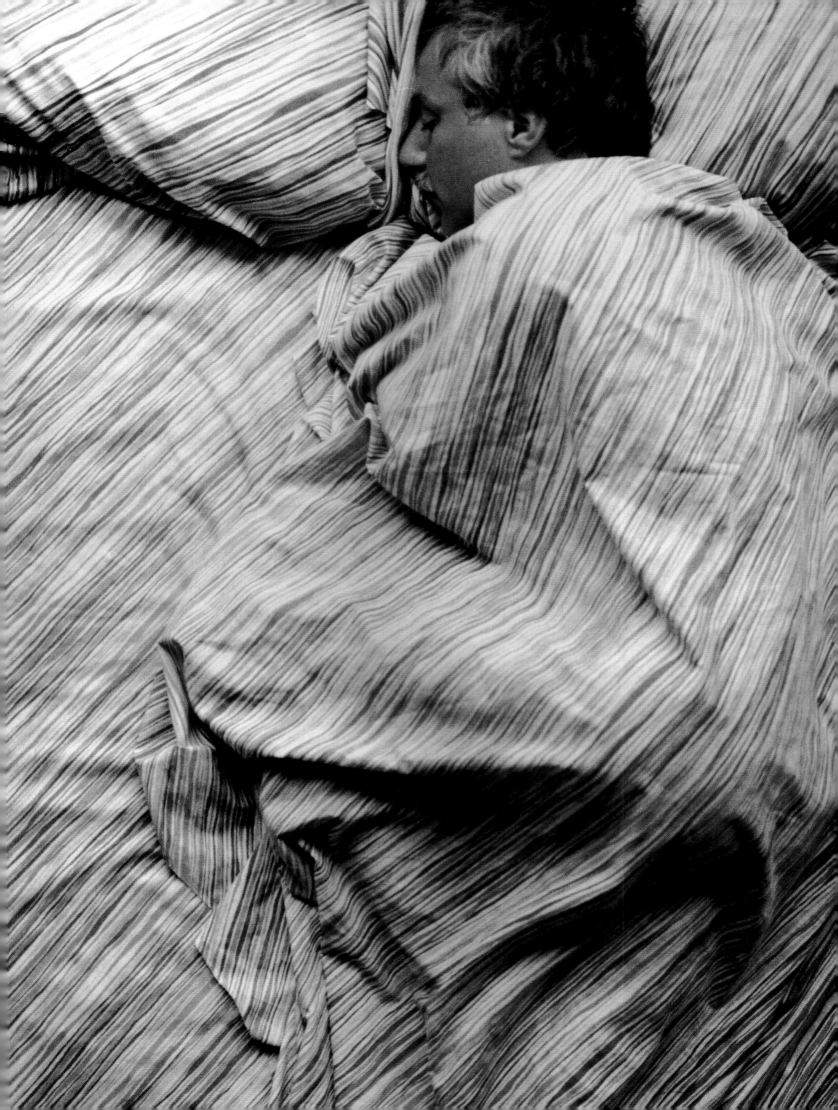

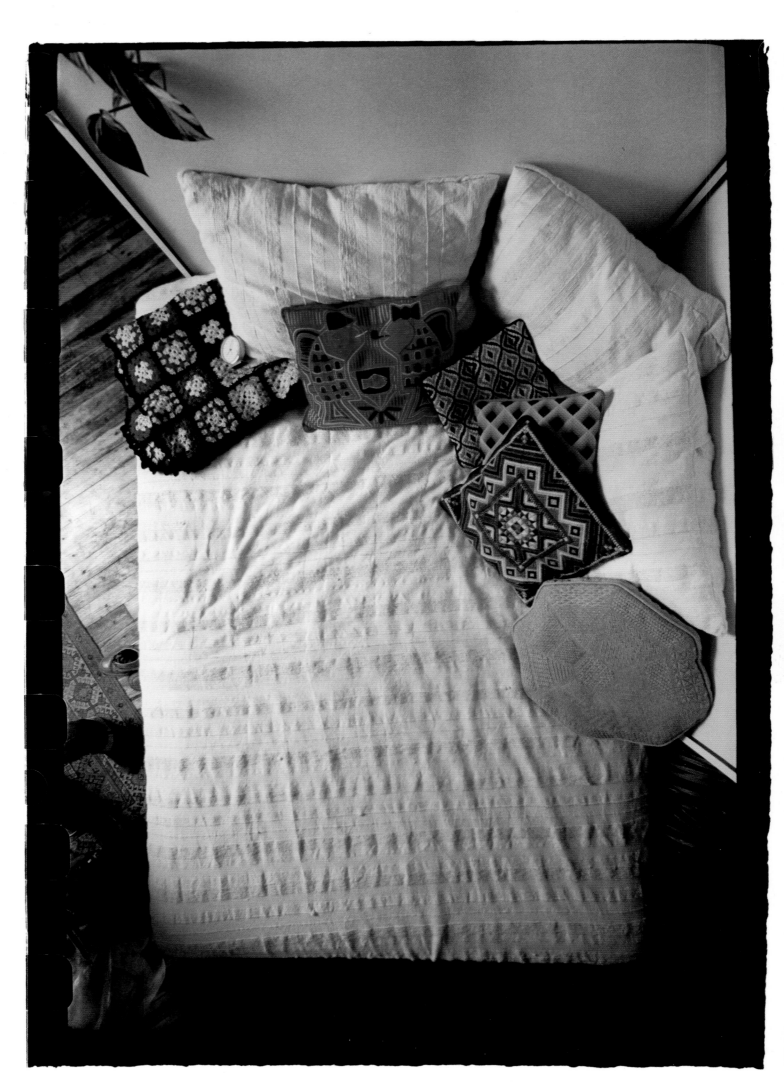

SLEEP
TED SPAGNA

EDITED BY
DELIA BONFILIO AND RON ELDRIDGE
WITH MARTYNKA WAWRZYNIAK

FOREWORD BY
MARY ELLEN MARK

ESSAY BY
DR. ALLAN HOBSON

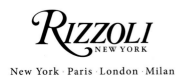

RIZZOLI NEW YORK

New York · Paris · London · Milan

FOREWORD

BY MARY ELLEN MARK

I was both surprised and honored to be asked to write an introduction for *SLEEP Ted Spagna*. Unfortunately, I never met Ted, but in talking to his close friends and family I've gotten a feel for what a special human being he was. He touched, encouraged, influenced, and inspired everyone who knew him. And through his work, he's deeply touched and inspired me.

It's indisputable that Ted's photographs merge art and science. He was fascinated with science and technology, but his first love was art, and he was truly an artist. He probably considered himself a conceptualist because his films and architectural work are conceptual. But his sleep project is more humanistic—the photographs are so touching and personal, so real and caring about humanity. For example, in the opening single portrait of himself, he seems so much like an innocent boy that you really want to reach out and run your hands through his hair. The well-known image *Peter & Cat* (page 97) is an example of the loving connection between a young man and his pet—the cat echoes the boy's utter relaxation. They float on the sheets almost like a dance. This is an iconic image— something we all can relate to and understand.

Ted takes you through the whole range of emotions and feelings. The photograph *Uncle Artie* (page 74), an old man by himself, is very sad. Sleep can be a very lonely time. Sleep can also be very joyous and comforting. In *Wave of Sleep* (pages 88-91), a group of friends were together in Vermont for an exhibition of work by one of Ted's closest friends at the University of Vermont. Ann sleeps next to Josh, Bob also sleeps next to Josh, Ted is in the middle, and Steve and Barbara sleep on the end. Six very close friends all cuddled together—looking like a litter of sleeping puppies.

Many of the photographs are humorous. For example, the perfect graphics and bright colors in the frames of *Mr. & Mrs. Dream Doctor* (pages 106-107), broken by one frame with a tilted pillow that also breaks the couple in half. Or *Two Women* (page 69), which seems to be a comedic dance in unison under the bright bed covers.

It is amazing how close Ted is able to get to his subjects and how much these pictures tell us about these people. Documentary photographers strive for total access and the opportunity to capture reality, truth, and intimacy. Ted has absolutely done this in his sleep photographs. His subjects trusted him completely and held nothing back, no matter how intimate the situation was (such as *Steve & Barbara* on pages 130–31 and *DeVito at the Sleep Lab* on page 38-39). Ted acknowledges his voyeurism. Obviously, like all photographers, he was very curious, even wanting to know what was happening when he wasn't there. And those who allowed him to photograph them agreed for the same reason—they wanted to know what happened as they slept—and they wanted to share it with him. And as viewers of Ted's photographs, we are also voyeurs looking at private and sometimes sexual moments of his sleeping subjects.

His photographs reveal not just the physical state, but also the emotional ups and downs of his subjects. The neurophysiologist who worked with Ted, Dr. Allan Hobson, had a theory that the person who moved first in bed was the "pacesetter." When Ted photographed his friend Josh with Josh's partner Judy (pages 16–17 and 68–69), she was the pacesetter. When she left and Josh was

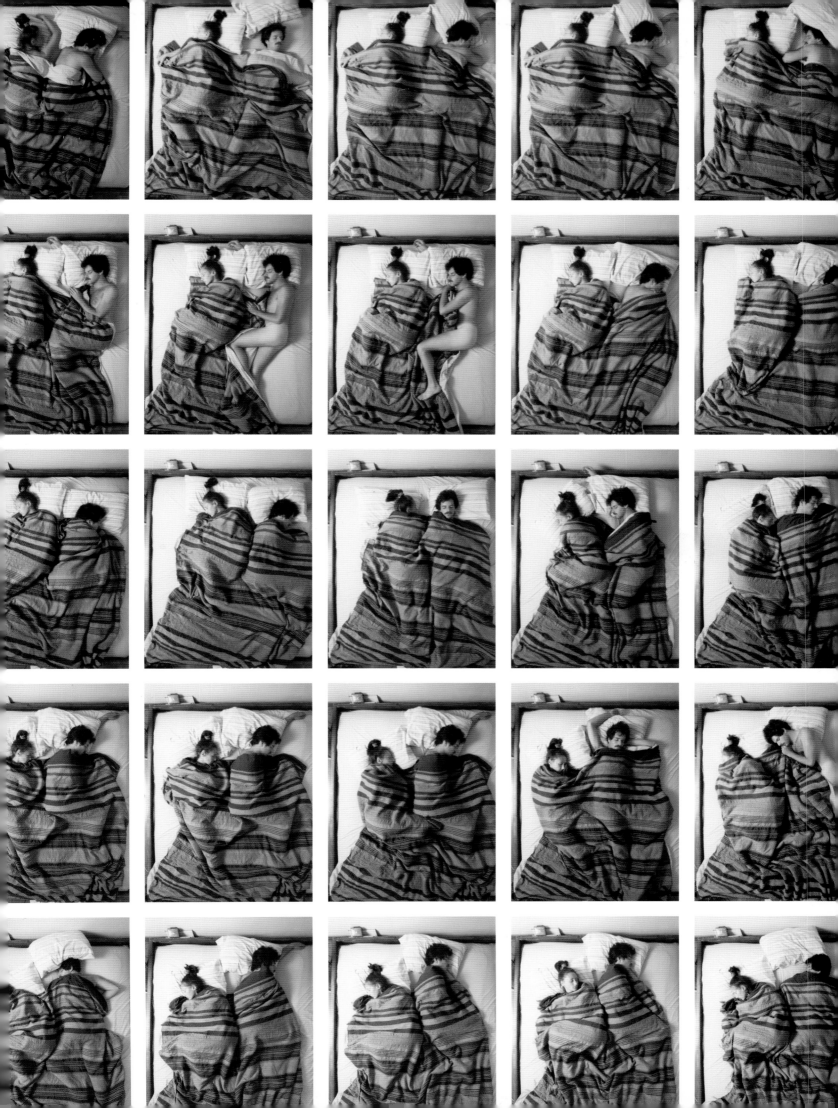

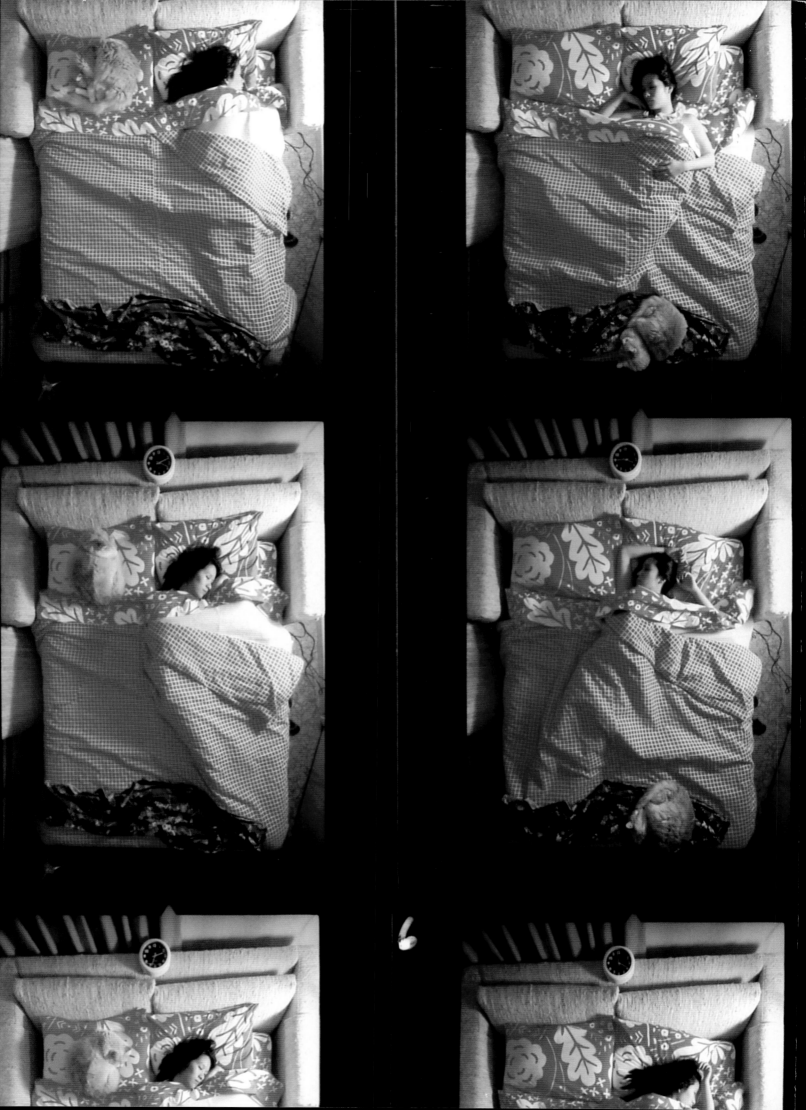

alone, Ted photographed Josh sleeping (pages 122–23). He's visibly agitated and restless. The photographs are riveting—it's like watching a secret film of someone's life.

After all, we spend one-third of our lifetime sleeping. The first person Ted photographed sleeping was himself. He was amazed. He discovered "a whole other person." This is how the sleep project started. Then he started with his family then his friends—everyone got involved.

Technically, Ted was very knowledgeable. He used various lighting techniques. The colors are rich, and, since most of his friends were artists, they often picked their most interesting bedding and cleanest underwear (or none at all). The "dance of sleep" that Ted photographed proves to be very beautiful. The folds of fabric and movement of the body work together to create extraordinary arrangements.

As he experimented with different lighting techniques, switching from strobes to low light to natural light, the work became more surreal. In a circa-1980 *Self-Portrait* (page 52–53), a mysterious night visitor joins the sleeper. A cigarette (or a joint) is lit, the visitor departs, and dawn changes the palette.

Ted felt that his elevated camera position, which he called "God's-eye view," "created a special tension for his images." I feel it is also the perfect position for the camera to capture everything in the frame graphically and efficiently. The camera becomes a fly on the ceiling.

Many of the photographs work as a sequence, which was how he primarily envisioned them. But, some of them can be pulled out and can stand on their own as single, iconic images, like the young man with his cat (page 97.) Or the middle-aged couple in bed in *The Prokops* (page 68)—what a revealing portrait, so much more revealing than if you sat them down to take their picture and they were aware of the camera.

Ted had an enormous influence on his closest friends, family, and subjects. Bob Rindler, his close friend from Cooper Union, said, "Ted continues to be one of the most influential people in my life. We always paced each other in our creative careers . . . in both the sprints and marathons . . . and he still always stands tall on my shoulder whispering in my ear as I make any decision about the smartest, most interesting, or, ultimately, the right path to take."

Ann McQueen, his close friend since Boston University film school, said, "Ted pushed me—pushed himself and everyone he encountered—to live and make art with energy. To take it all to the limit. To explore, ask questions, to follow the answers and ask again. I've always fallen short, but his inspiration has never left me."

Ted's photographs are beautiful, intimate, and human; they show me something I've never seen before. When I look at the work of his sleep project—or as he calls them, his all-night portraits— I feel similarly to how I feel after reading a great novel or watching a great film. Seeing Ted's photographs has enriched my life and given me something that I will always carry with me. I regret that none of us will have the opportunity to be inspired by the amazing work that he would have continued to make.

THE INFLUENCE ON SCIENCE

BY DR. ALLAN HOBSON

Ted Spagna's photographs have done more than any other medium to make sleep science visible and, hence, directly understandable to the general public. It has been conservatively estimated that fifteen million people have seen his *Peter & Cat* sequence (pgs 64-67), which appeared on the cover of the *New York Times Magazine* on July 4, 1977. Countless others the world over have learned from the televised animation of his time-lapse photographs that sleep postures are more dynamic and more regularly varied than anyone previously suspected. Ted Spagna's visual message thus conveys the main findings of the science of sleep both precisely and concisely.

Nonetheless, the popularization of sleep research will not be Spagna's most lasting legacy. Indeed, his photographic popularity may retard the recognition that his work flows in the mainstream of the modern confluence of art and science that began with the study of animal motion by Étienne-Jules Marey (1830–1904) and was made famous by Eadweard Muybridge (1830–1904), who photographed Leland Stanford's horses flying and his own graceful mistress as a nude descending a staircase. From there it is but one step to Marcel Duchamp and 1913's Armory Show explosion that reverberates in the work of Andy Warhol, who, like Spagna, filmed sleep.

Whether or not Spagna's sleep portraits capture a hidden self, they are unquestionably surprising in their revelations of sleep as behavior—especially the tenderness of sleeping couples—and they are unquestionably visually rich, owing to Spagna's meticulous concern with photographic technique. In this regard I particularly admire his *Allen Moore Scroll*, which was made to decorate the curved wall of the *Dreamstage* exhibition and became *National Geographic*'s sleep centerfold. While some may find such relatively rare black-and-white studies more mysterious (and more resonant with the dark mystique of sleep), no one can deny that his color work properly exposes the lush decor of the bedrooms and the warmth and the vegetative power of sleep. At times seemingly staged, Spagna's subjects are so variously draped, shaped, dressed, or undressed as to denote an unexpected communicative function of sleep as a social behavior that should be further explored.

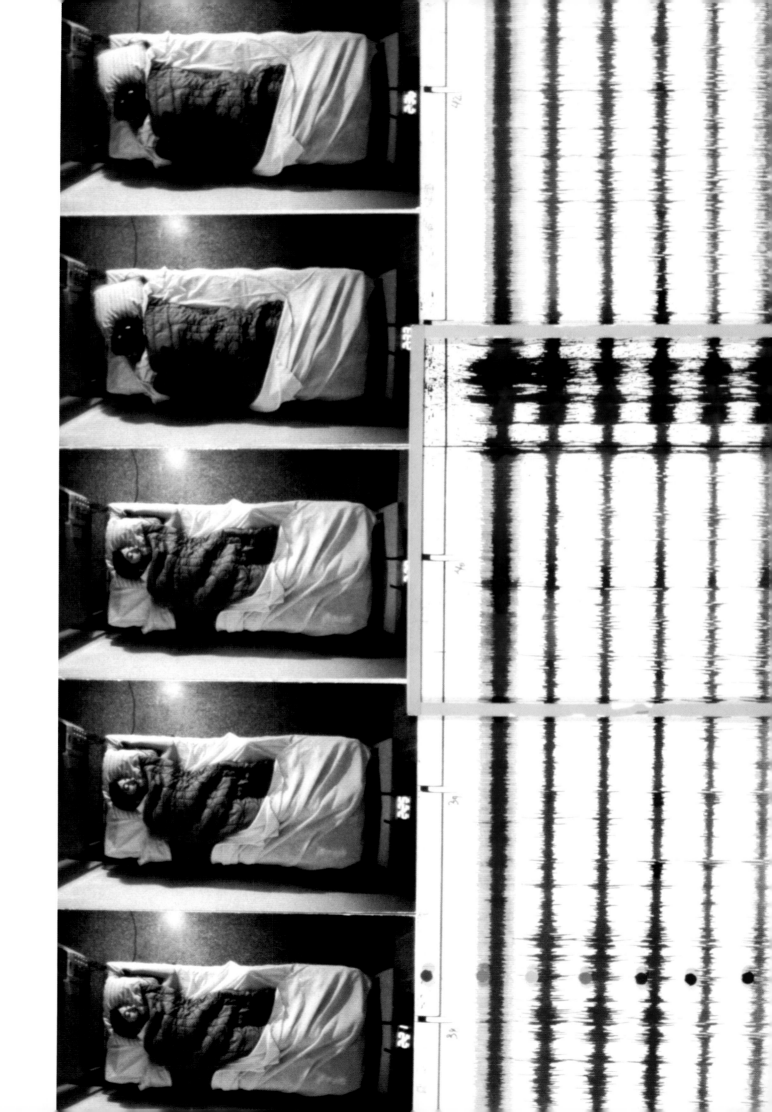

Since Spagna's contributions to sleep science are widely known
literature, it will suffice here to emphasize a general point: that the
to study sleep—time-lapse photography—has been available for
However, none of us scientists used it until Ted Spagna came alc
use it. Hans Berger, a pioneer in electroencephalography, didn't i
Kleitman, the "father" of sleep research, didn't use it. How many
niques for the study of behavior are overlooked today? Aside fror
shot by artist Benjamin Bergery, I have seen no high-quality film s
in sleep. What sort of facial expressions do we make while drean
our eyes really move? Judging from neuroscientist Giovanni Berlu
film of a cat's eye in REM sleep, we may anticipate enlightenmen
work. Will Ted Spagna's successor please stand up?

Spagna's work should encourage artists to cross the line that art
apart. Vice versa, scientists should be inspired by Spagna to reve
they all must feel in their own close encounters with nature. As p
need to emphasize field boundaries to nourish and protect parac
lectual territories. But some methods—and some states of mind
ies; they naturally and effortlessly encompass the paradigms of b
work and our lives would be richer if each of us nourished, as Sp
and scientific parts of ourselves.

Adapted from an article previously published in the Association of
Professional Sleep Societies' *APSS Newsletter* 4, no. 4 (December 1989).

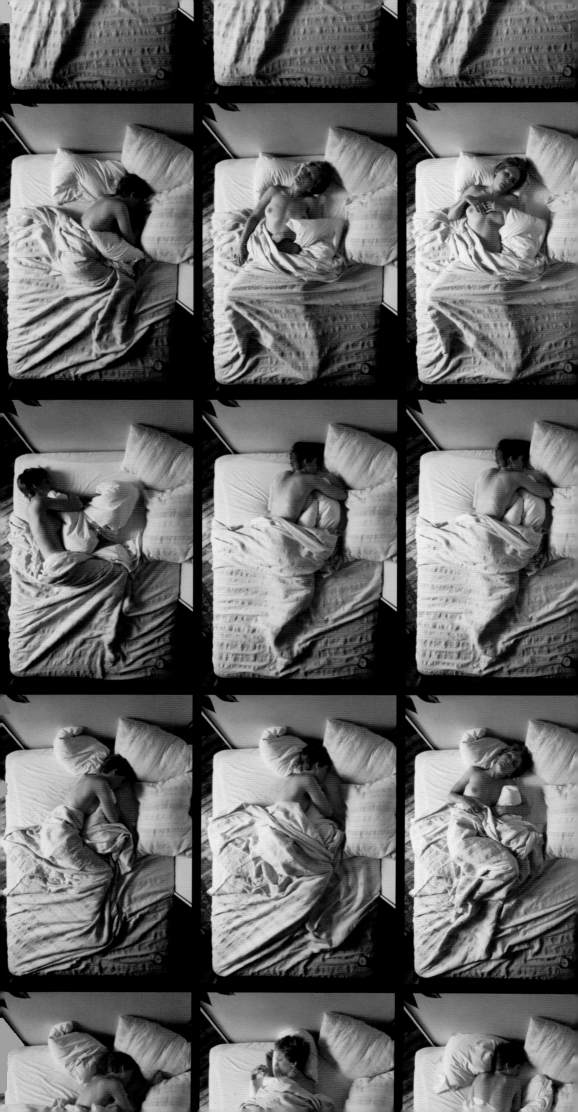

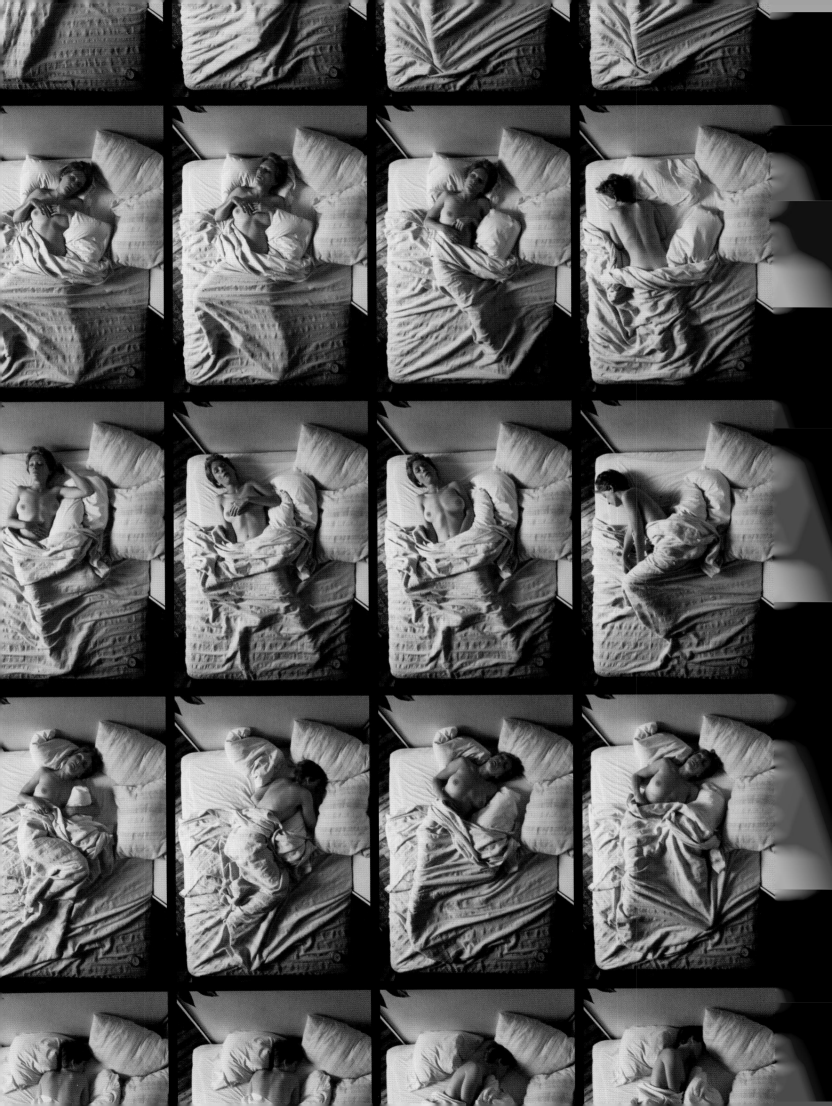

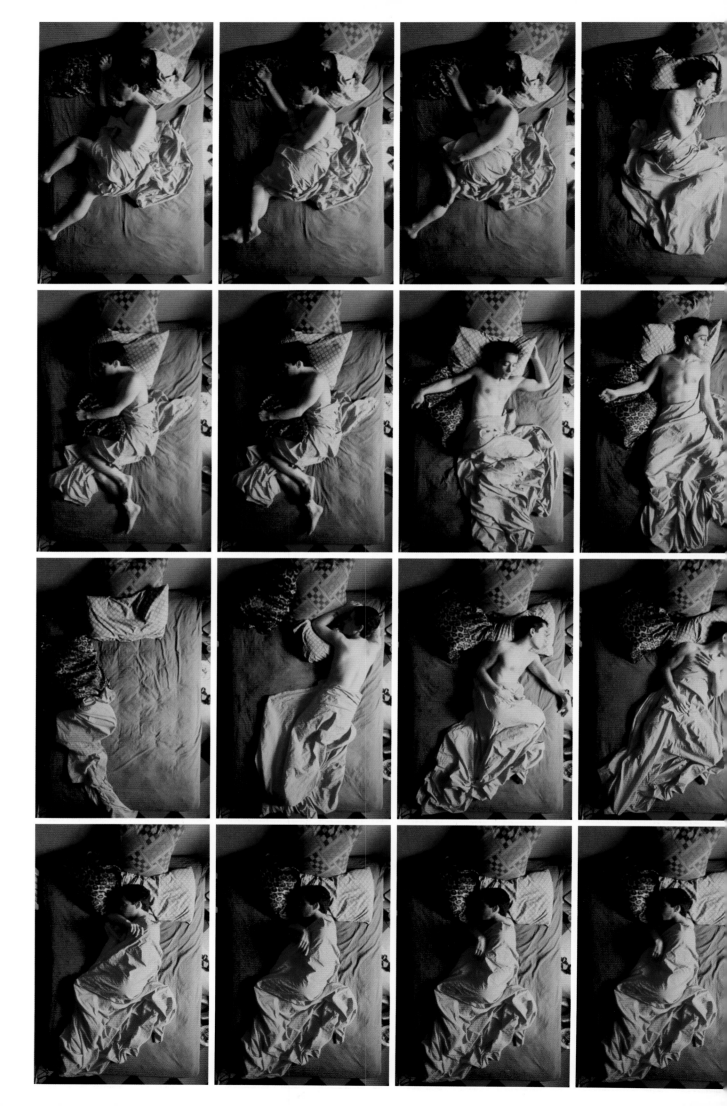

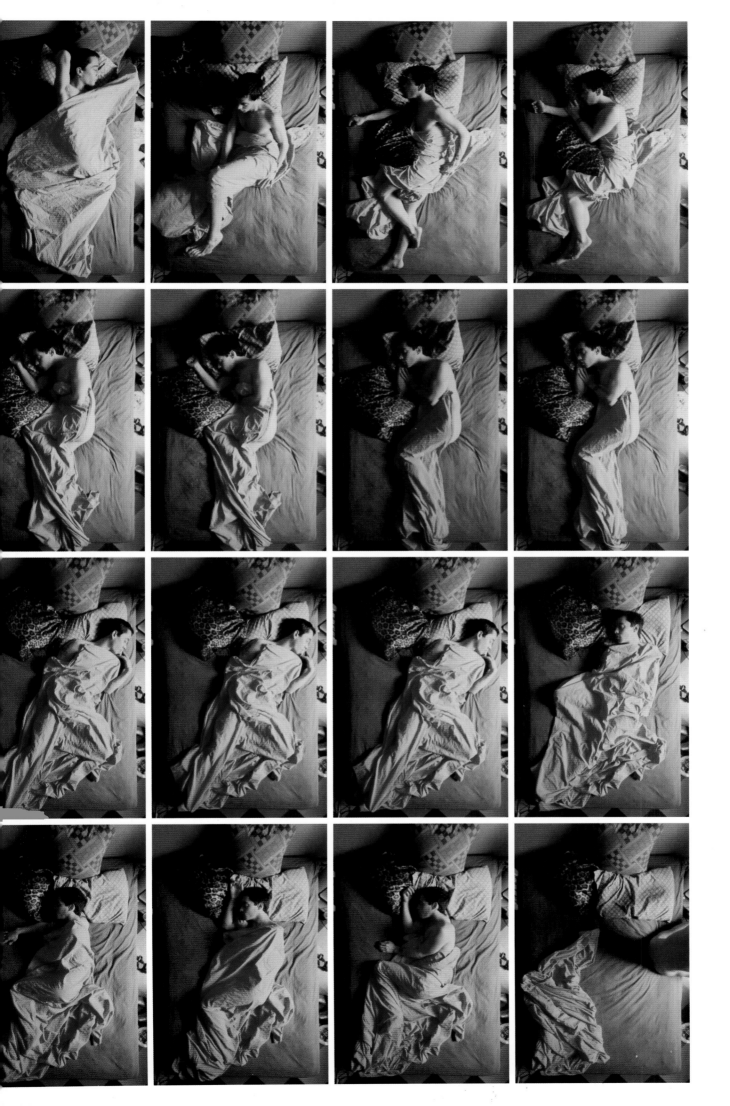

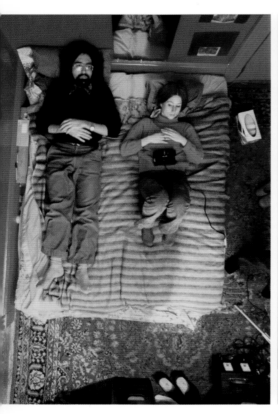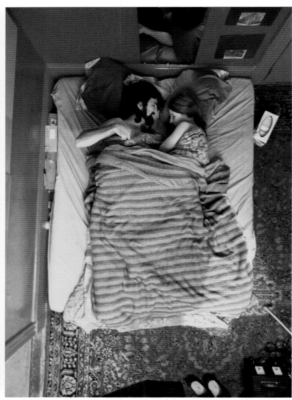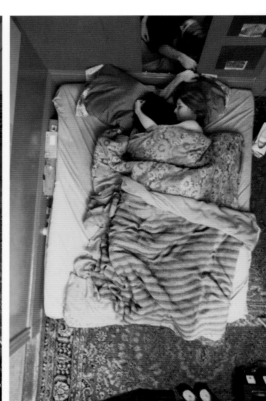

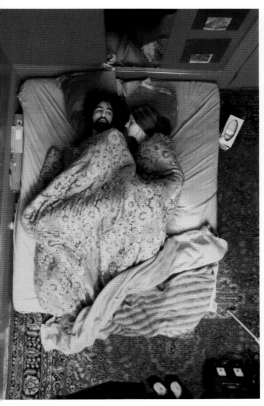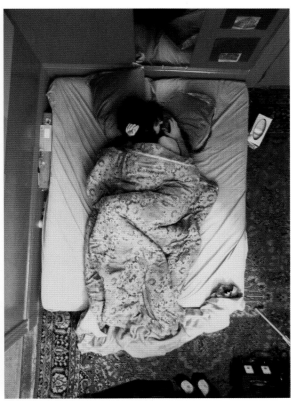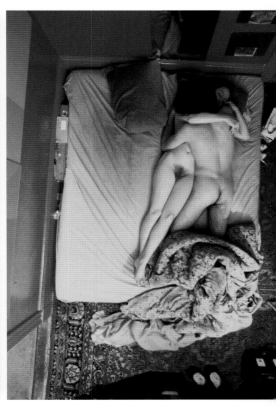

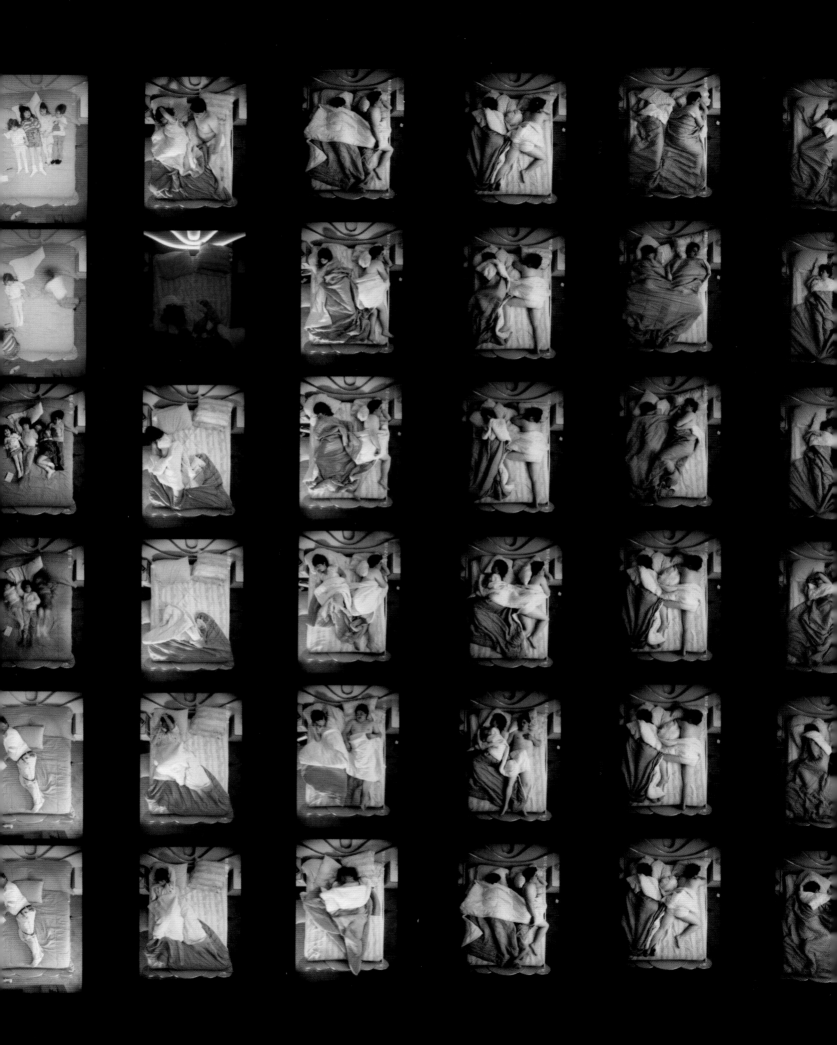

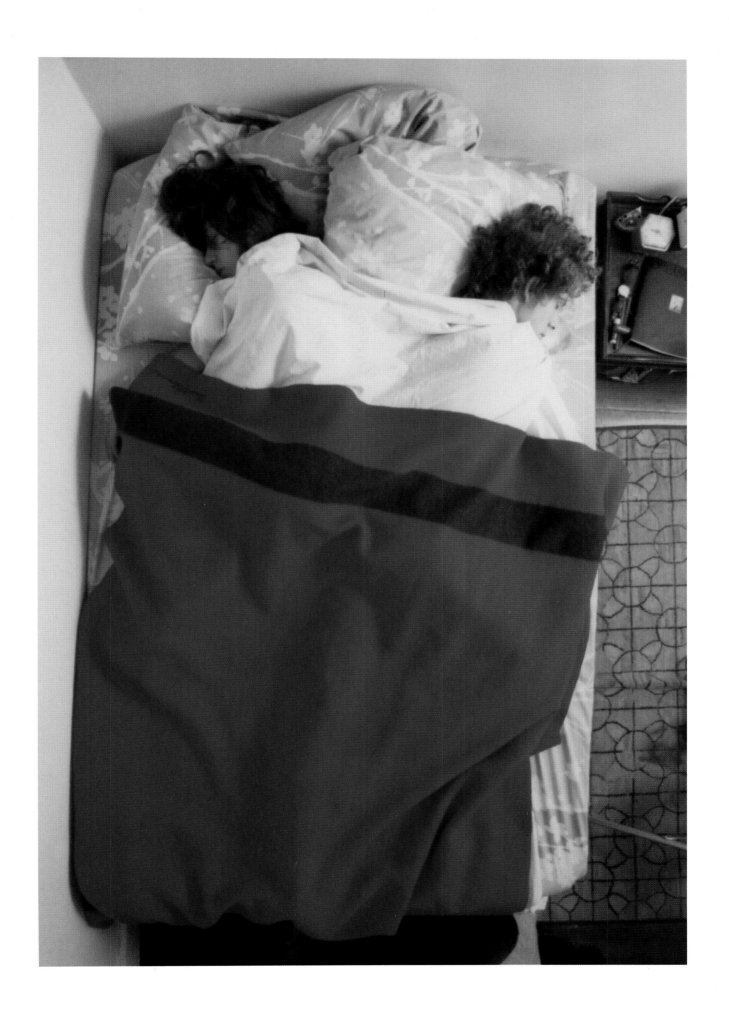

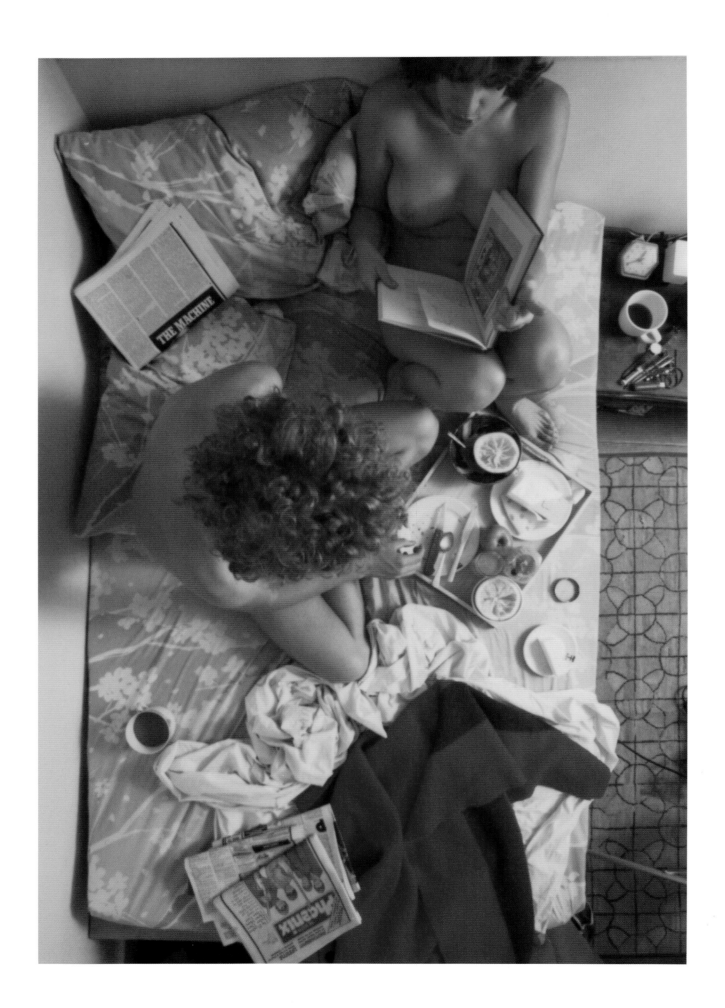

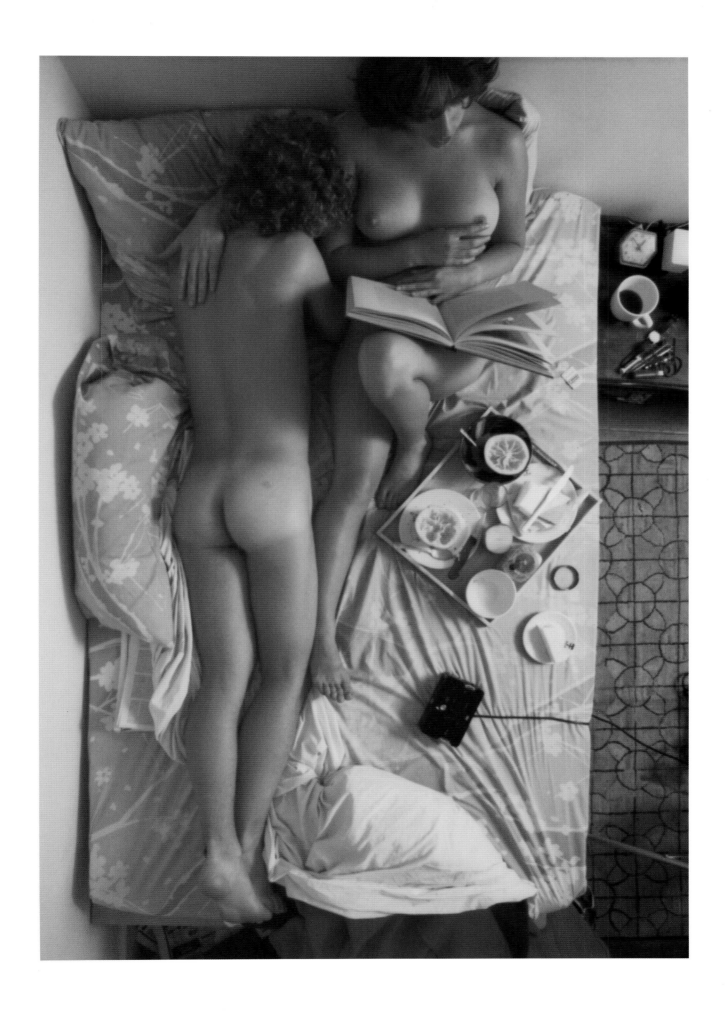

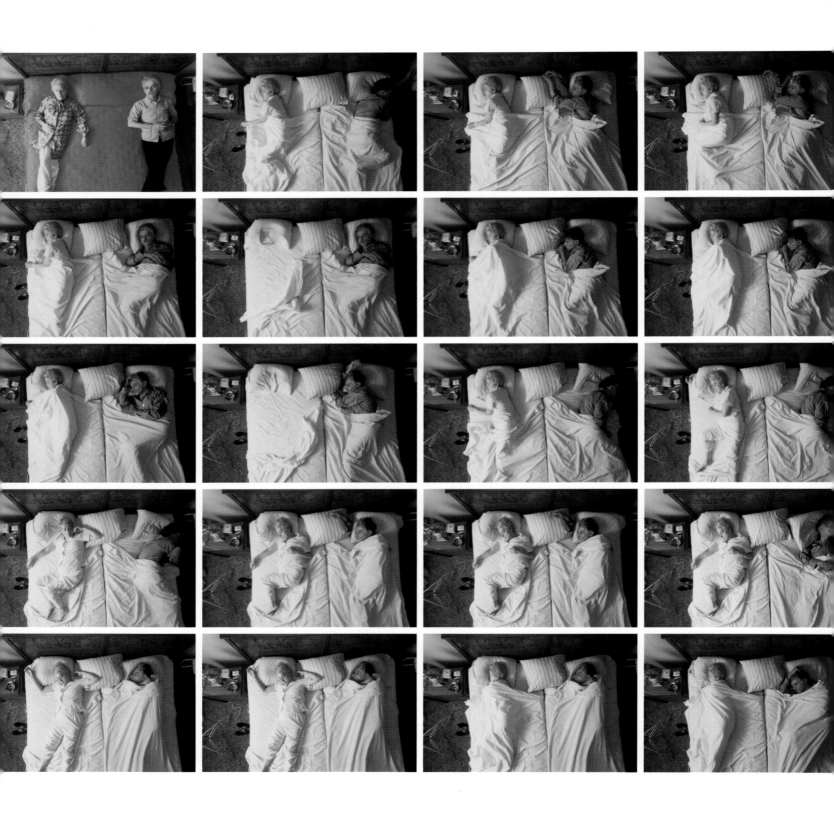

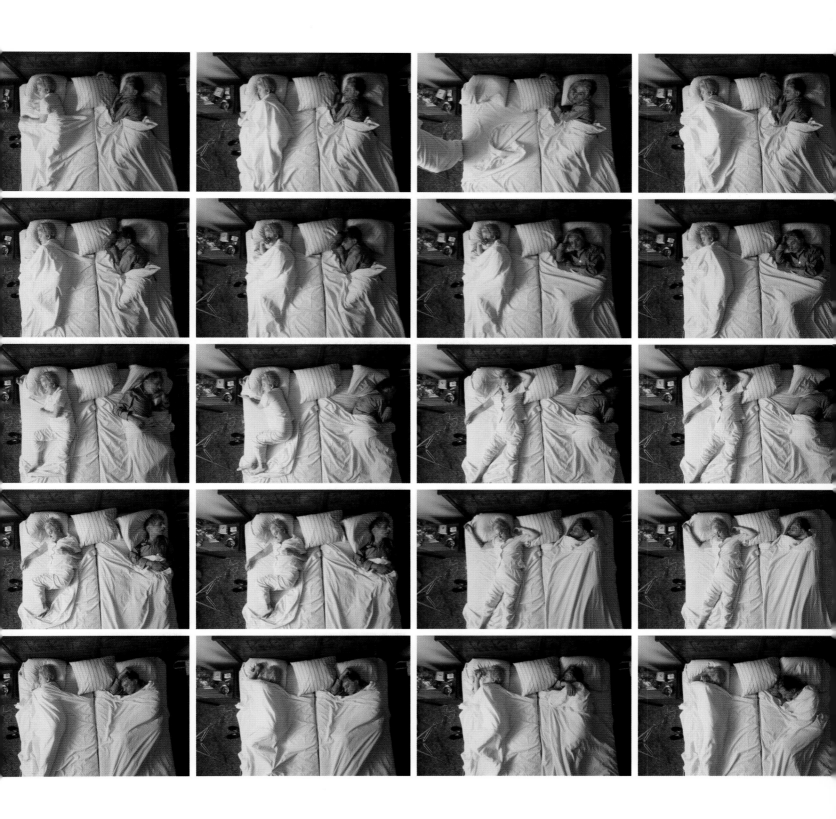

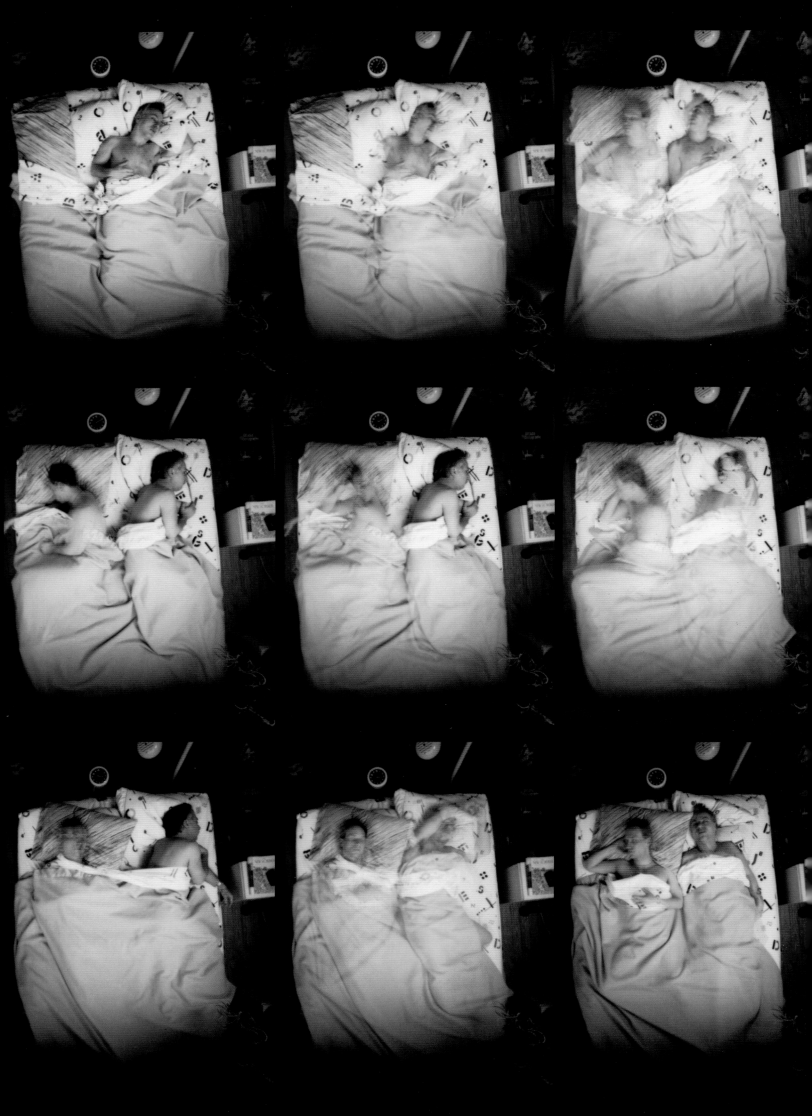

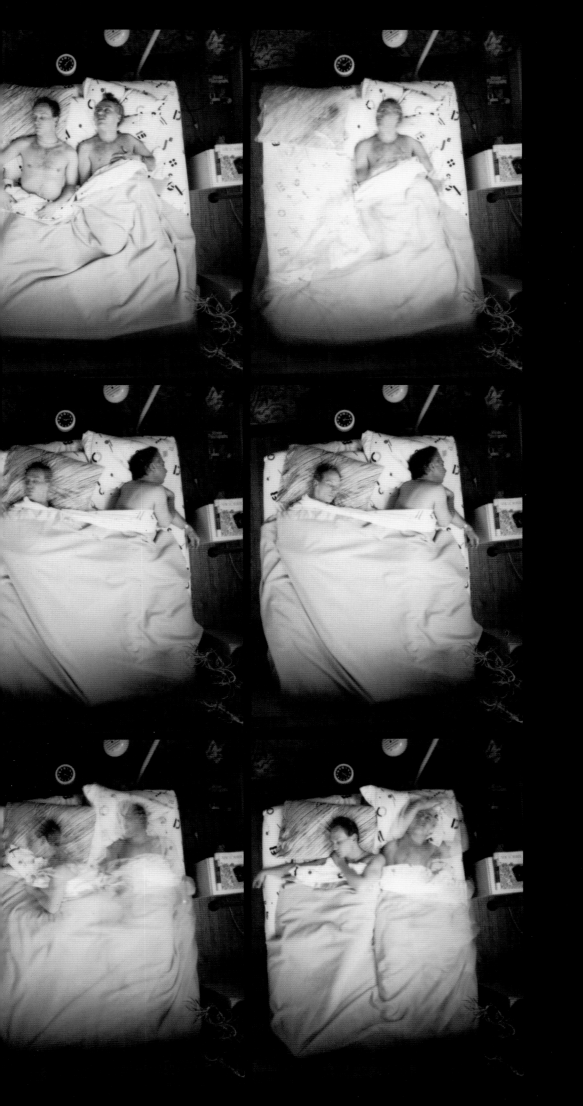

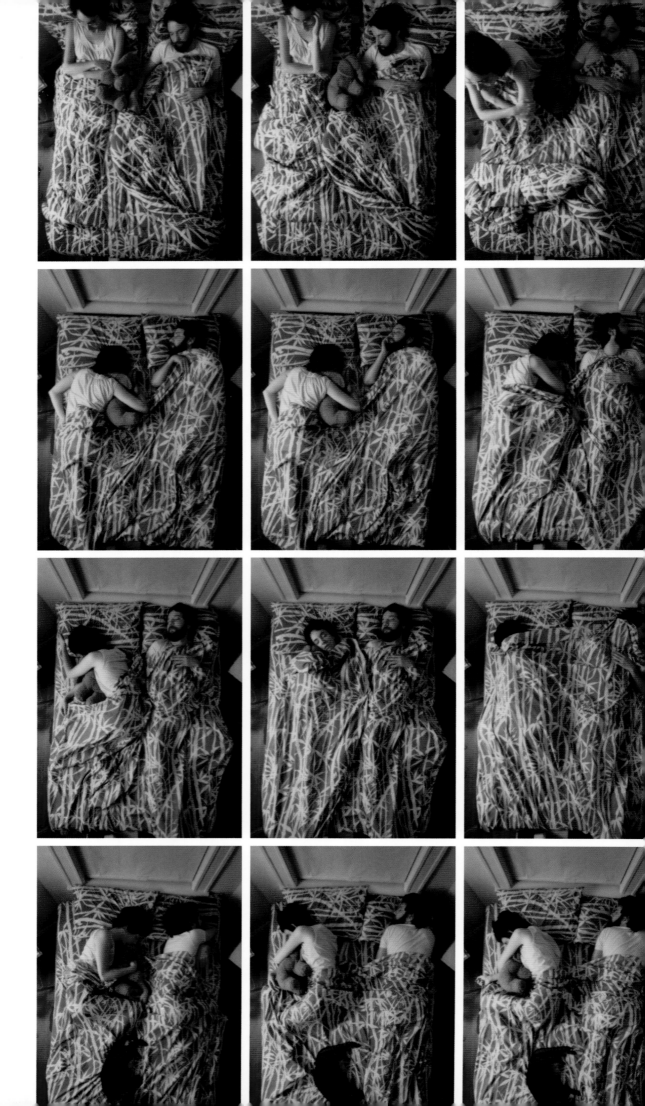

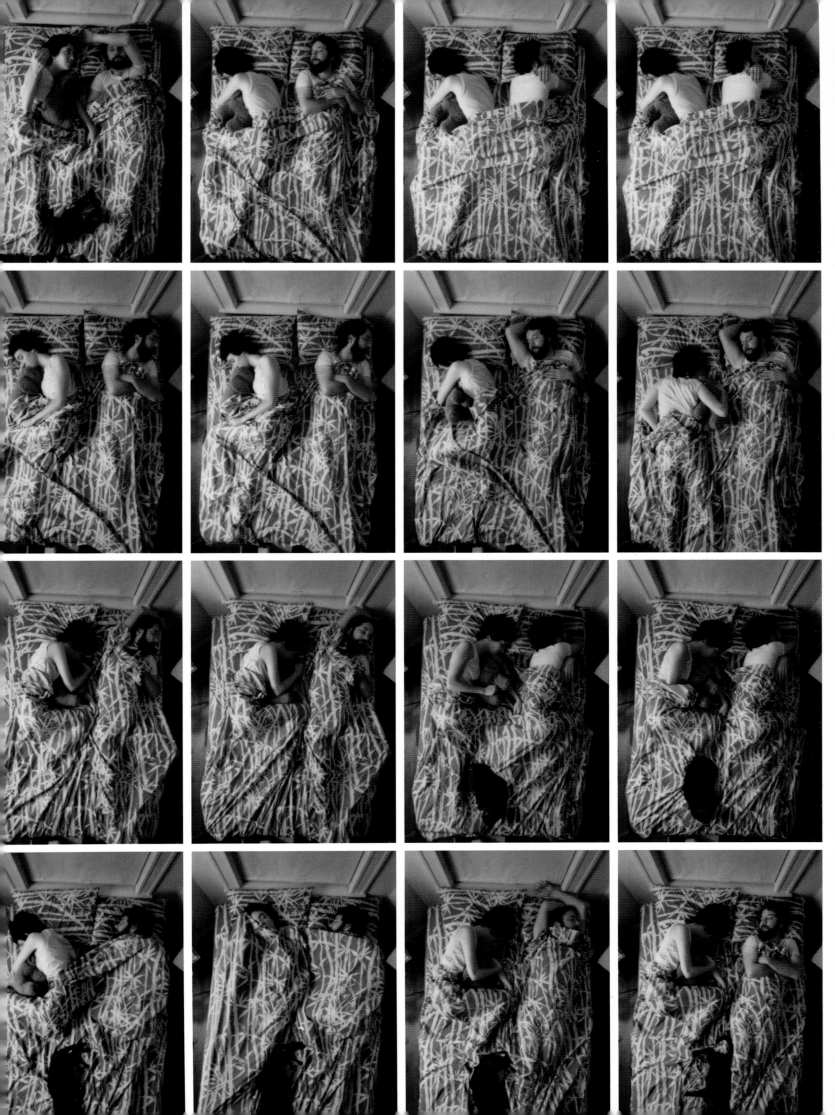

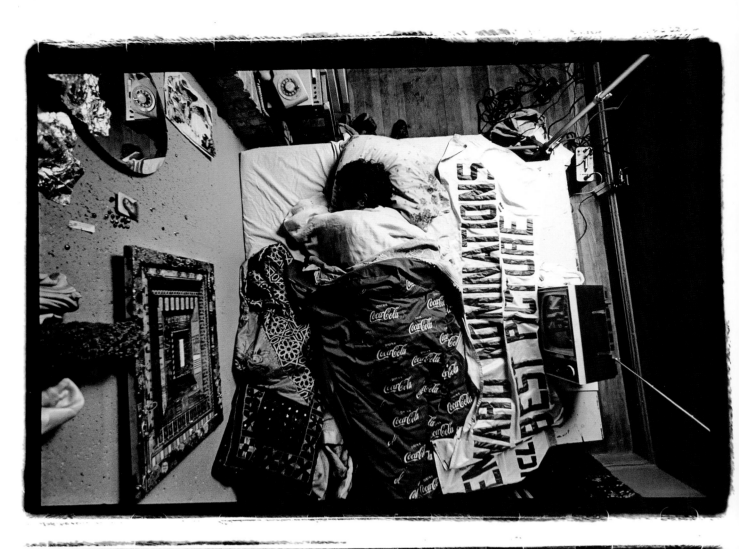
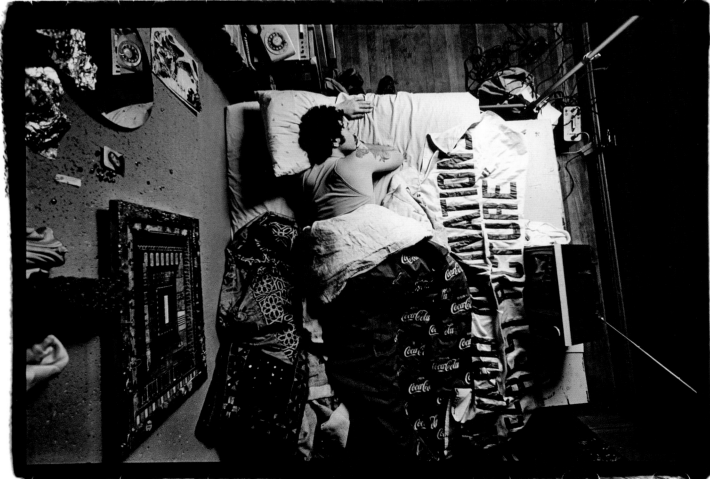

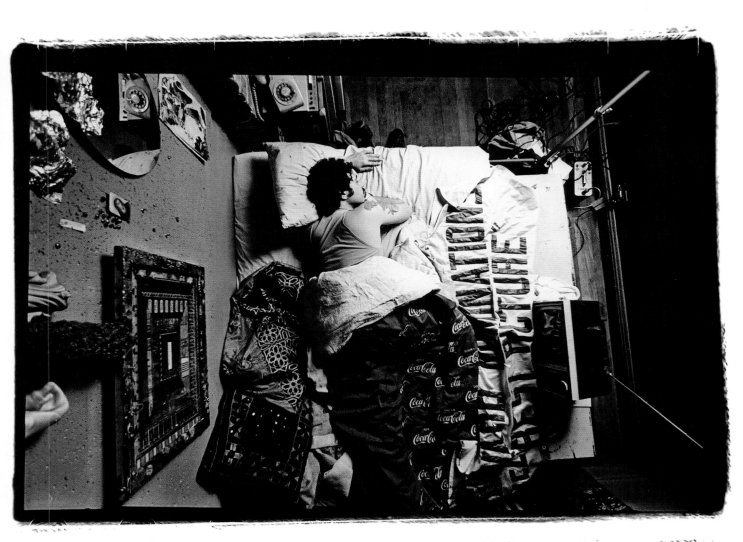

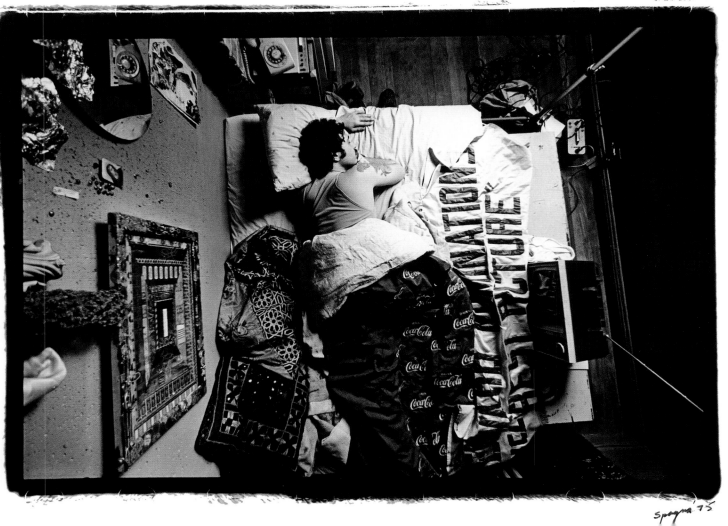

Spagna '75

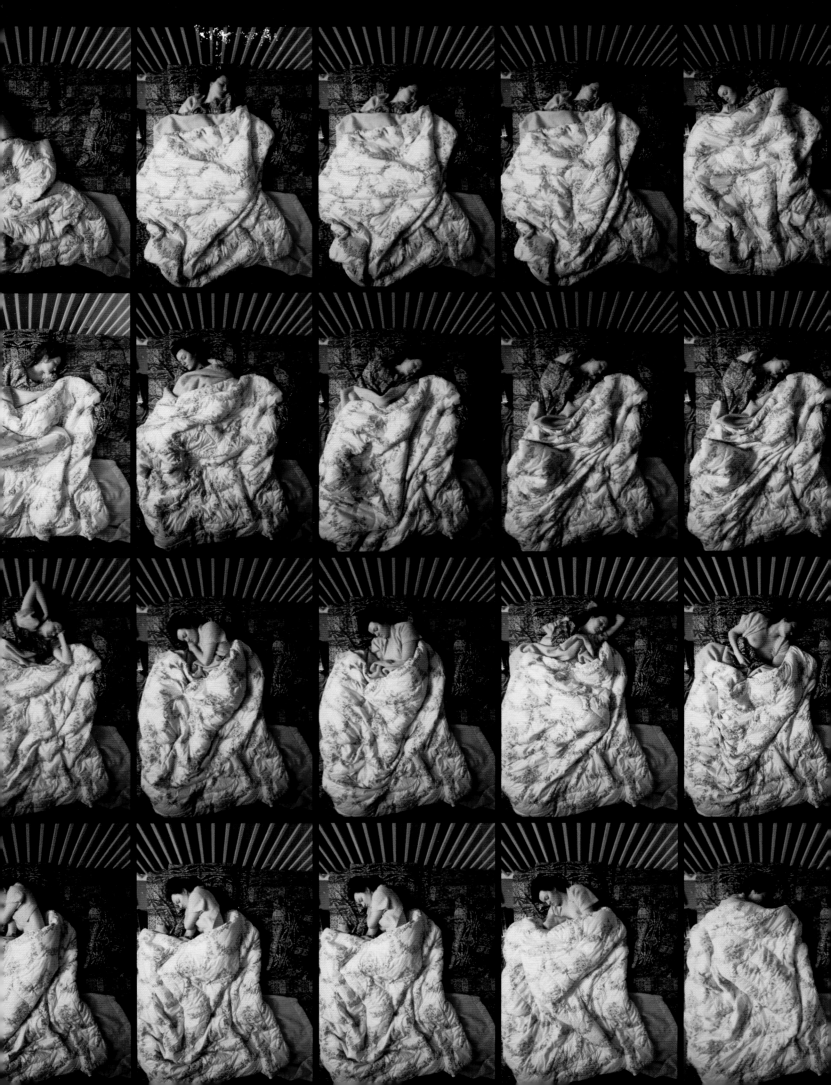

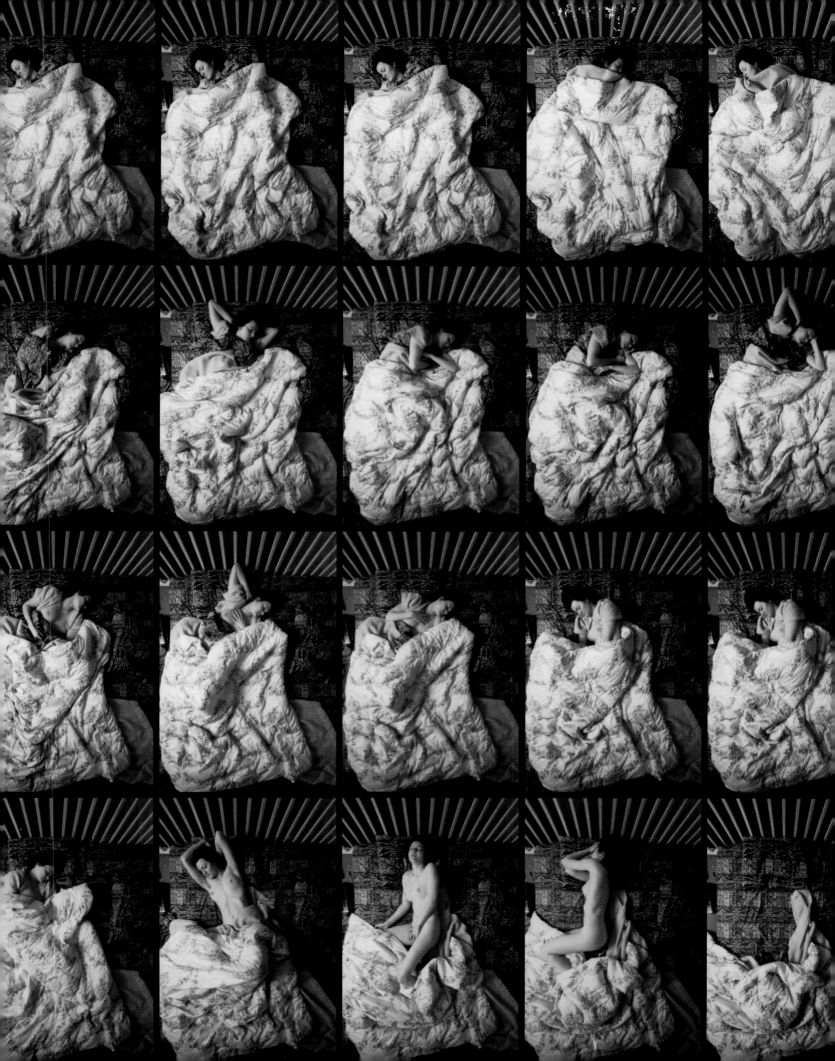

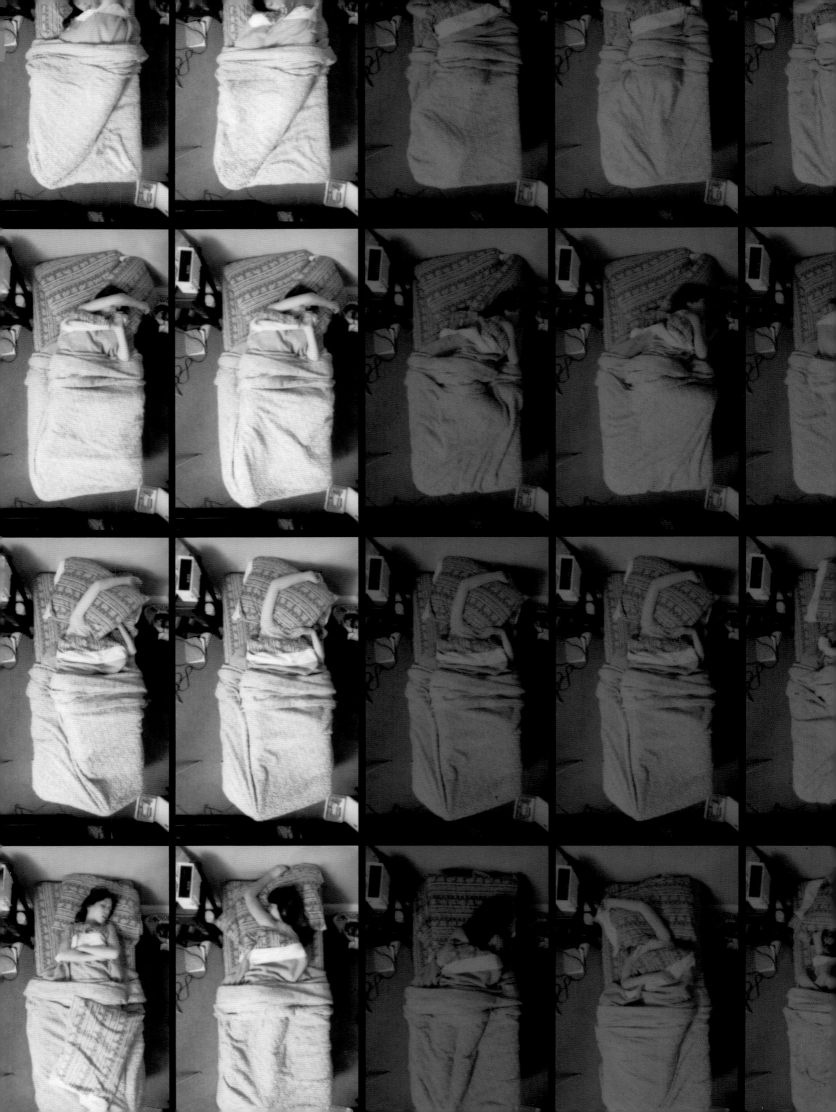

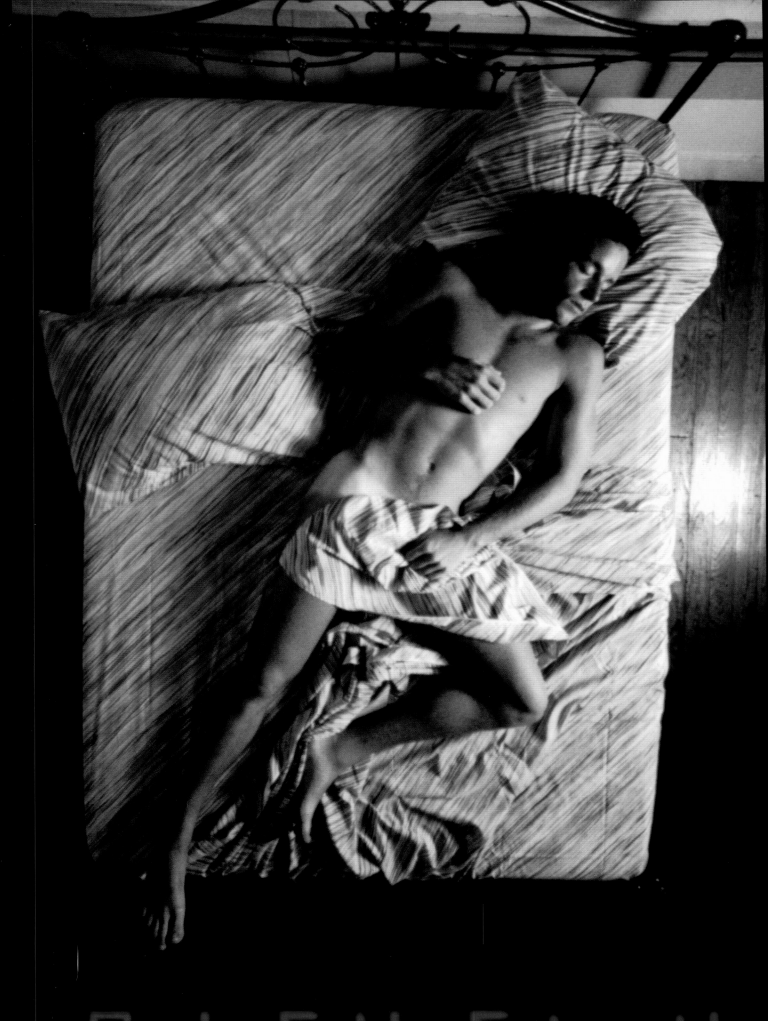

01 54 56.4

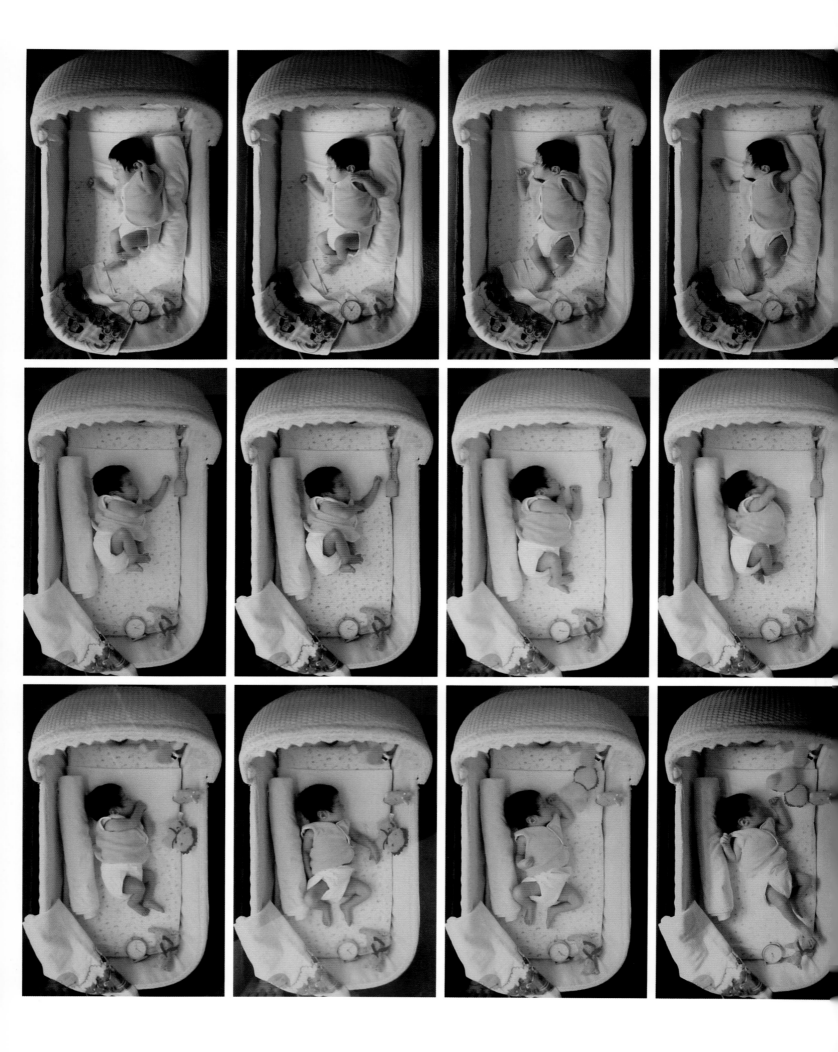

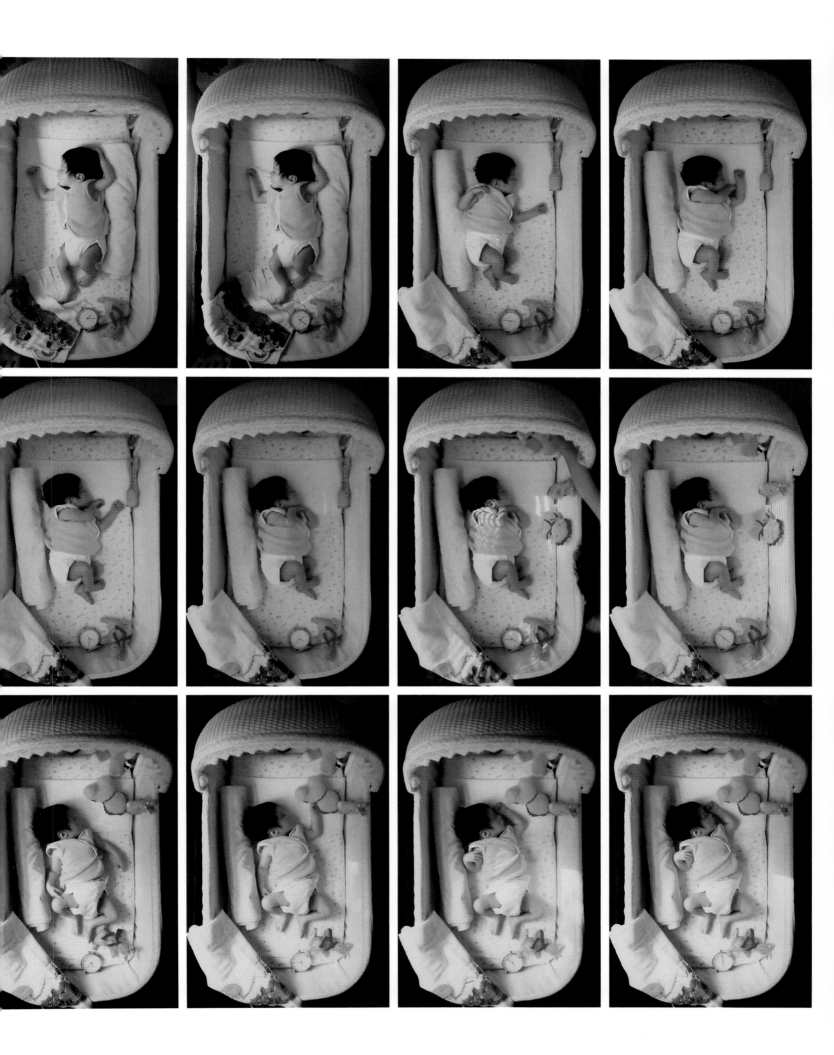

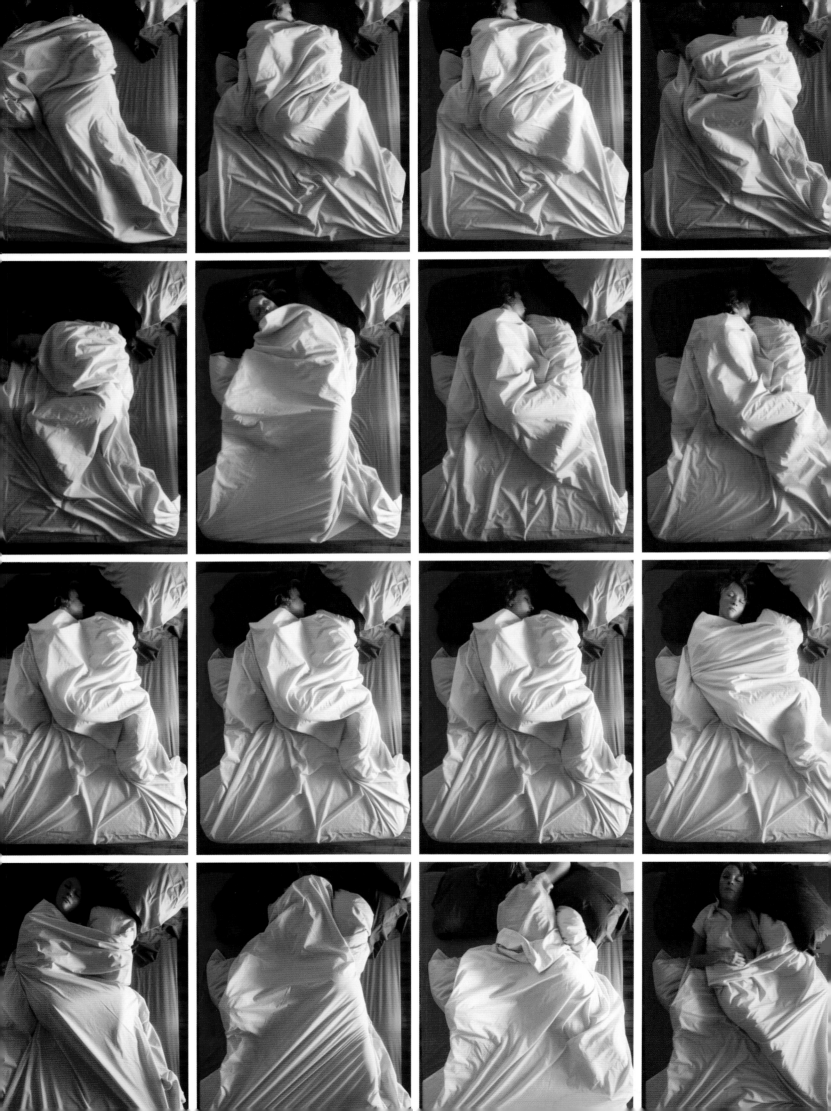

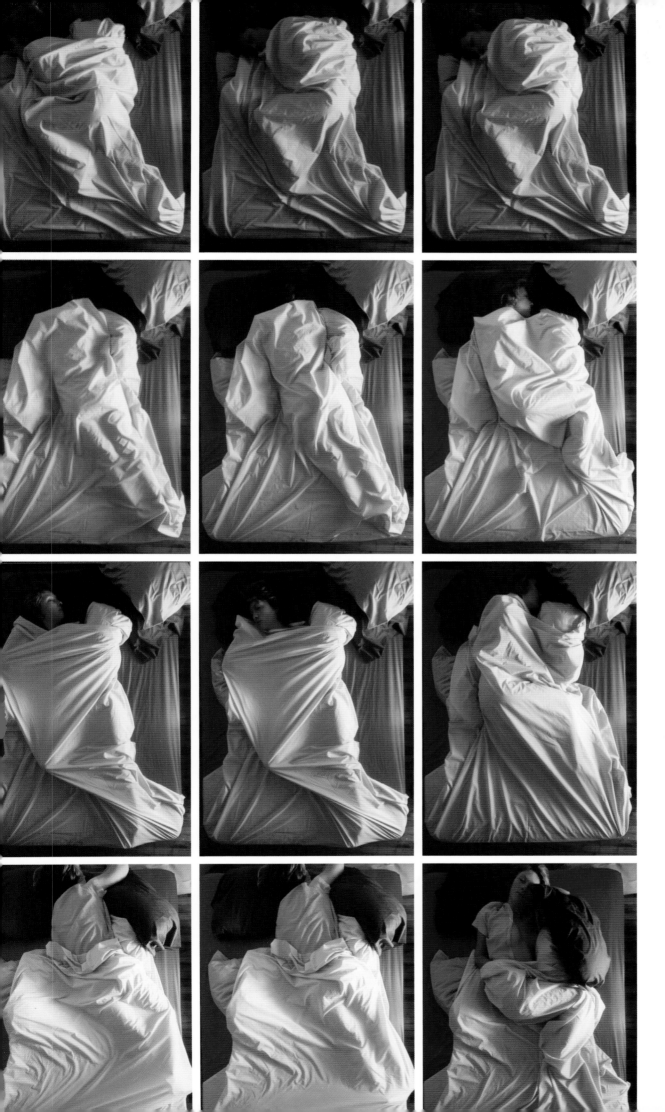

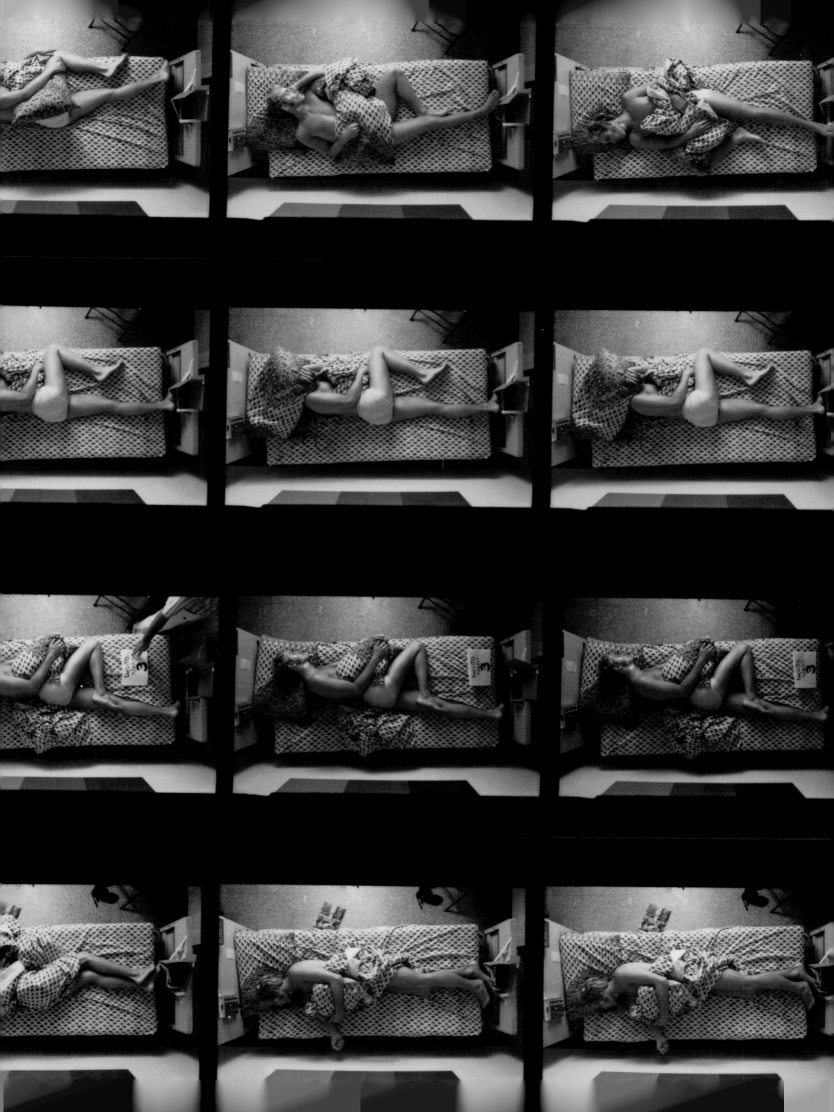

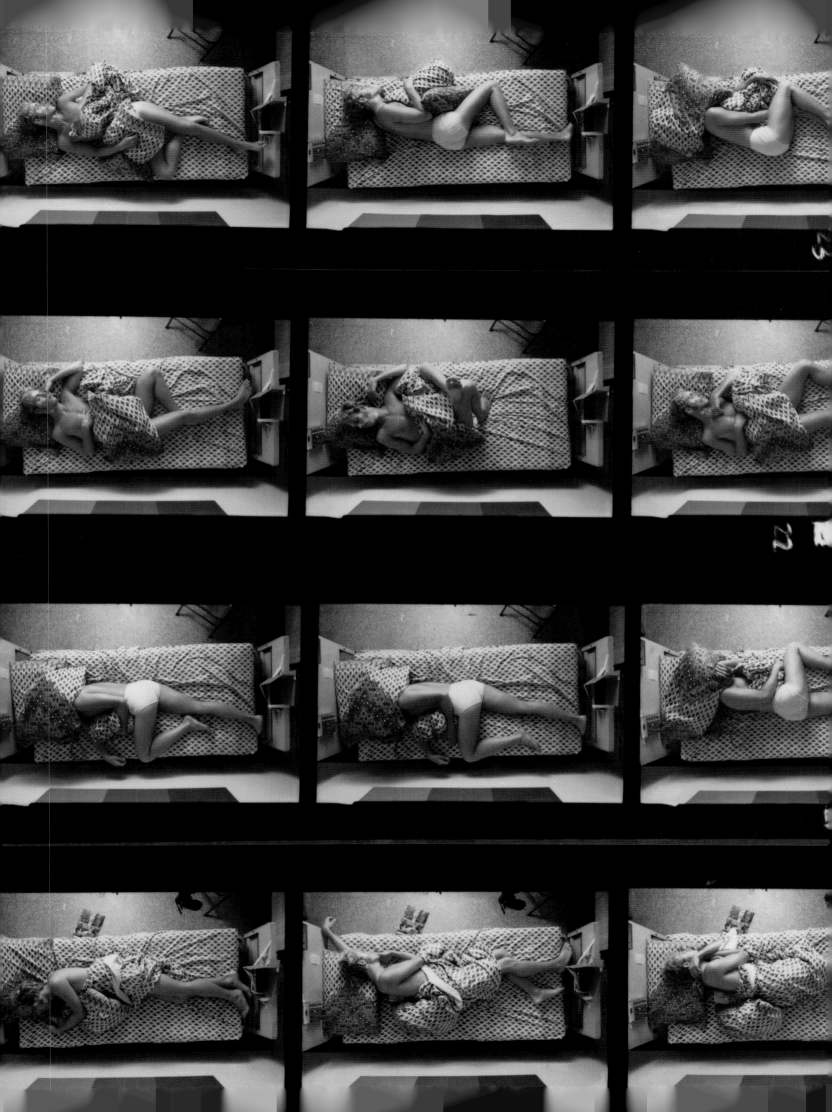

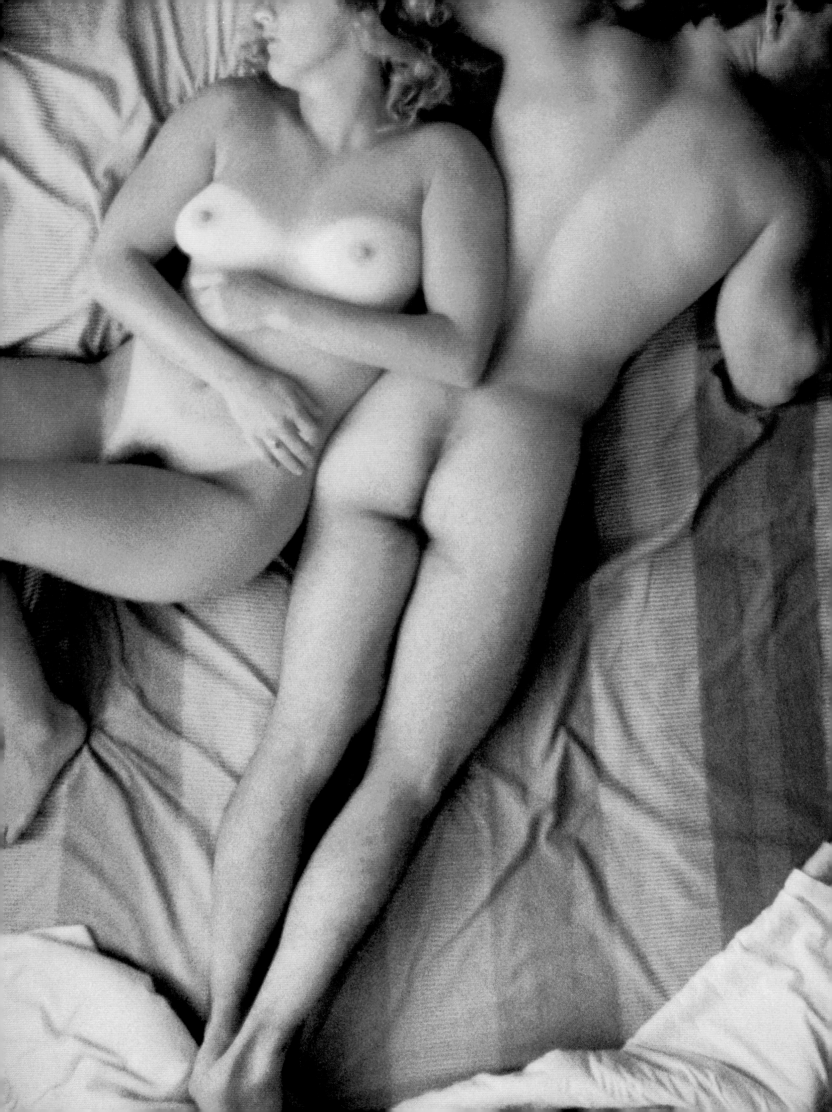

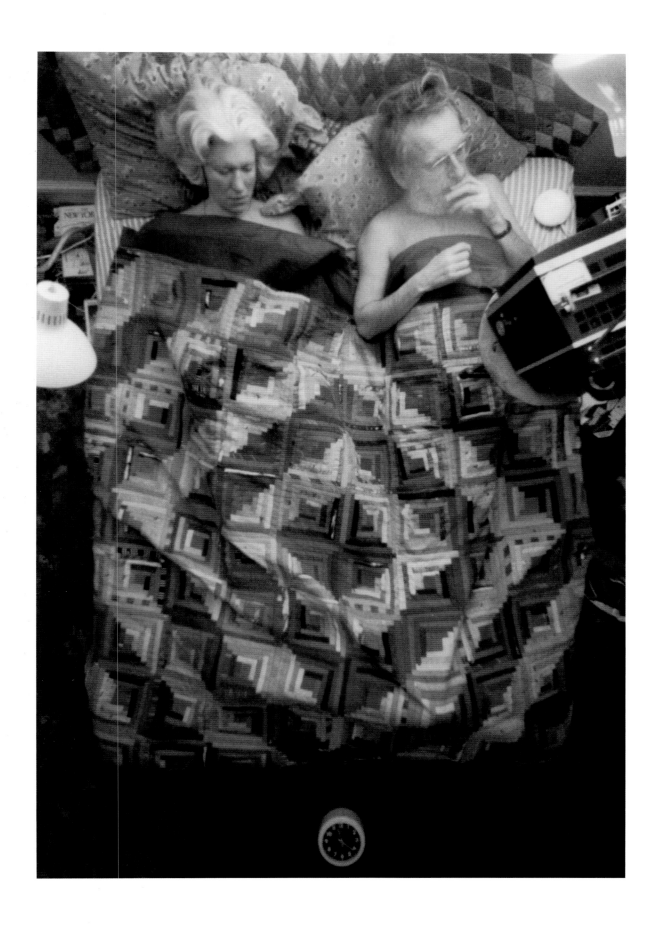

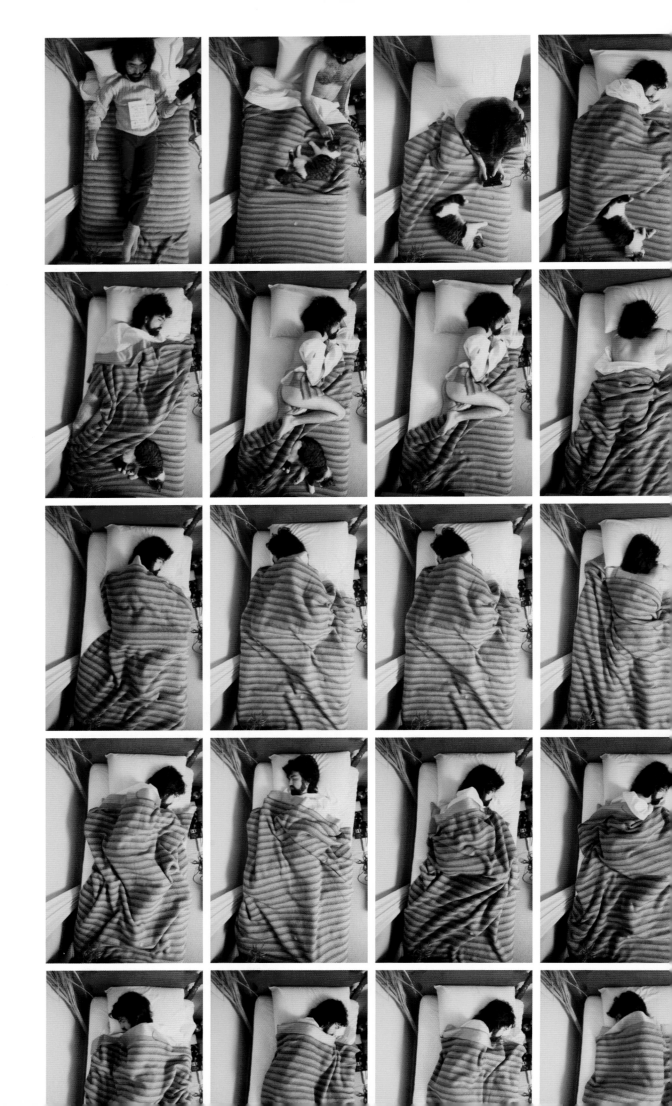

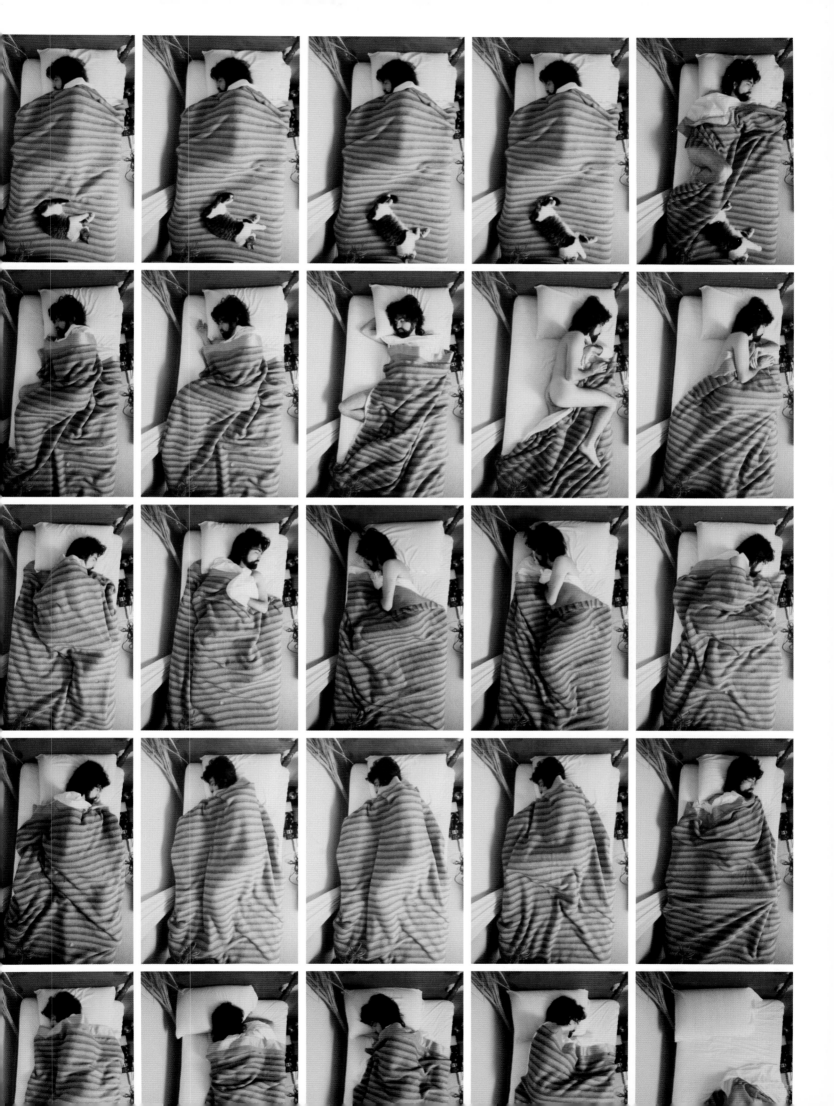

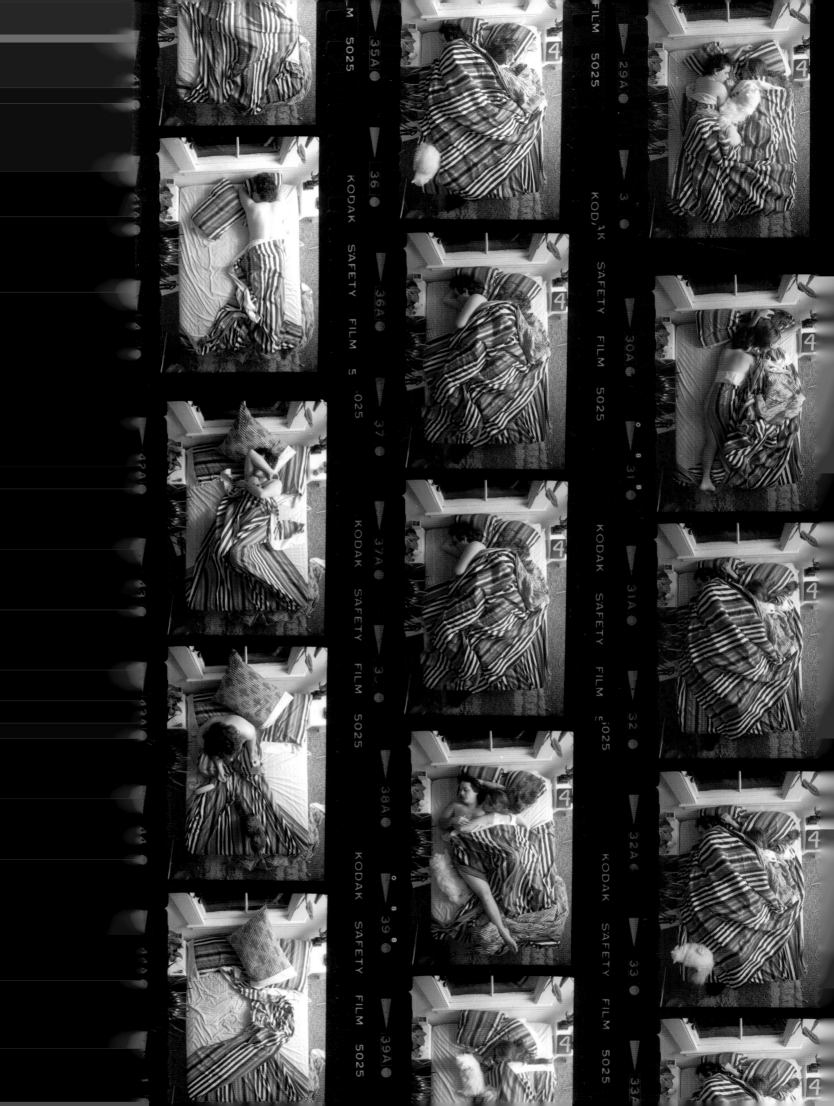

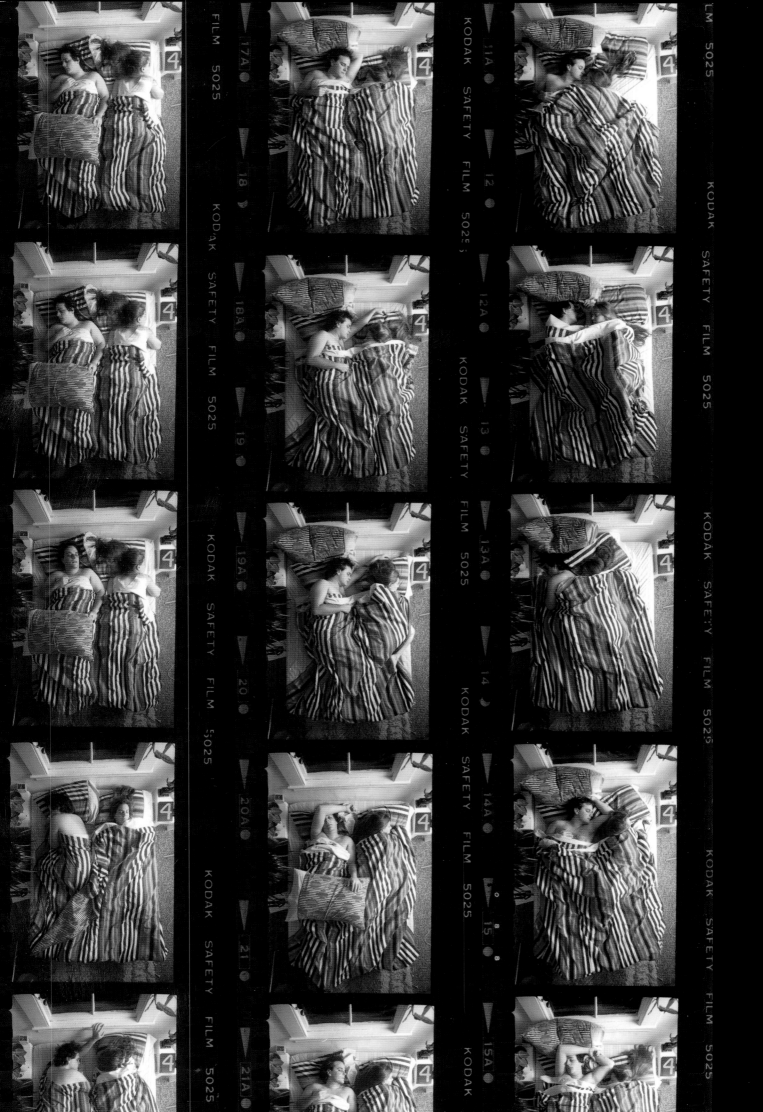

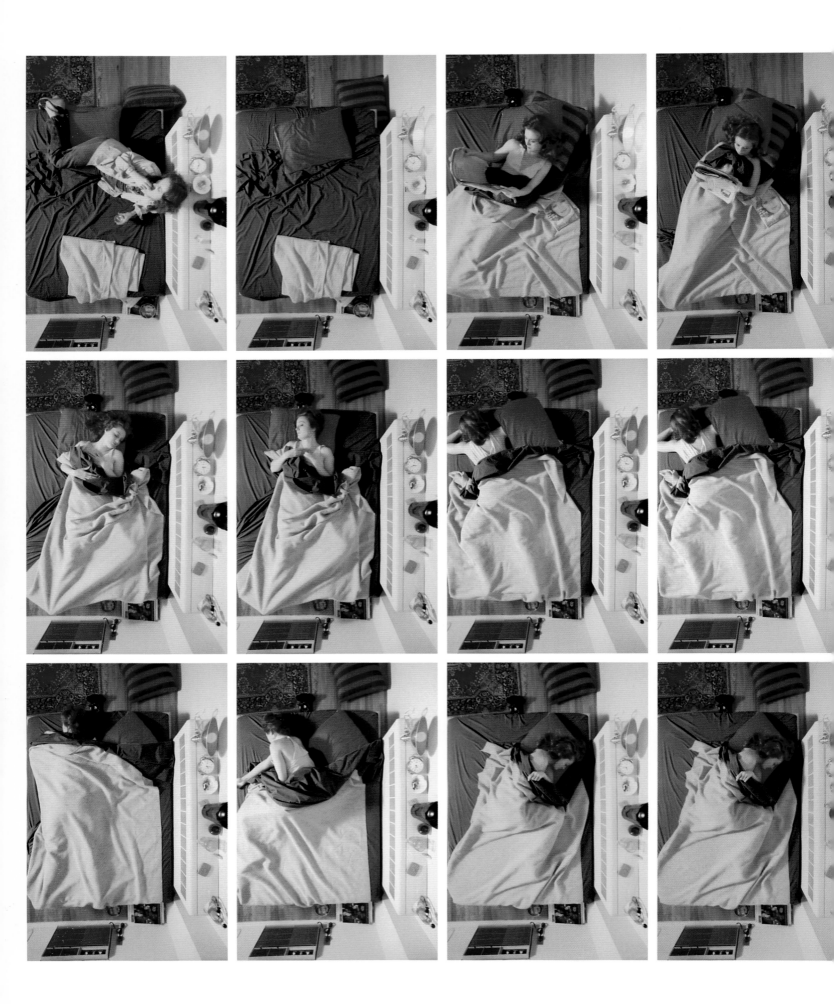

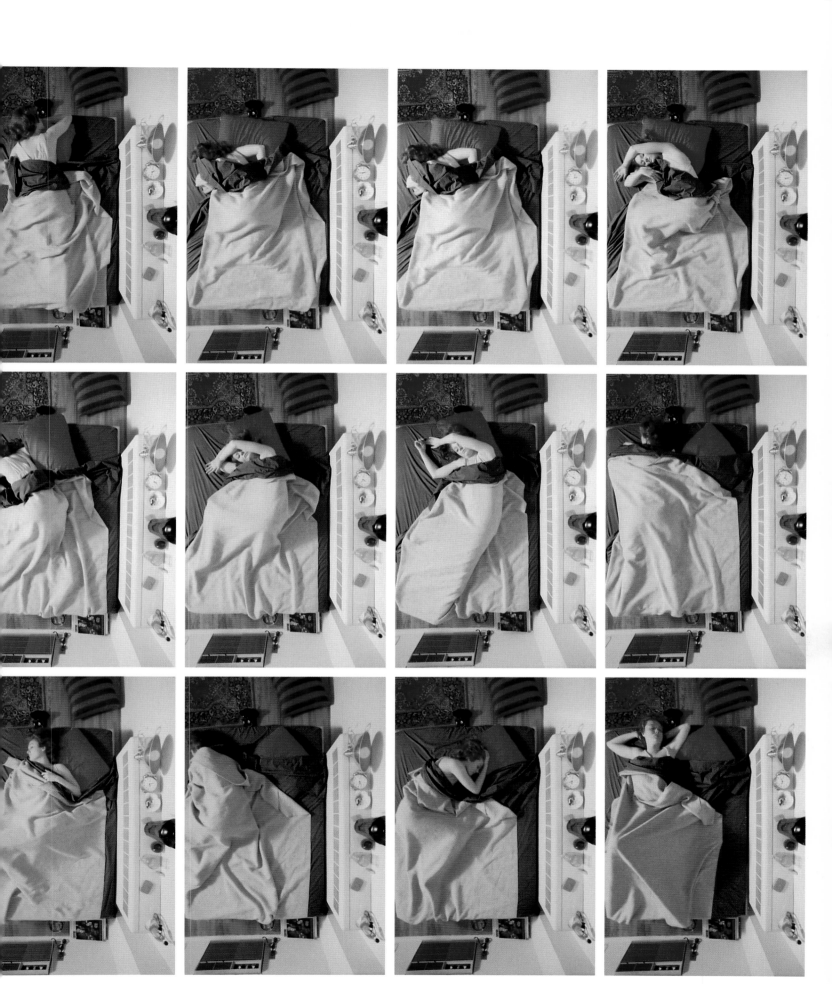

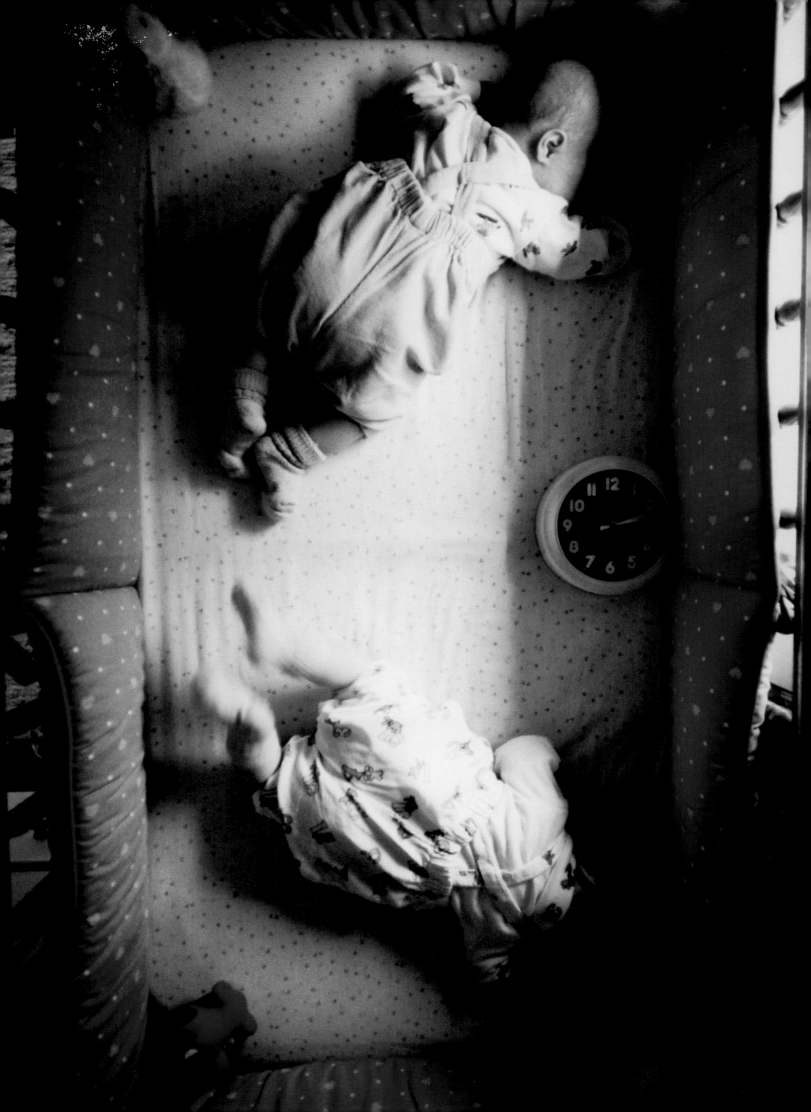

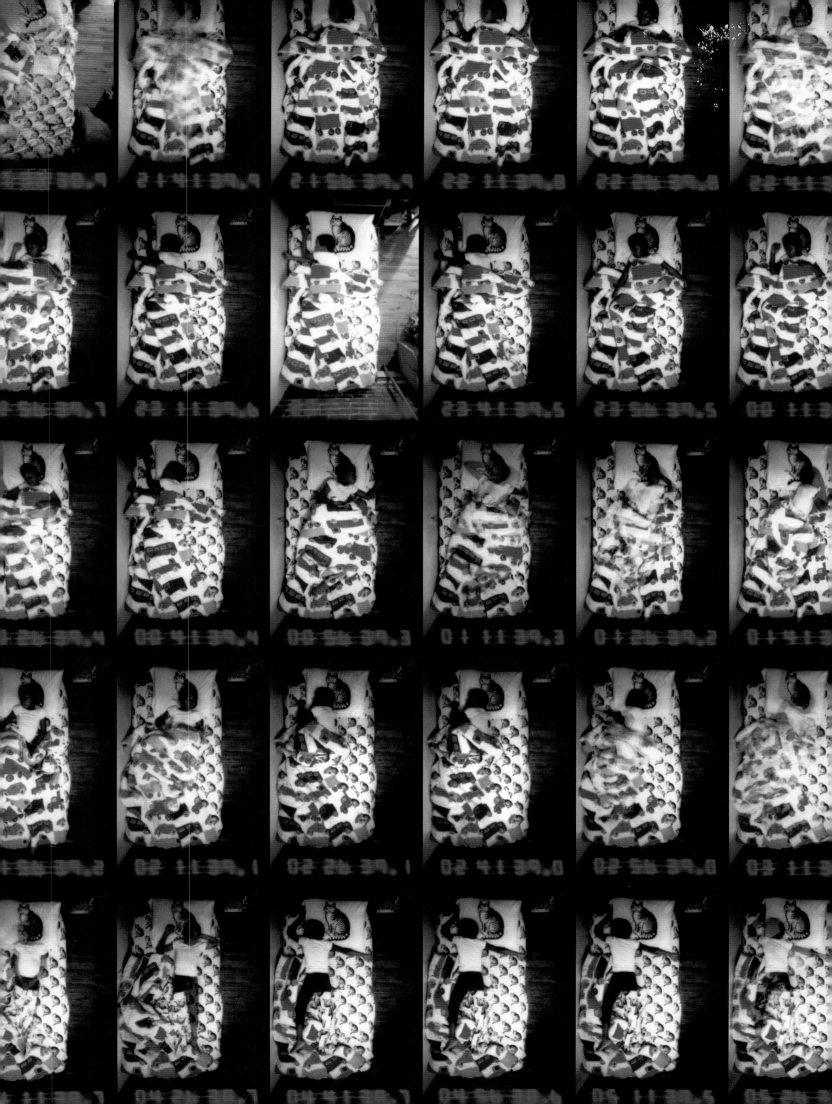

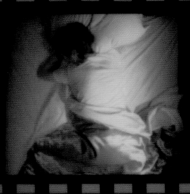
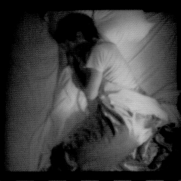
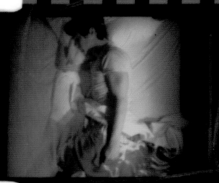
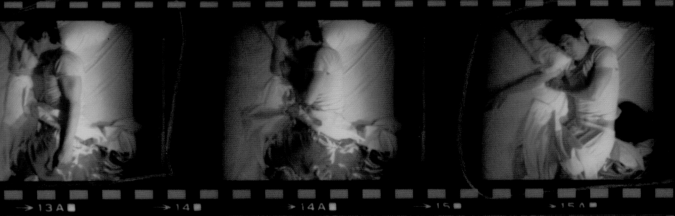
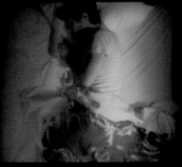
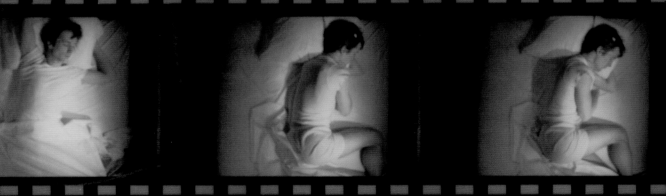
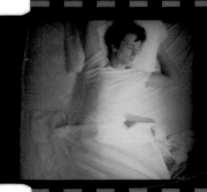
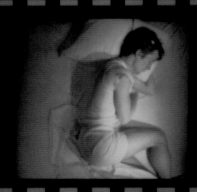
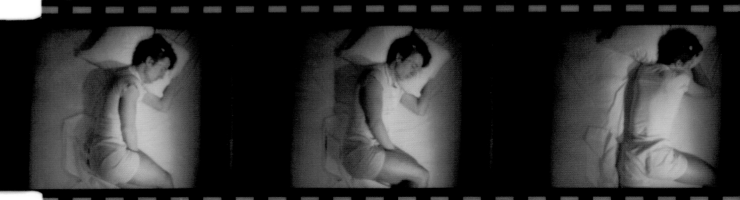
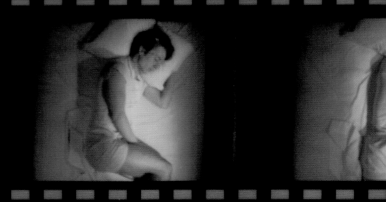
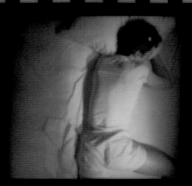

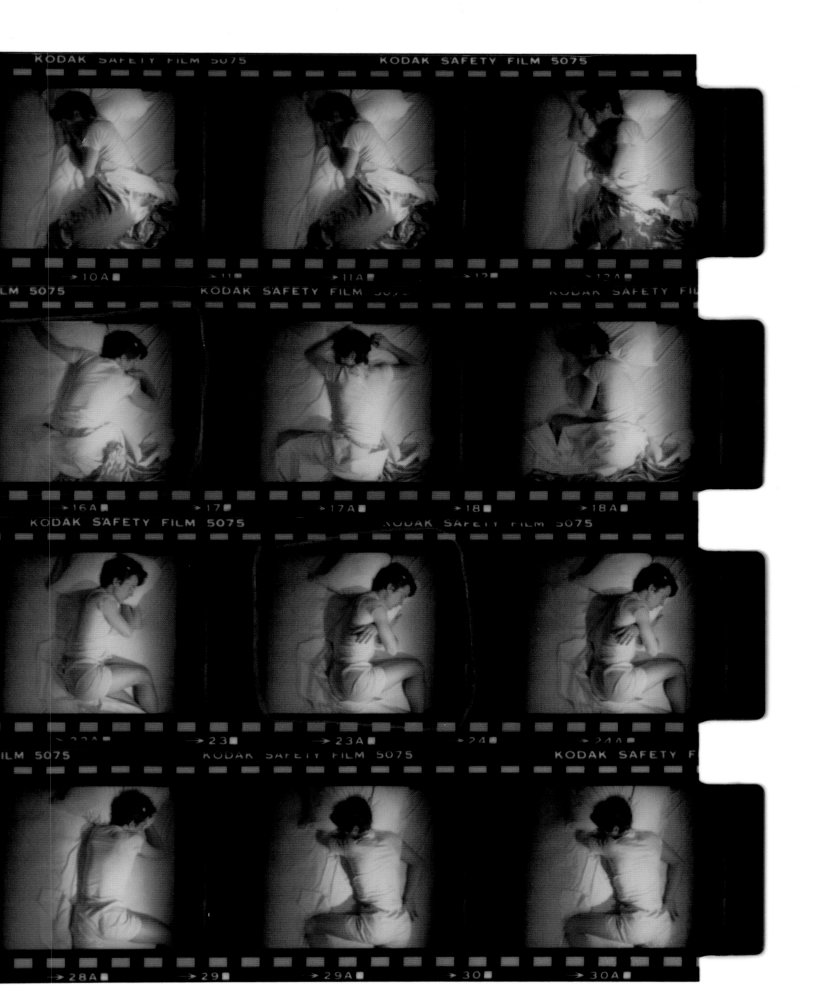

51

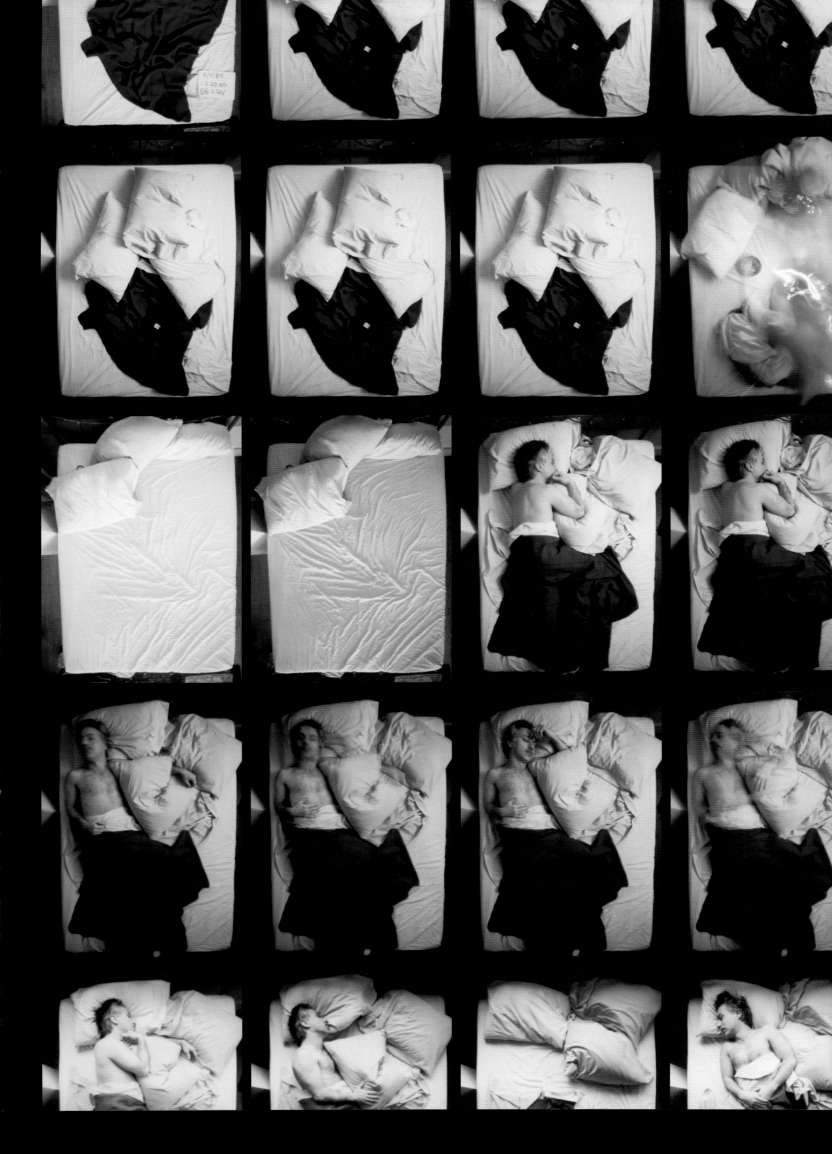

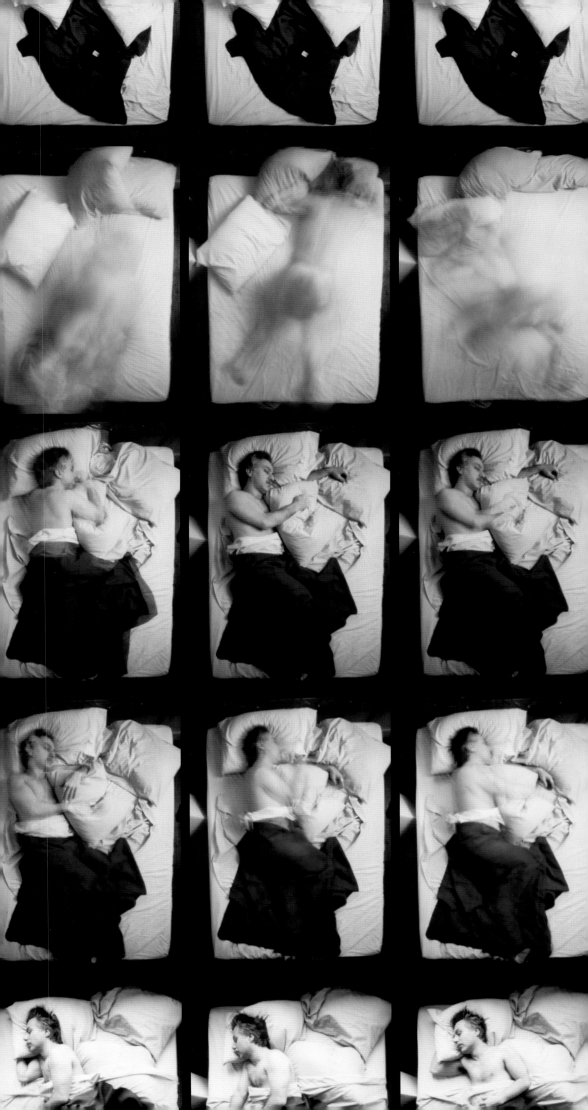

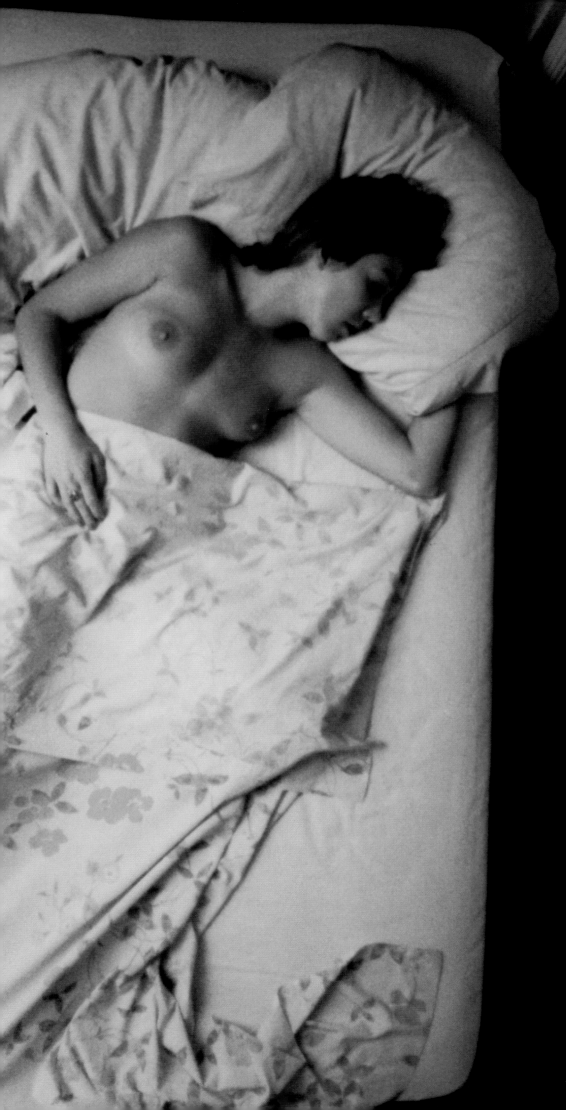

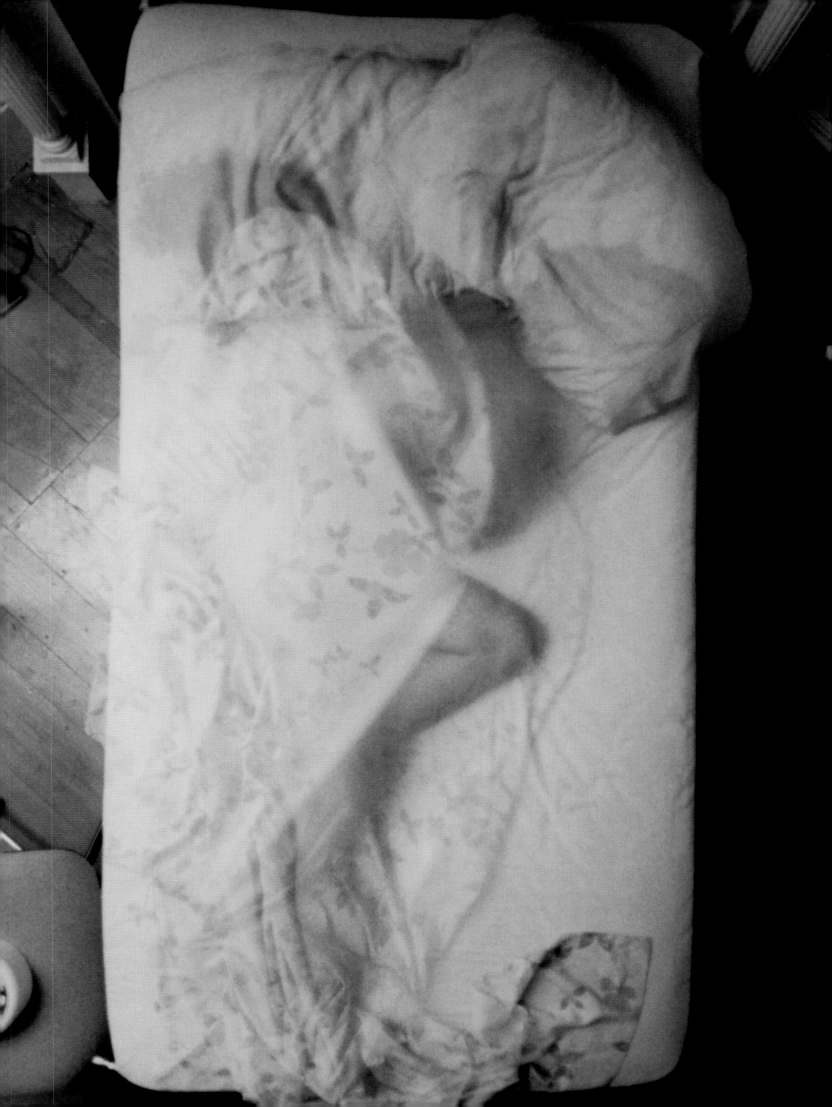

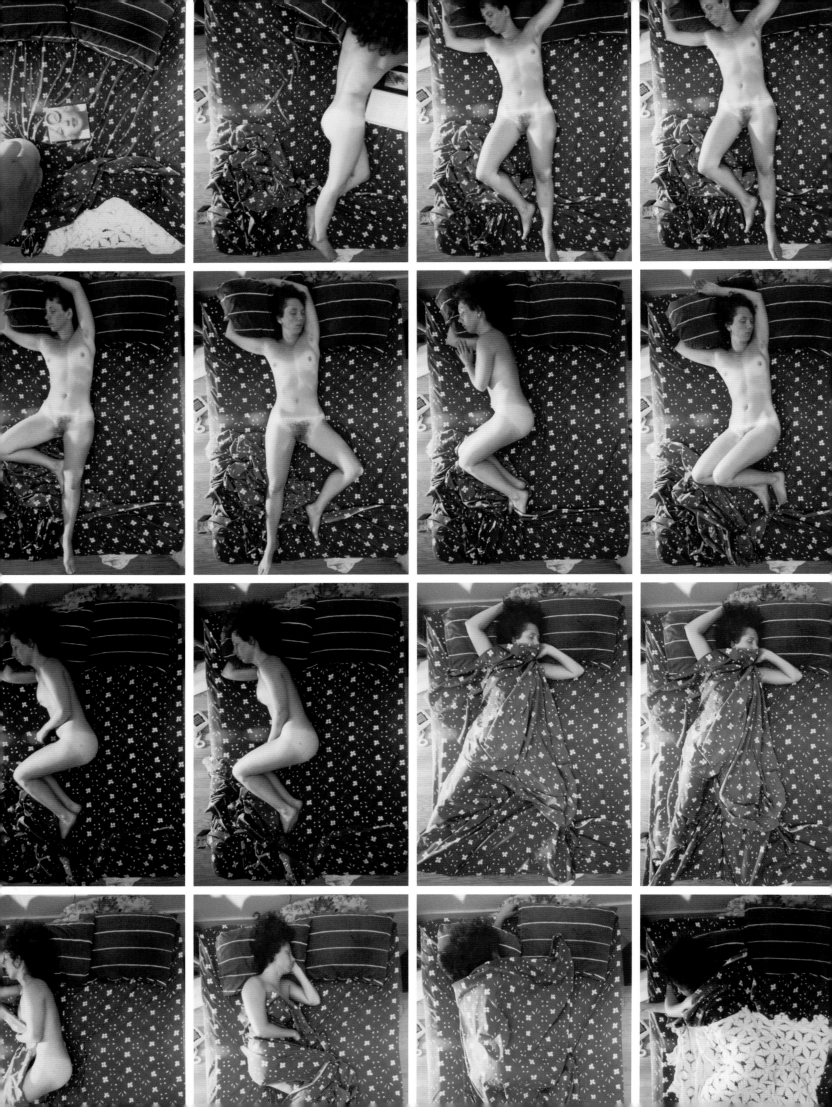

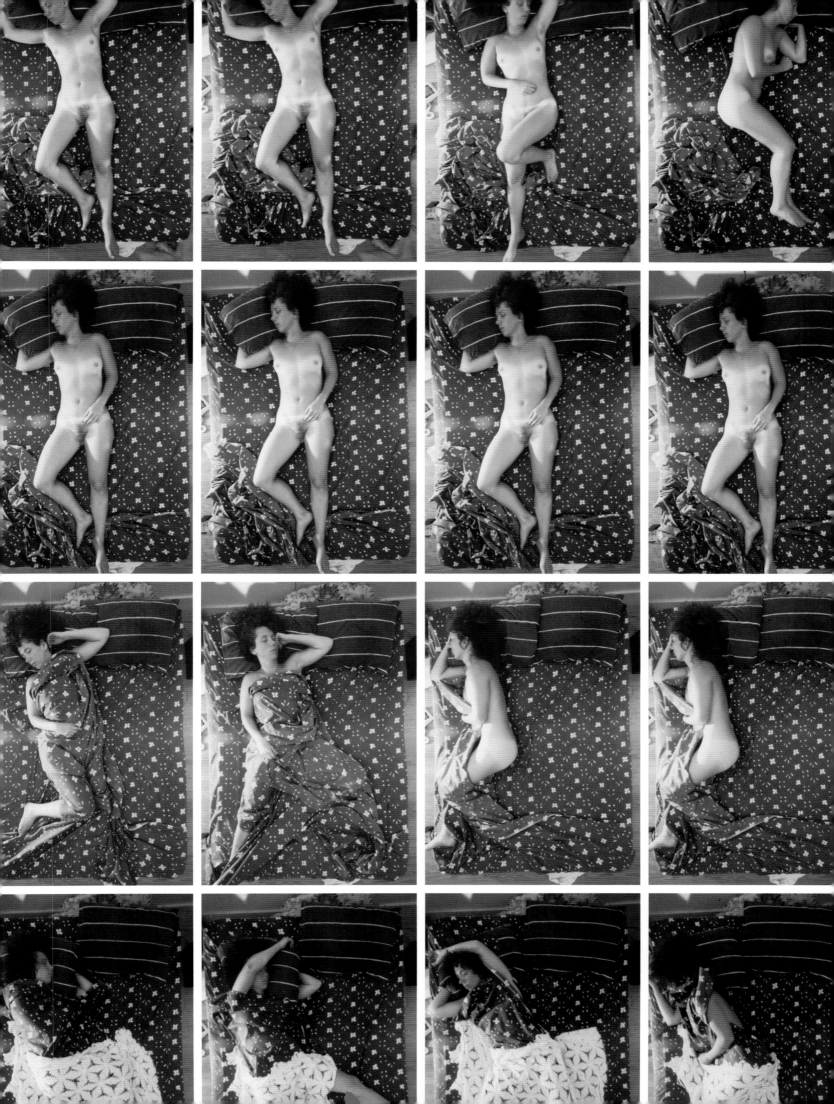

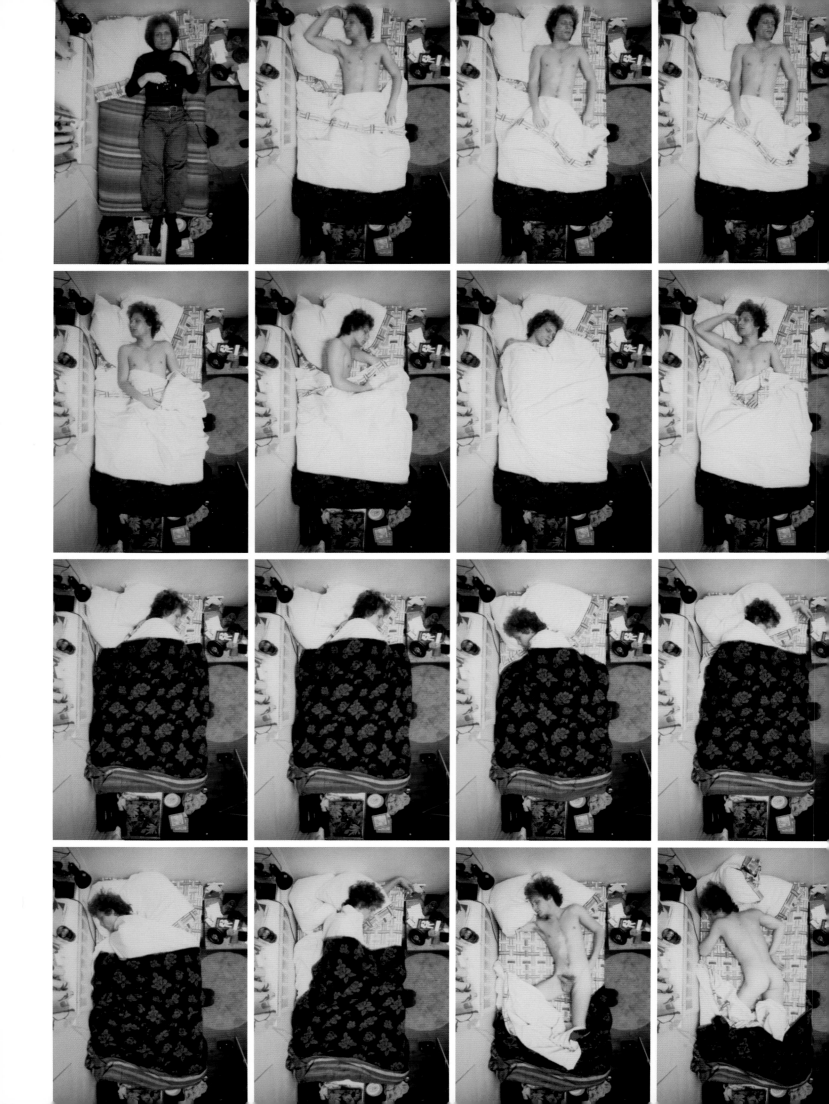

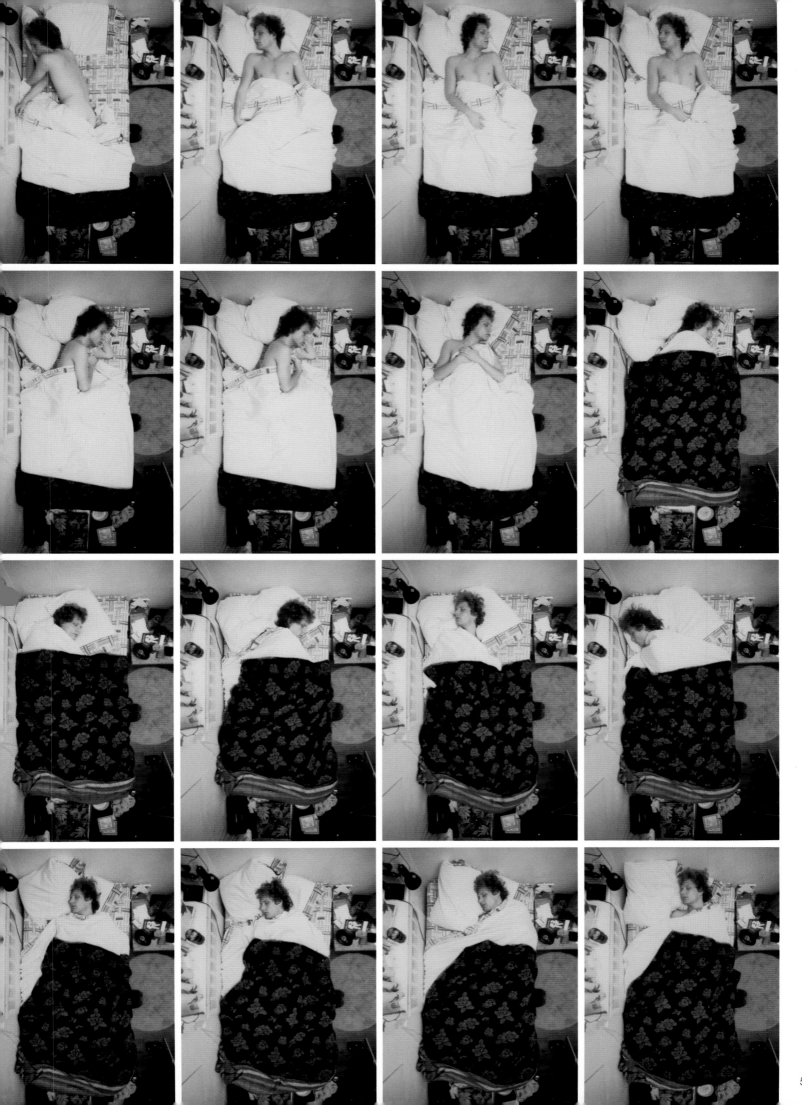

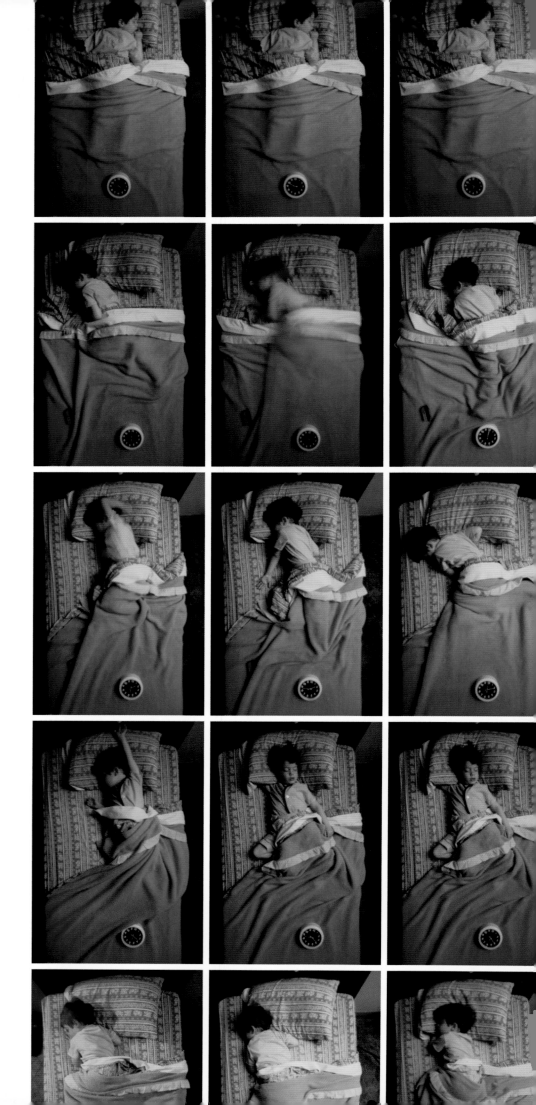

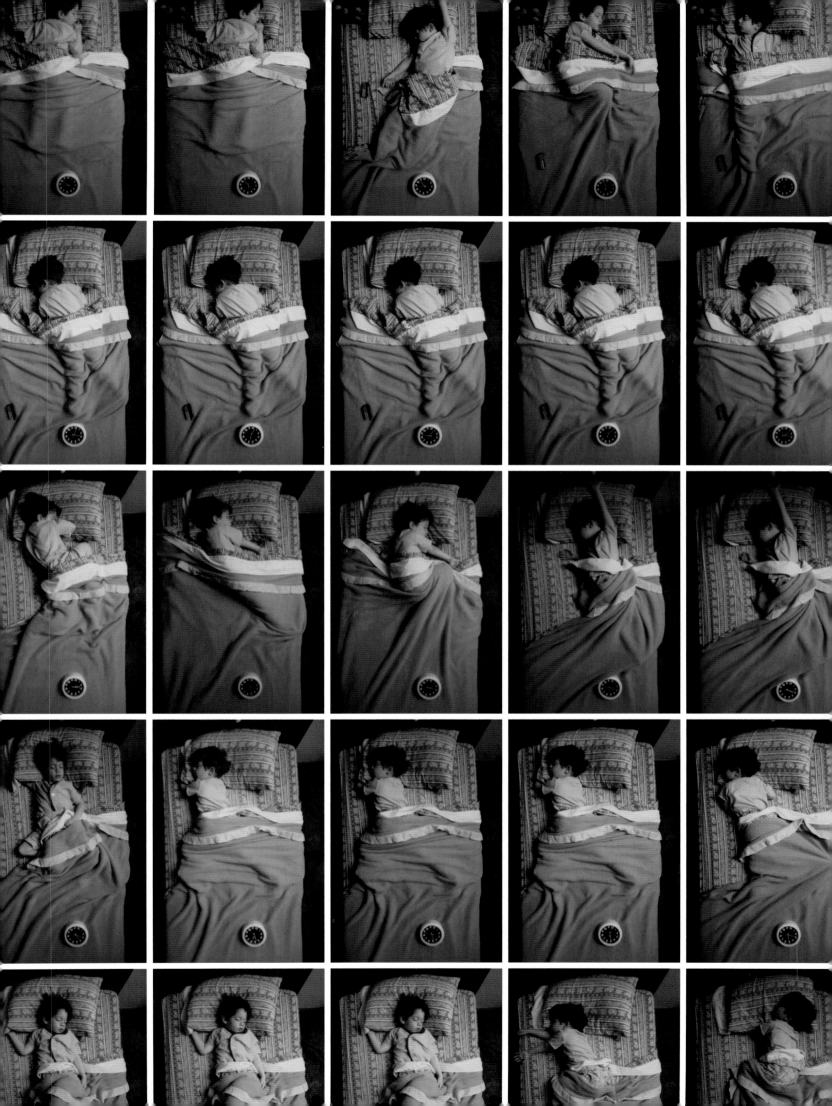

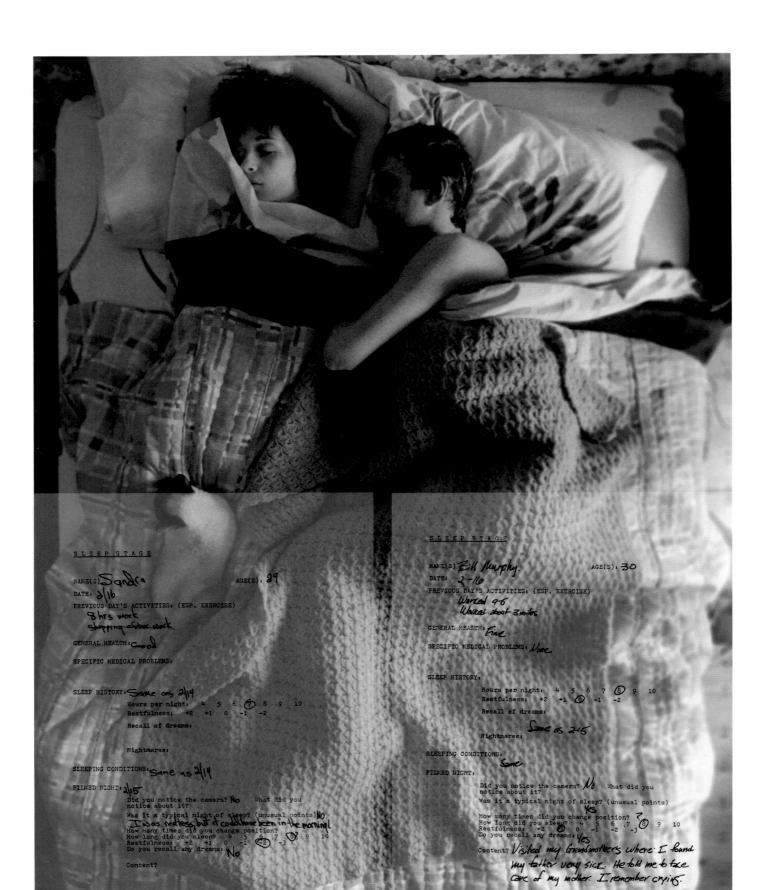

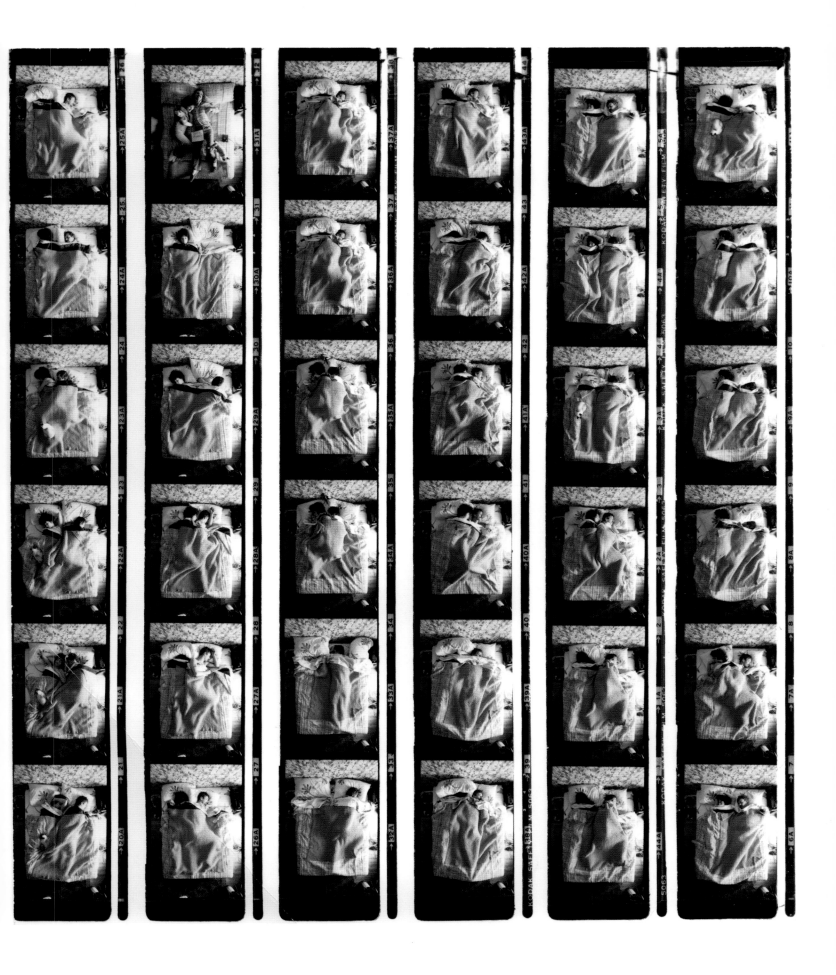

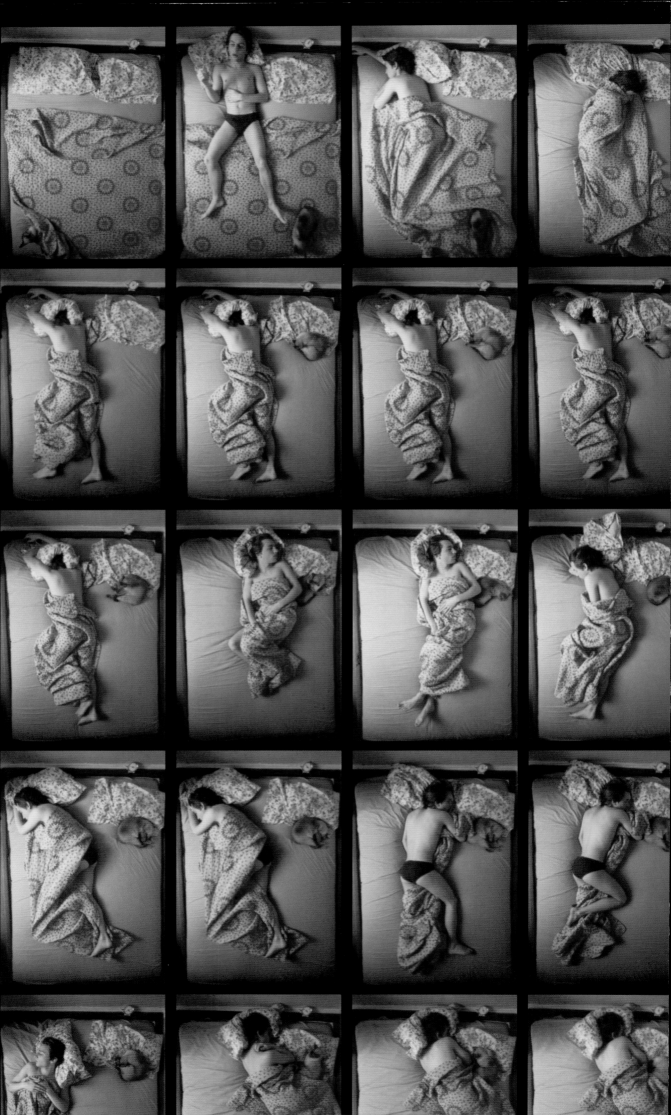

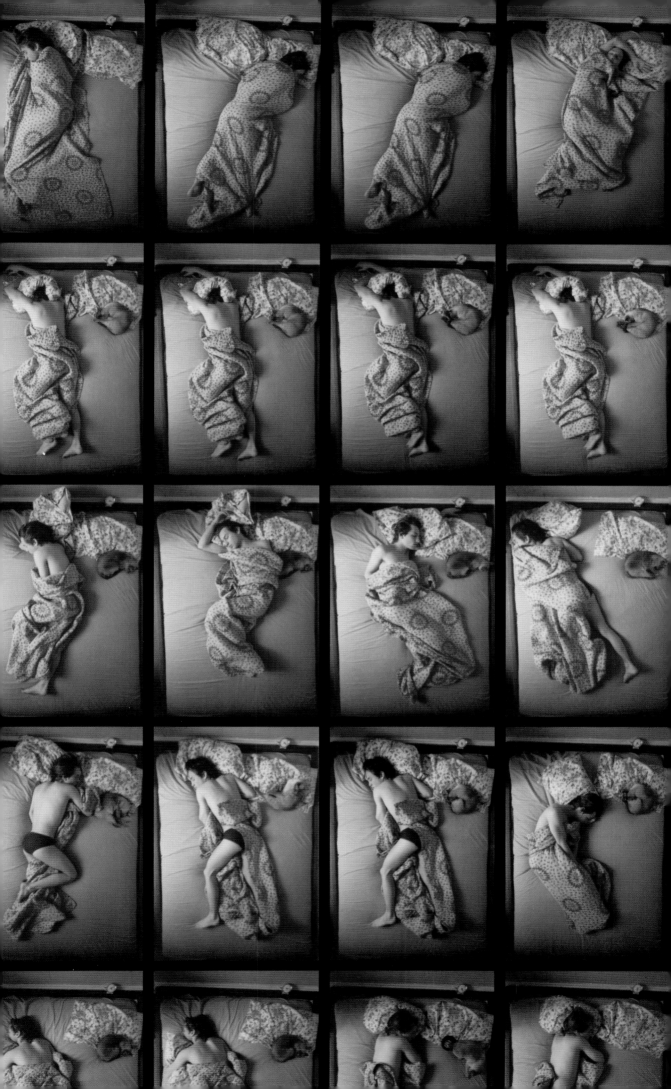

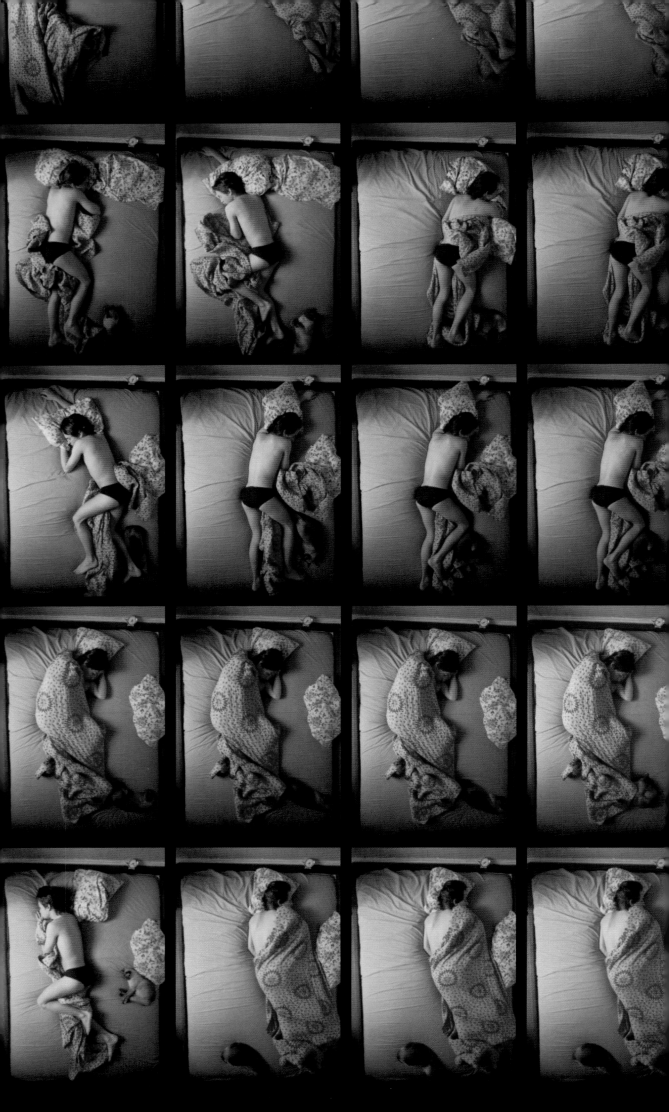

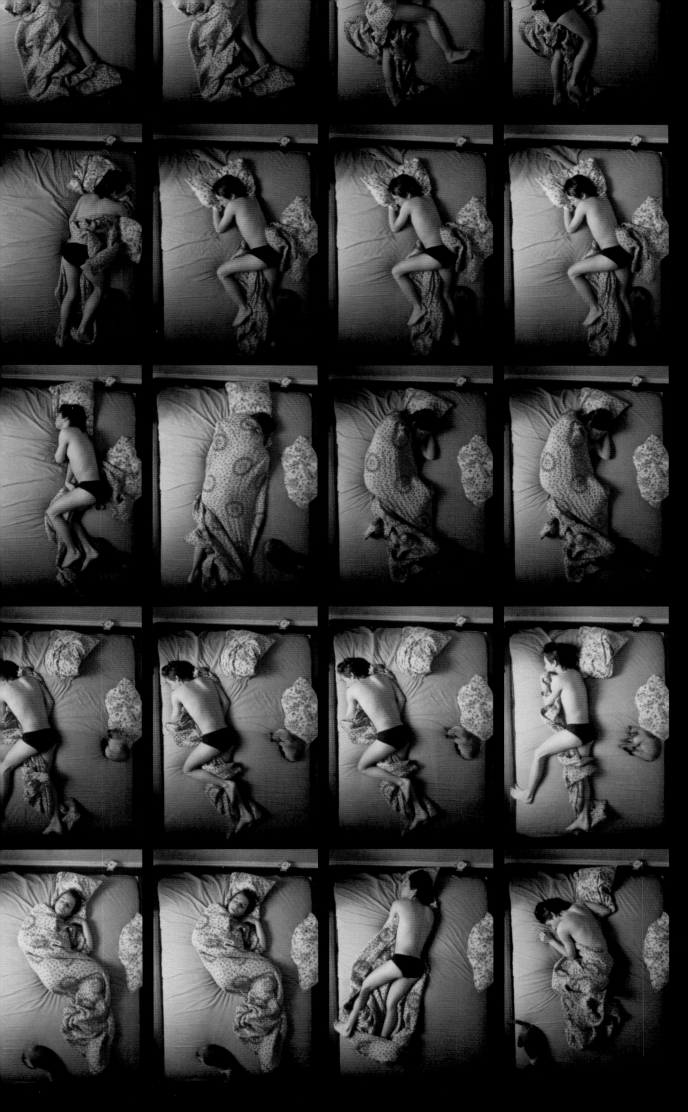

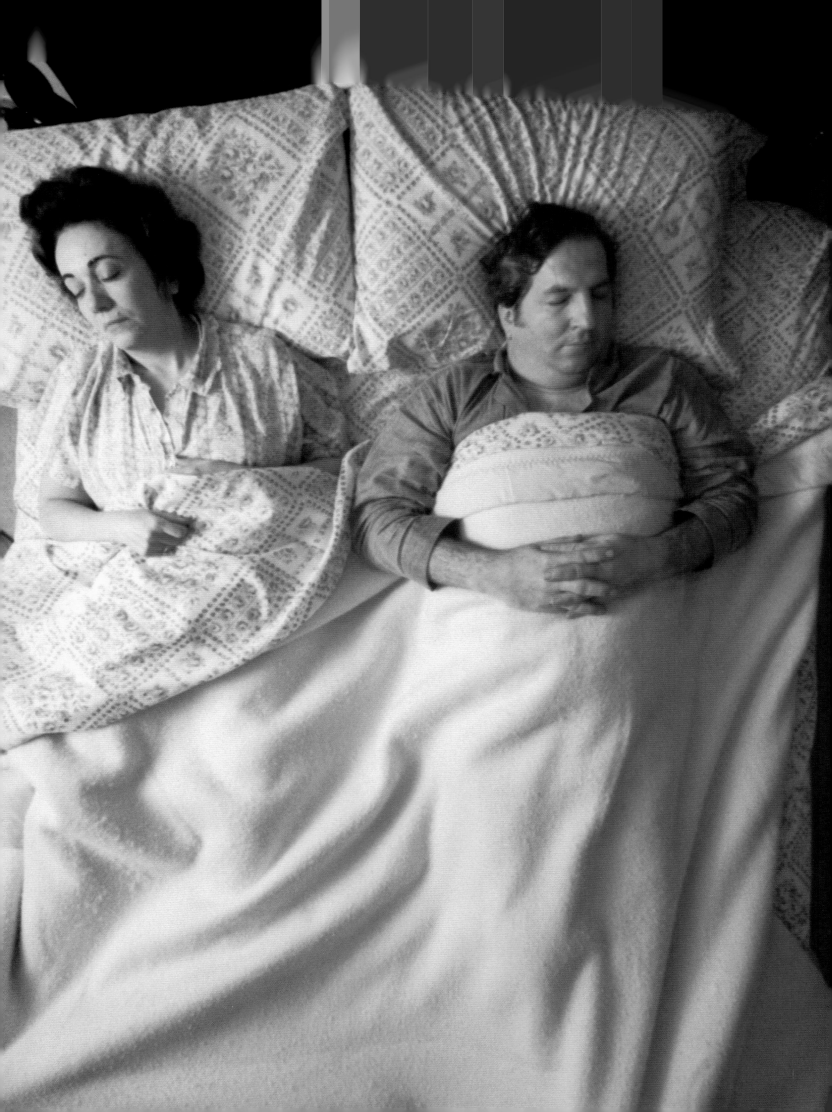

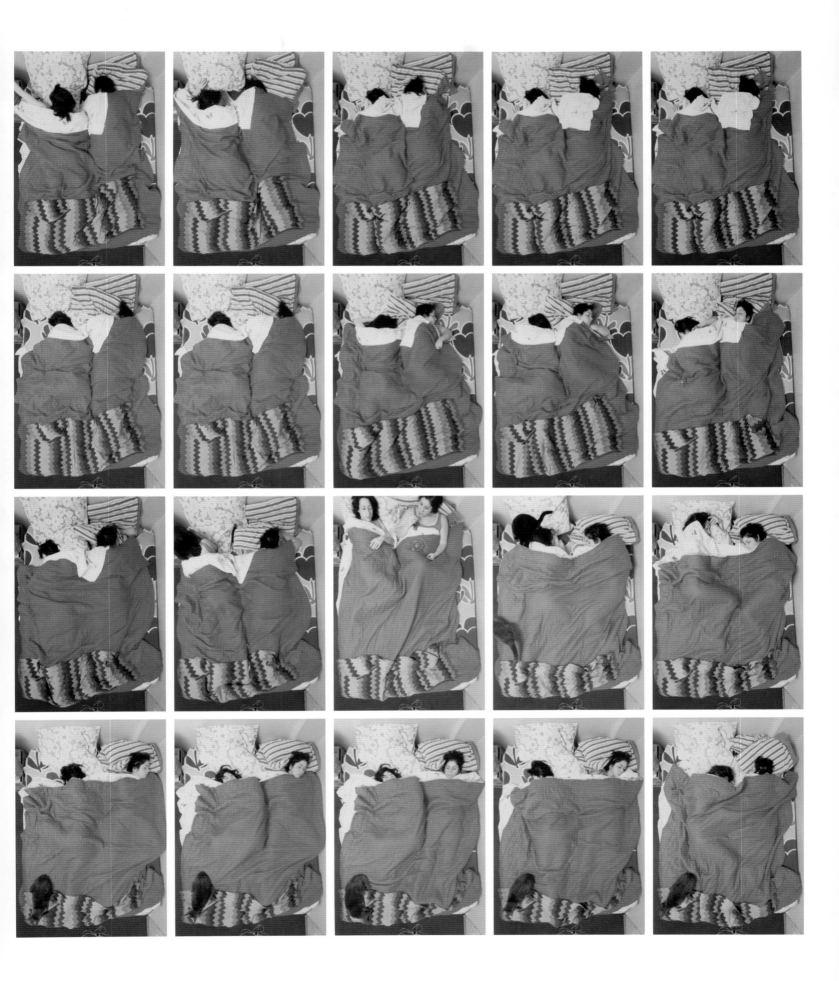

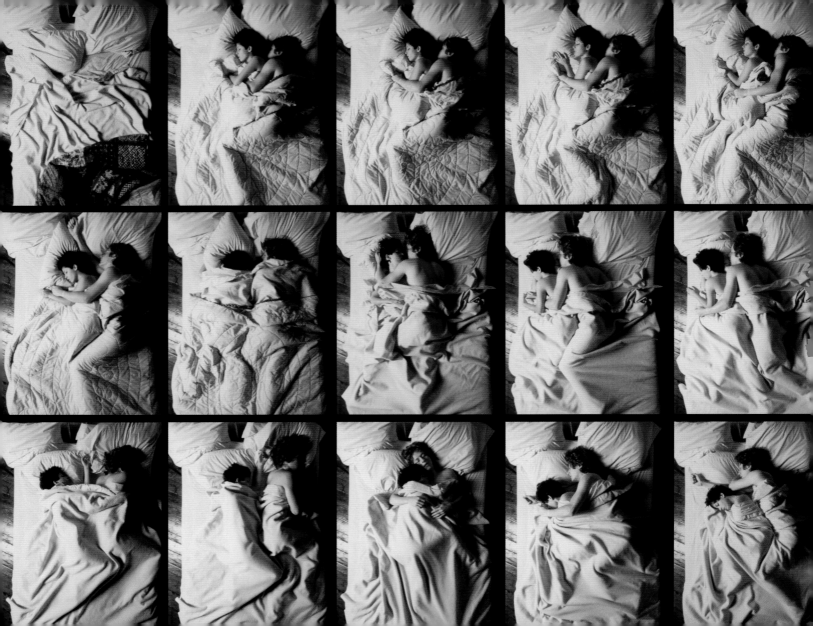

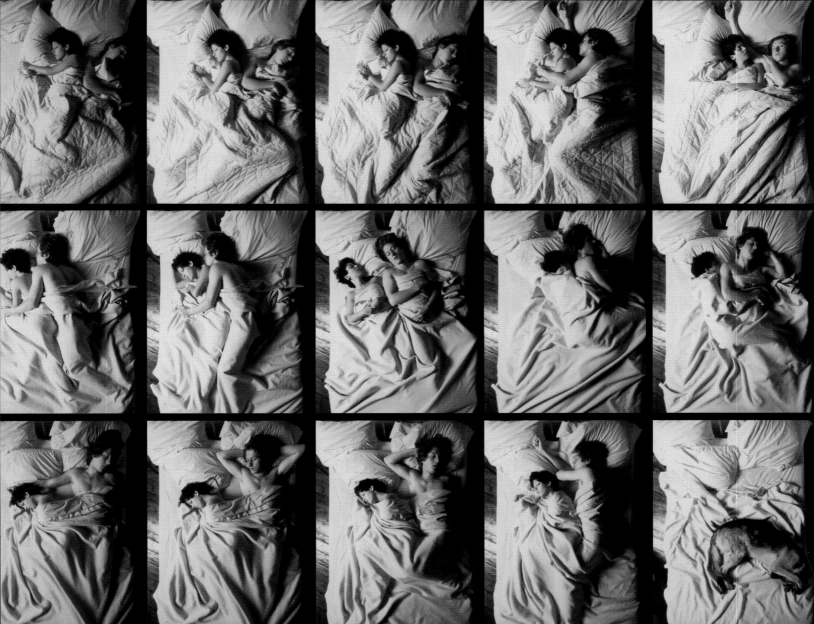

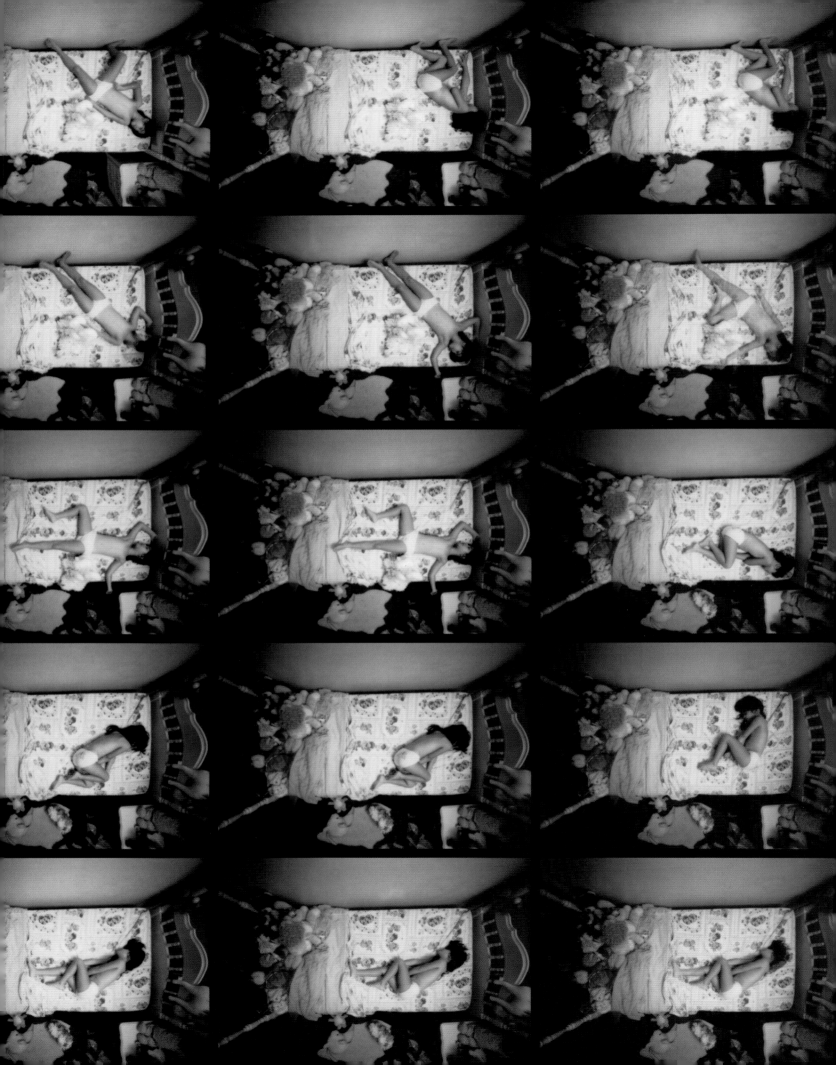

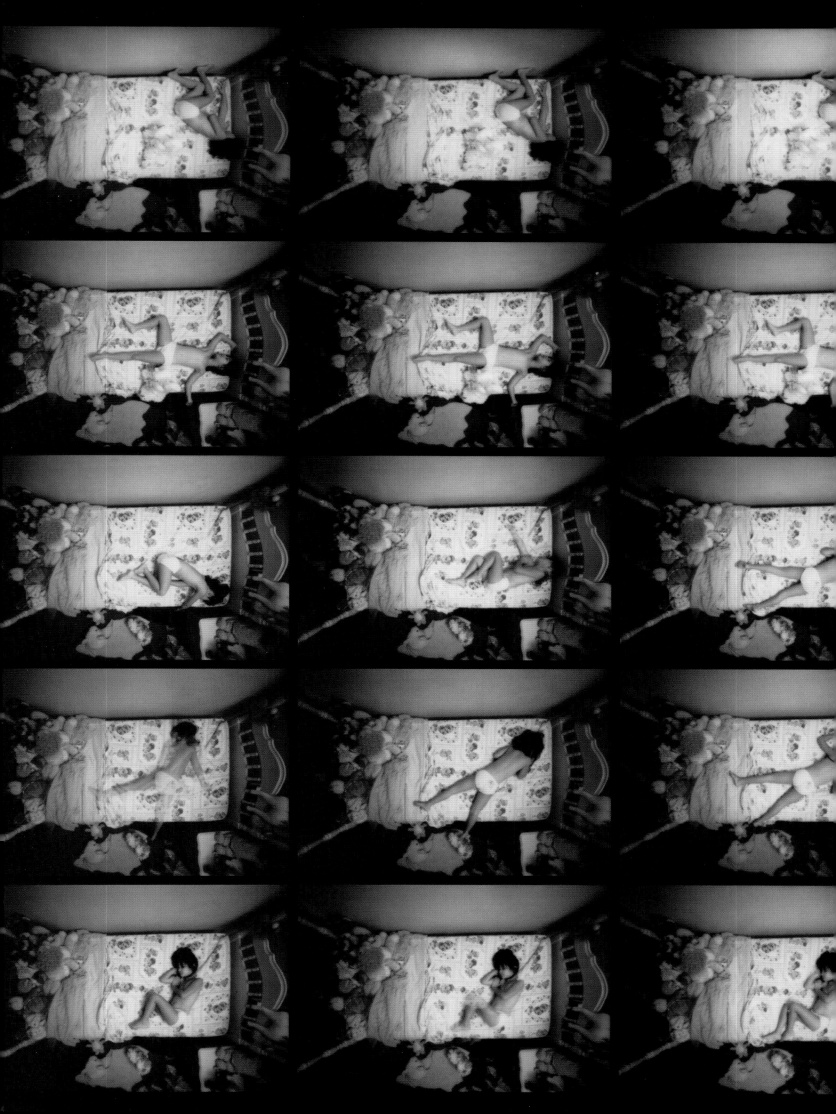

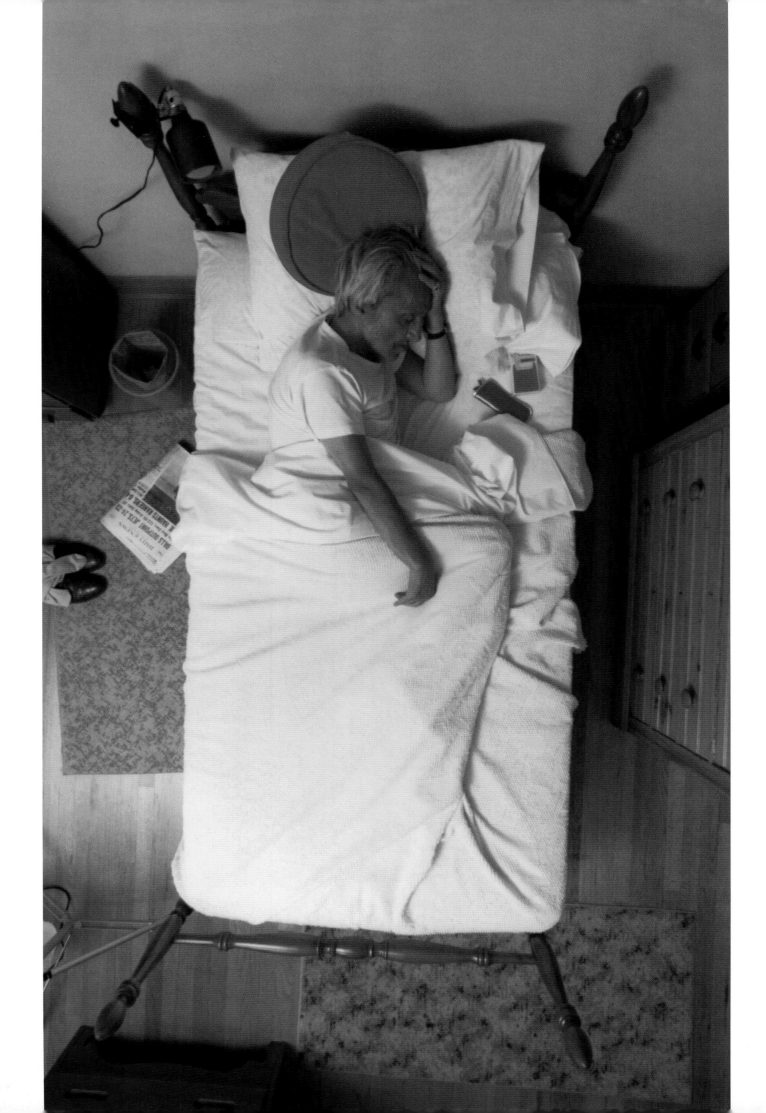

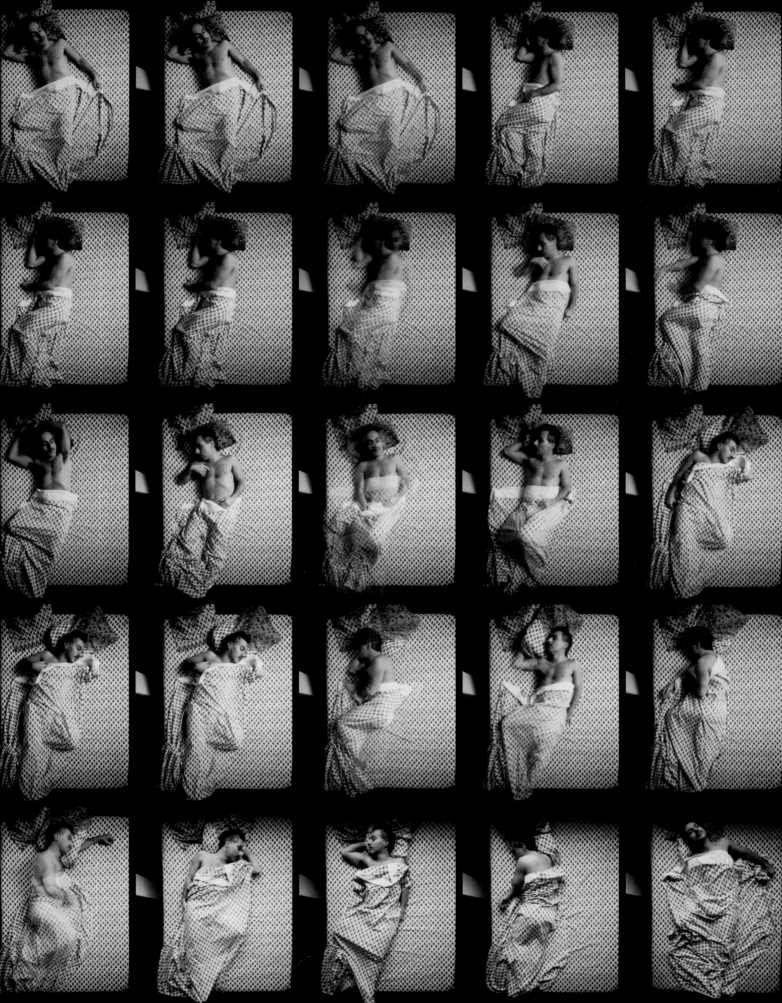

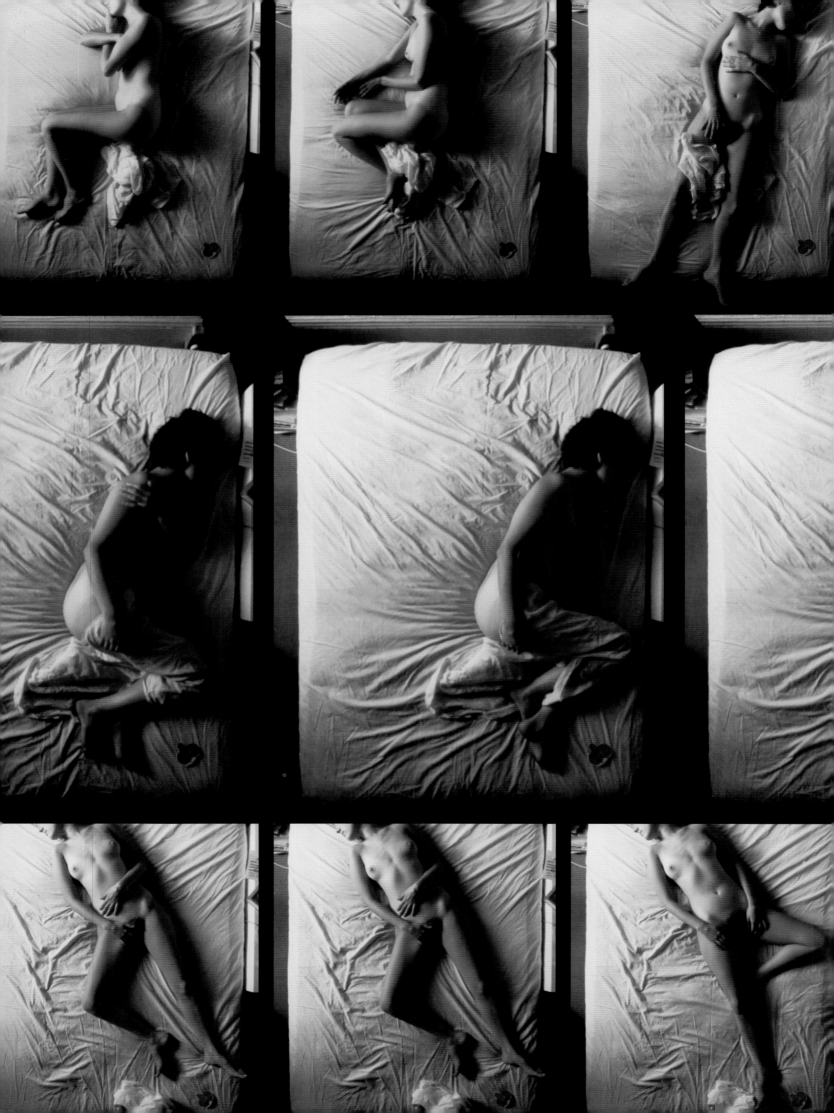

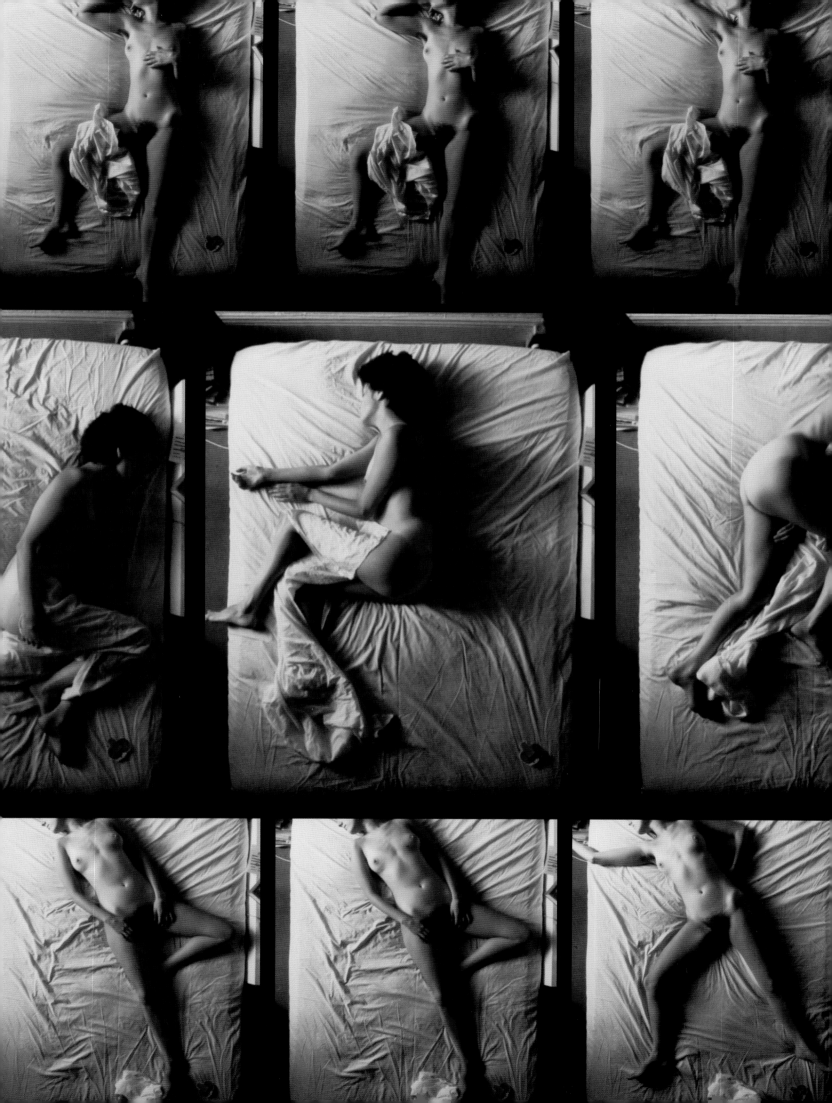

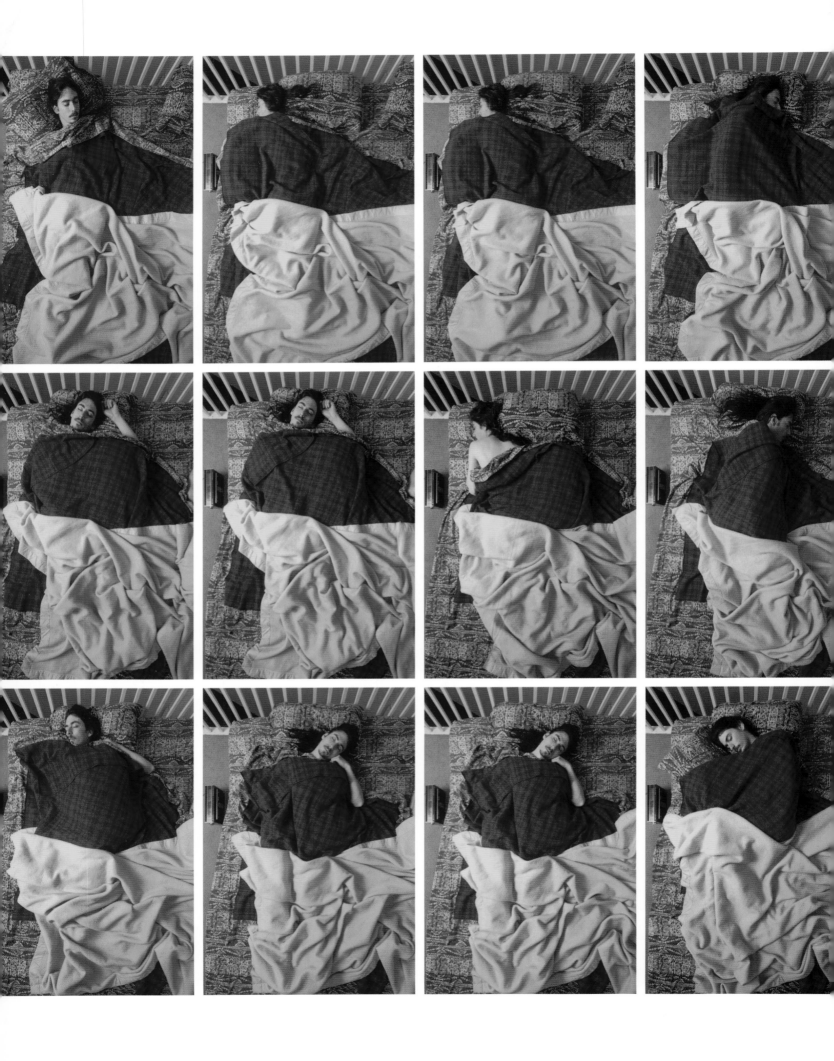

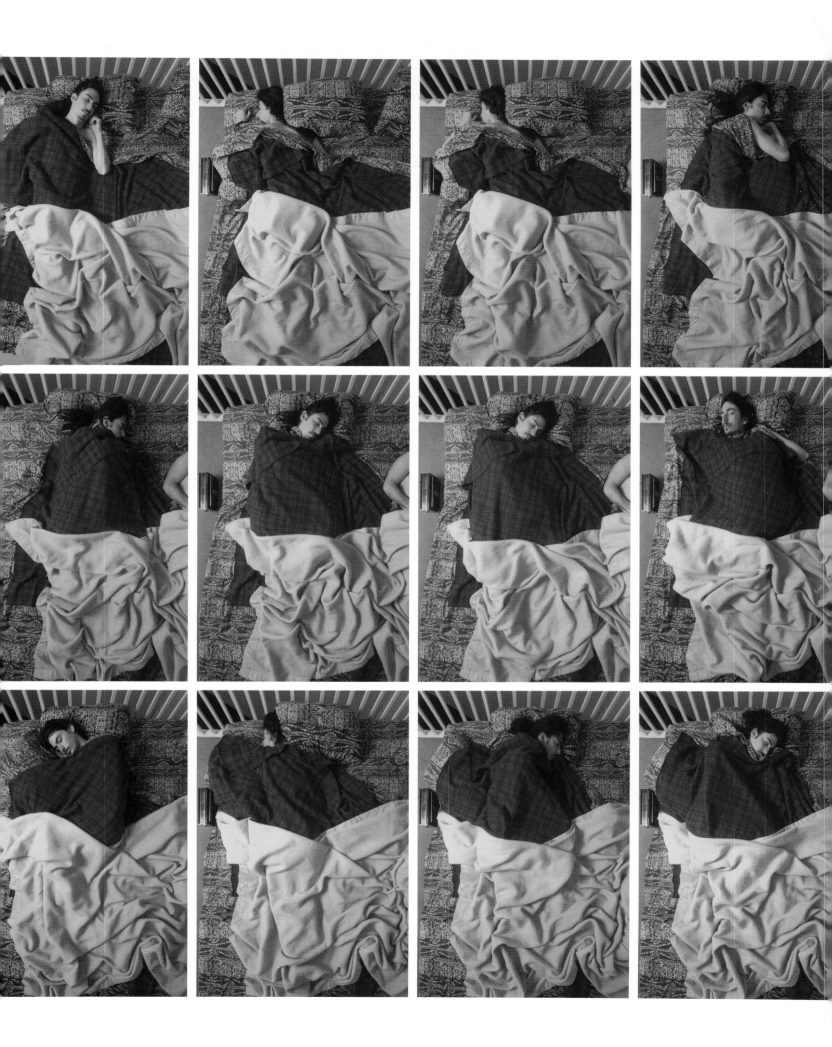

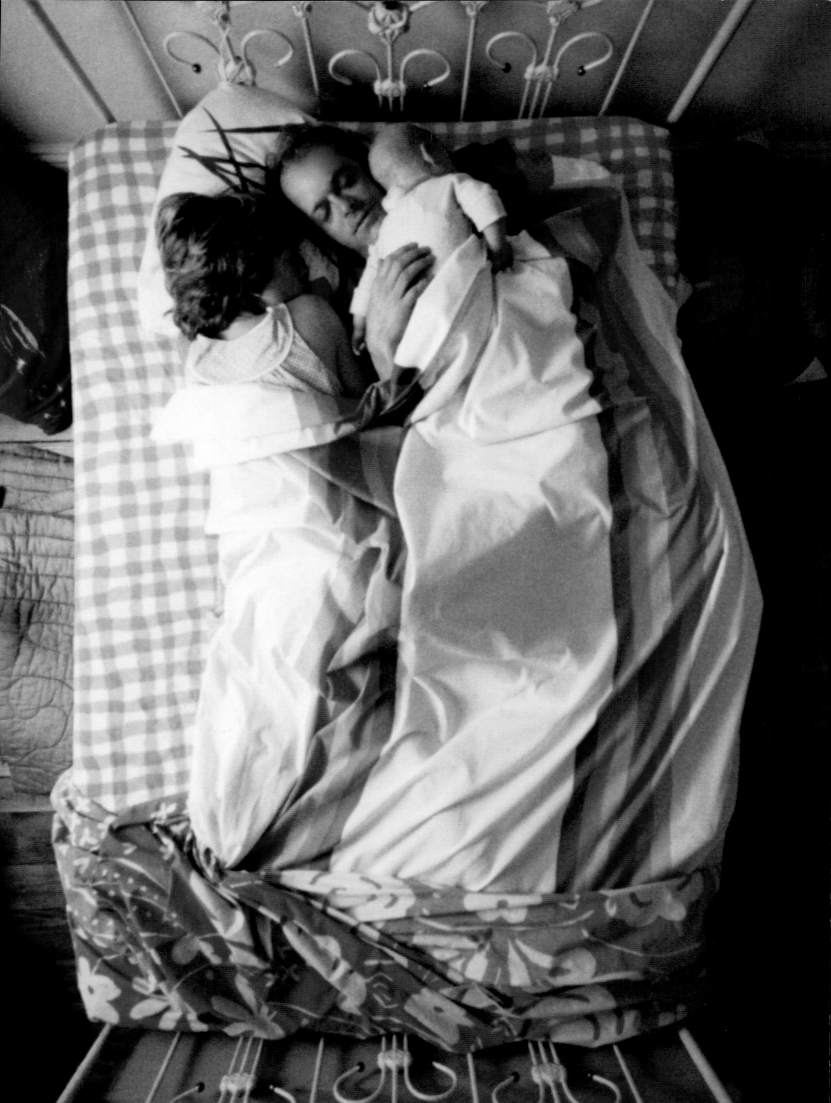

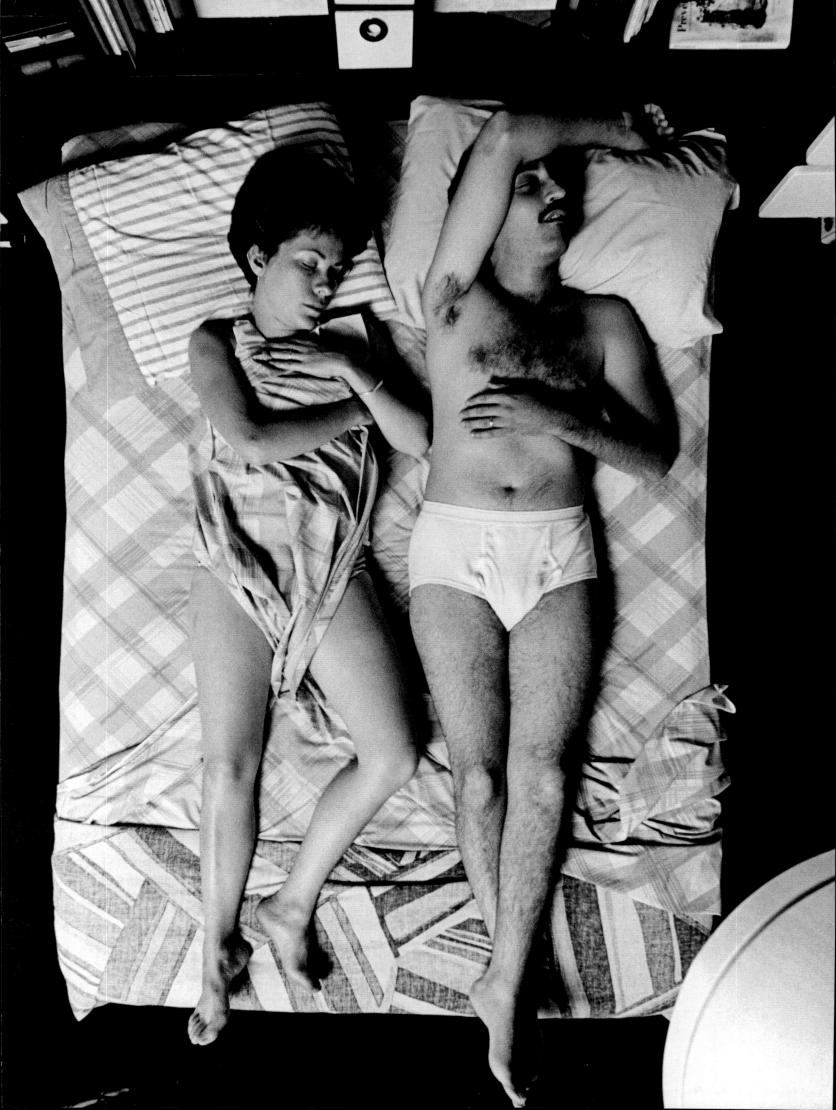

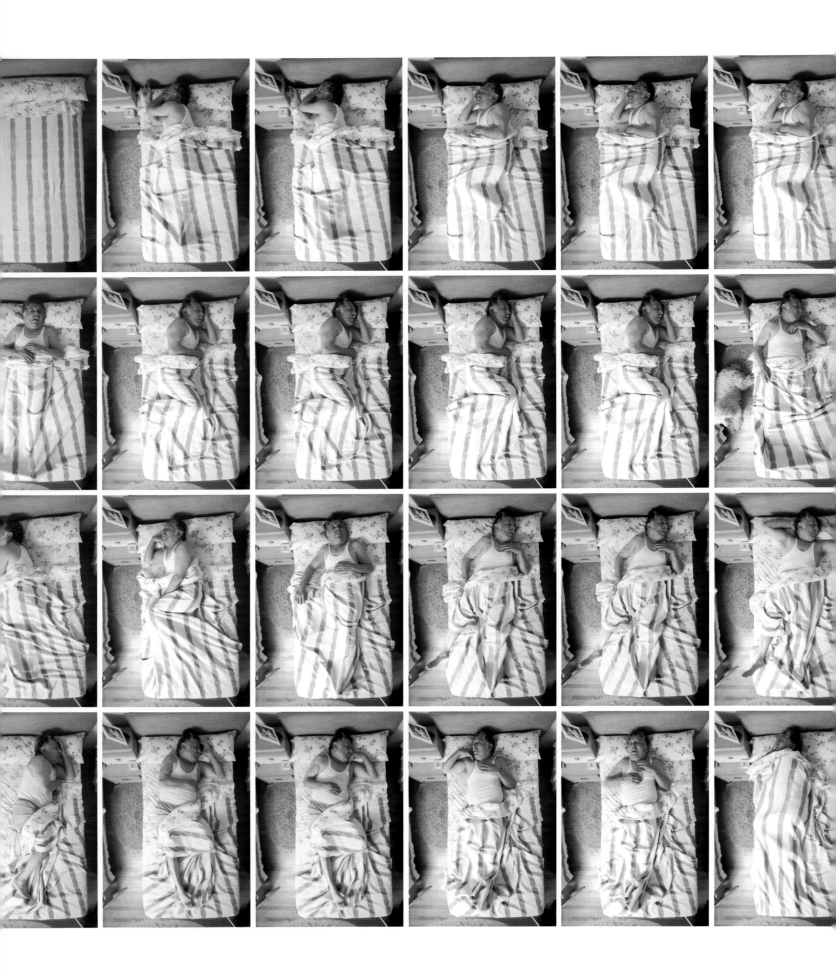

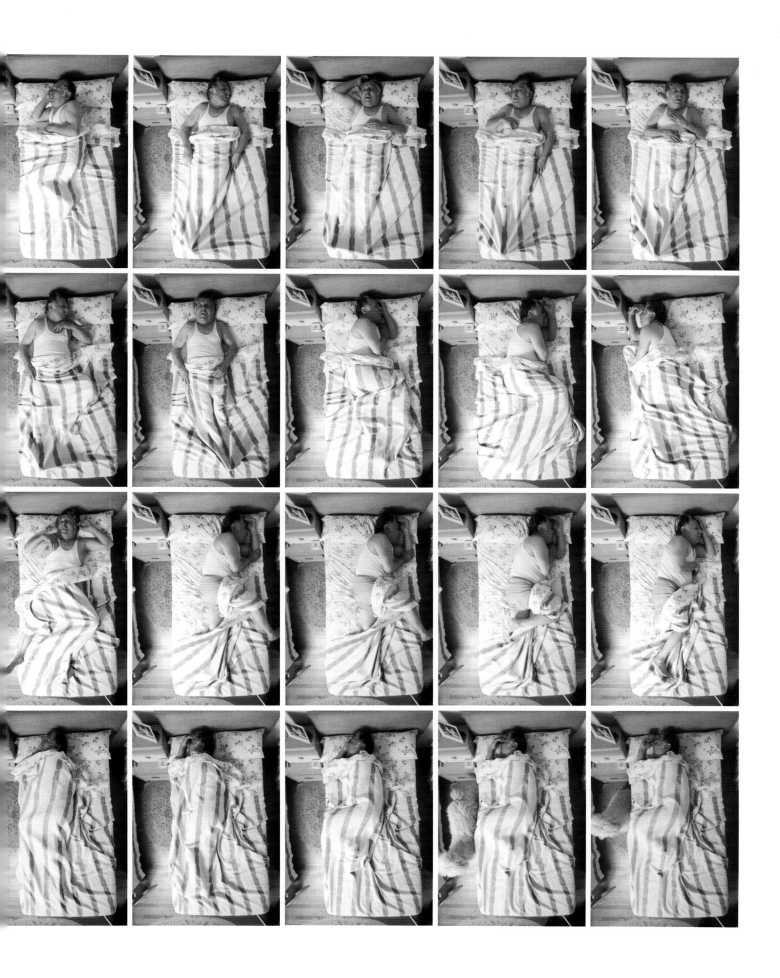

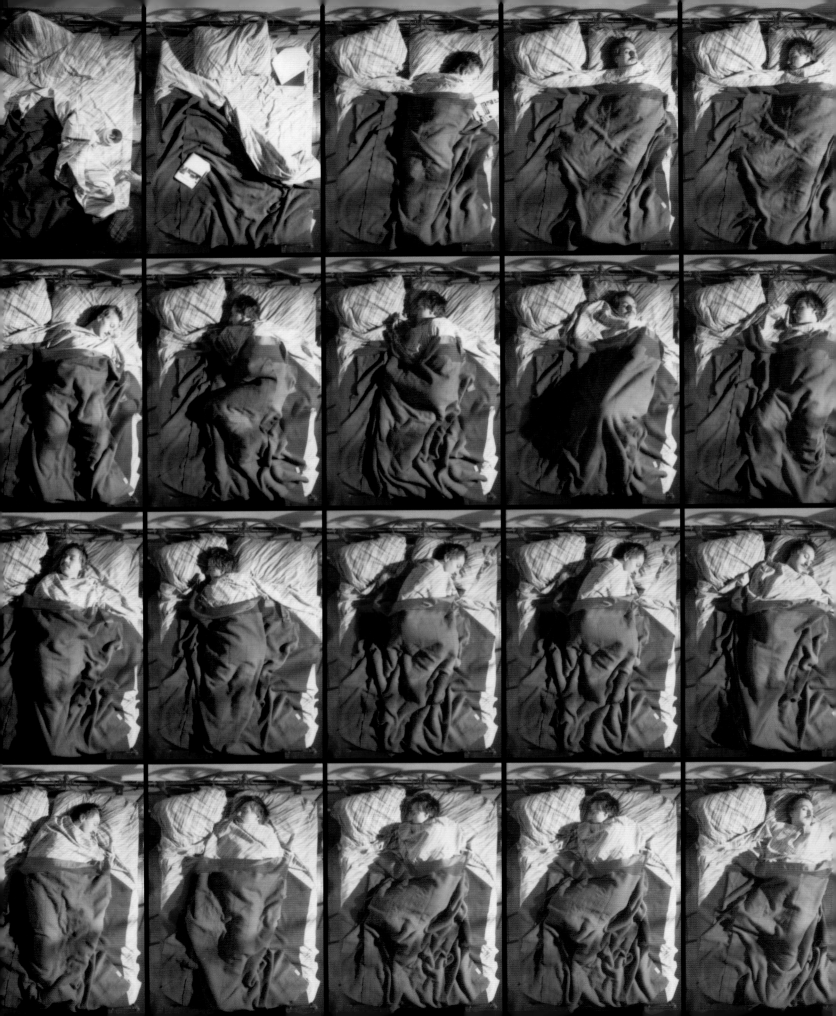

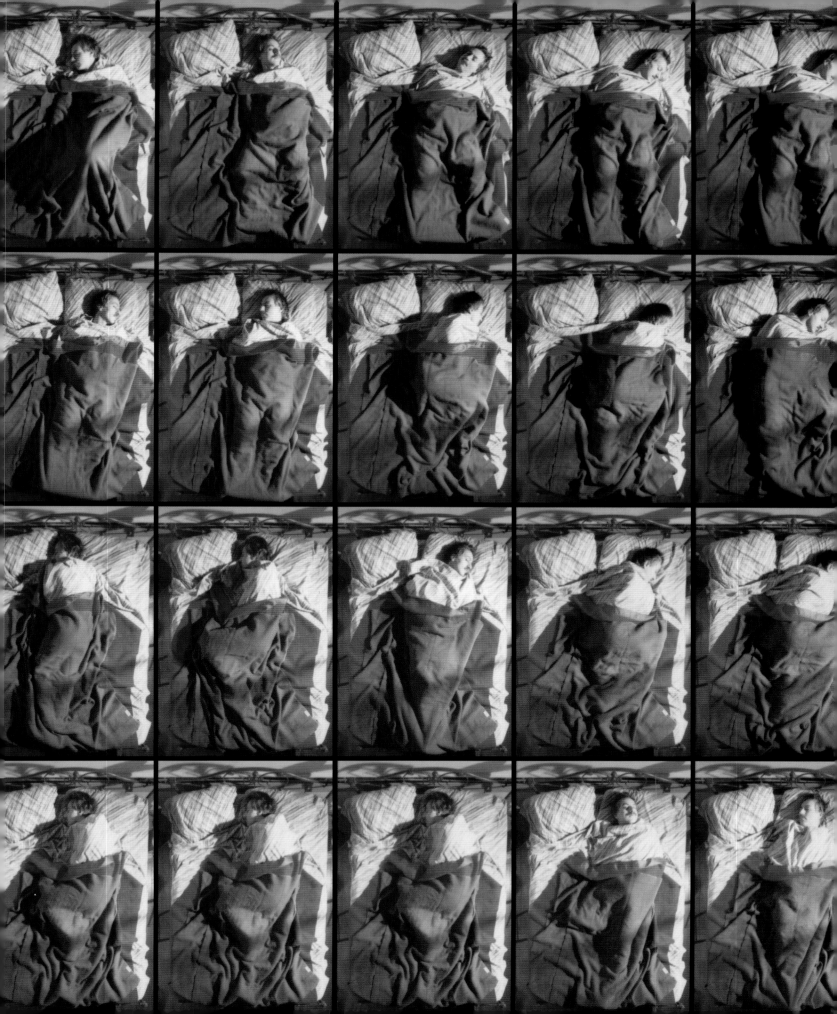

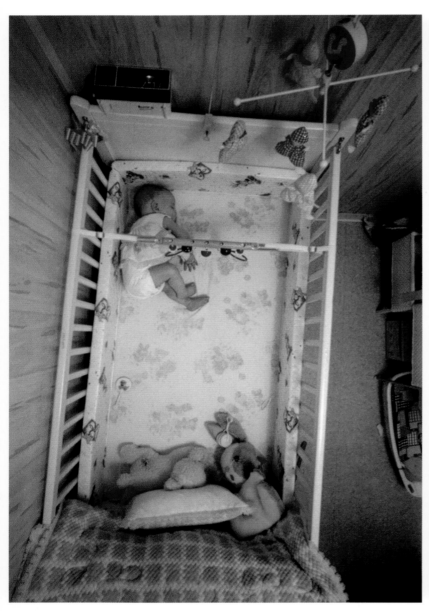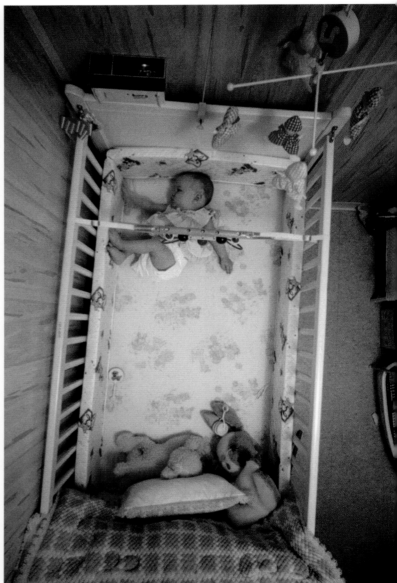

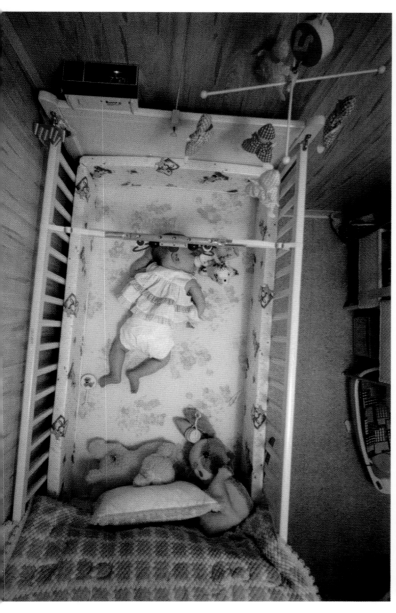 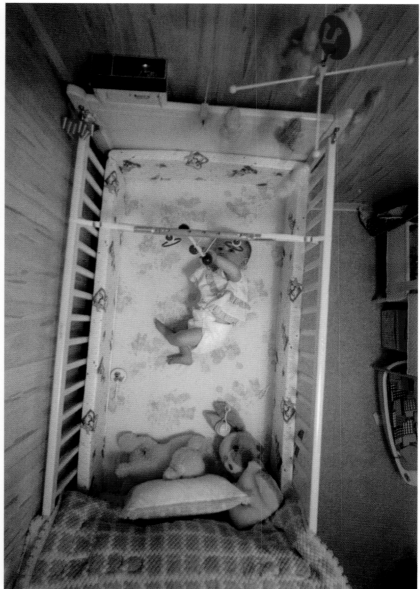

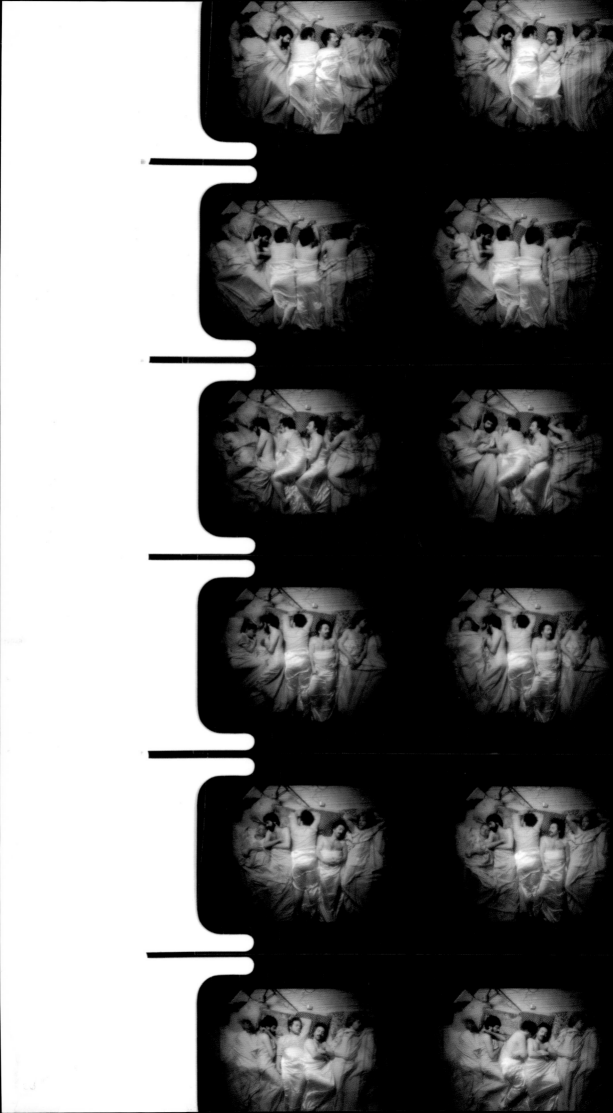

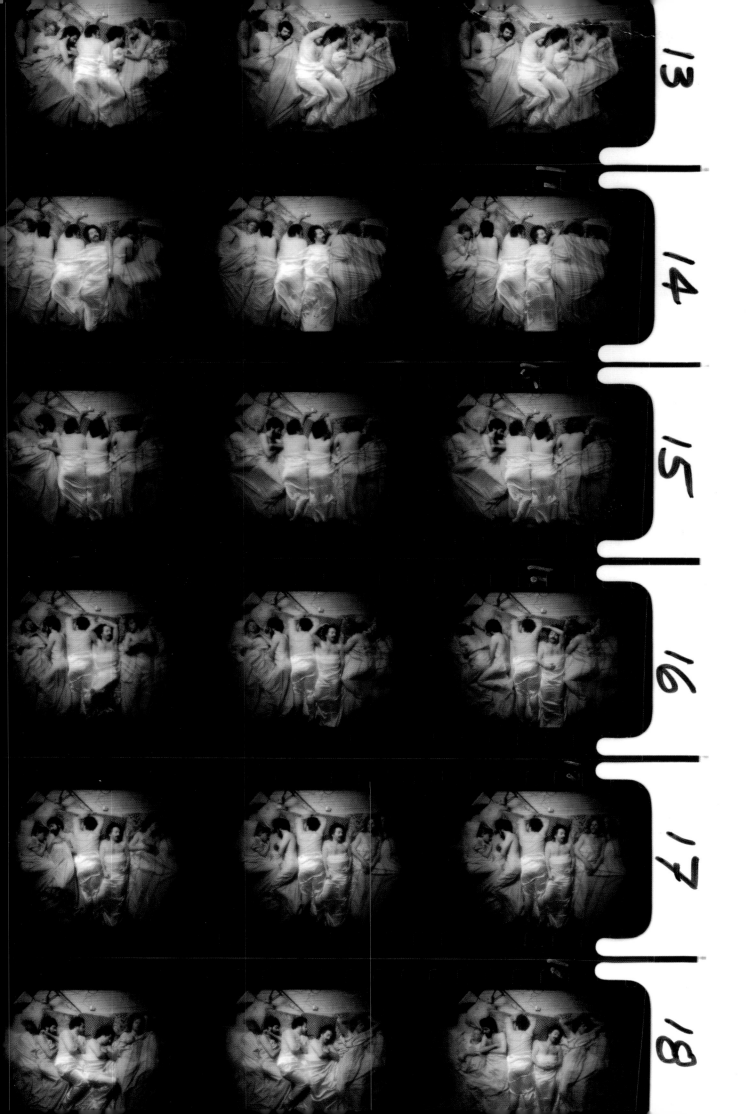

99

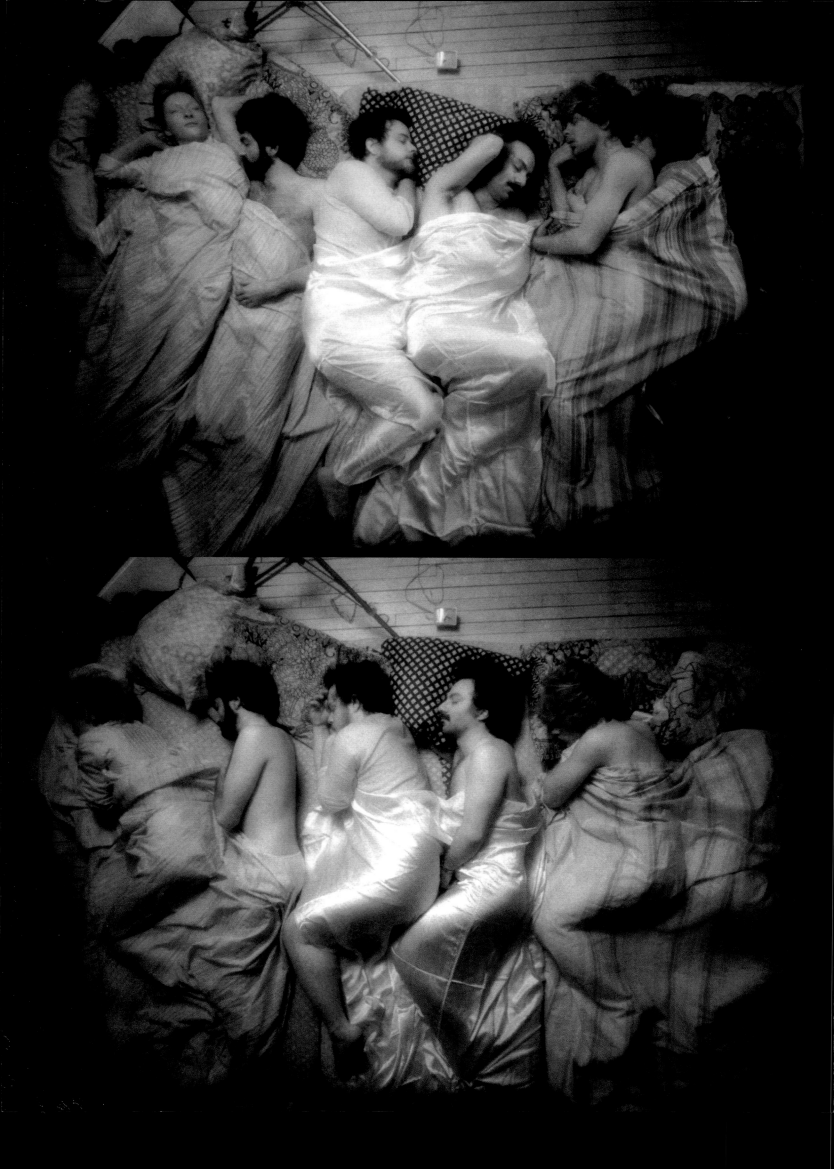

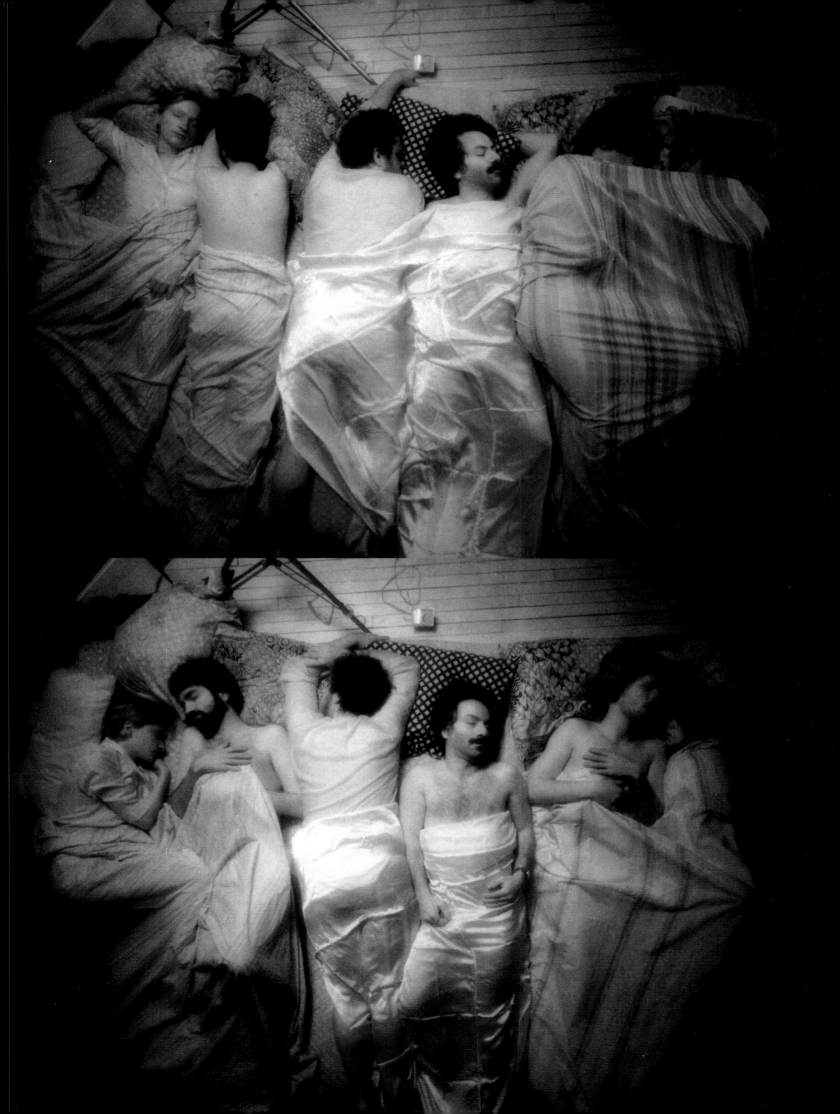

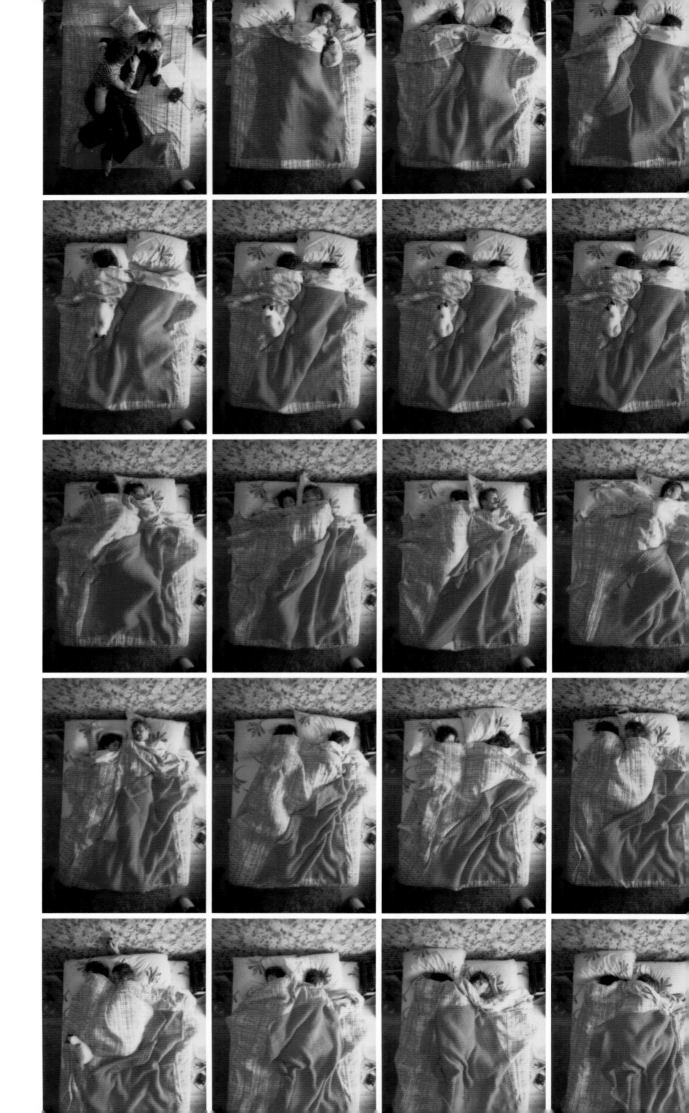

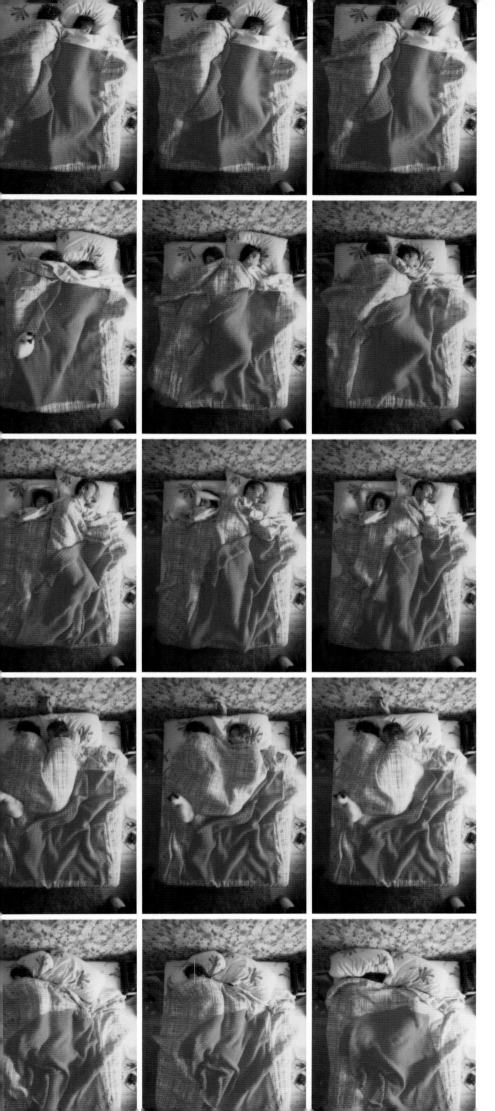

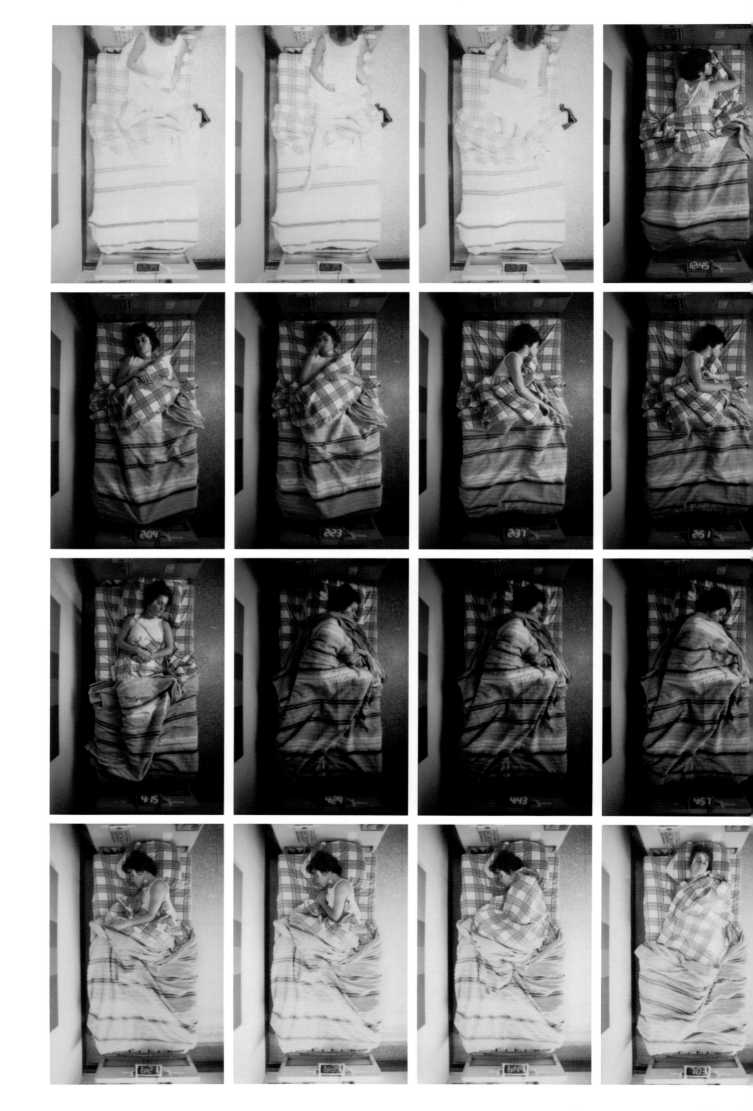

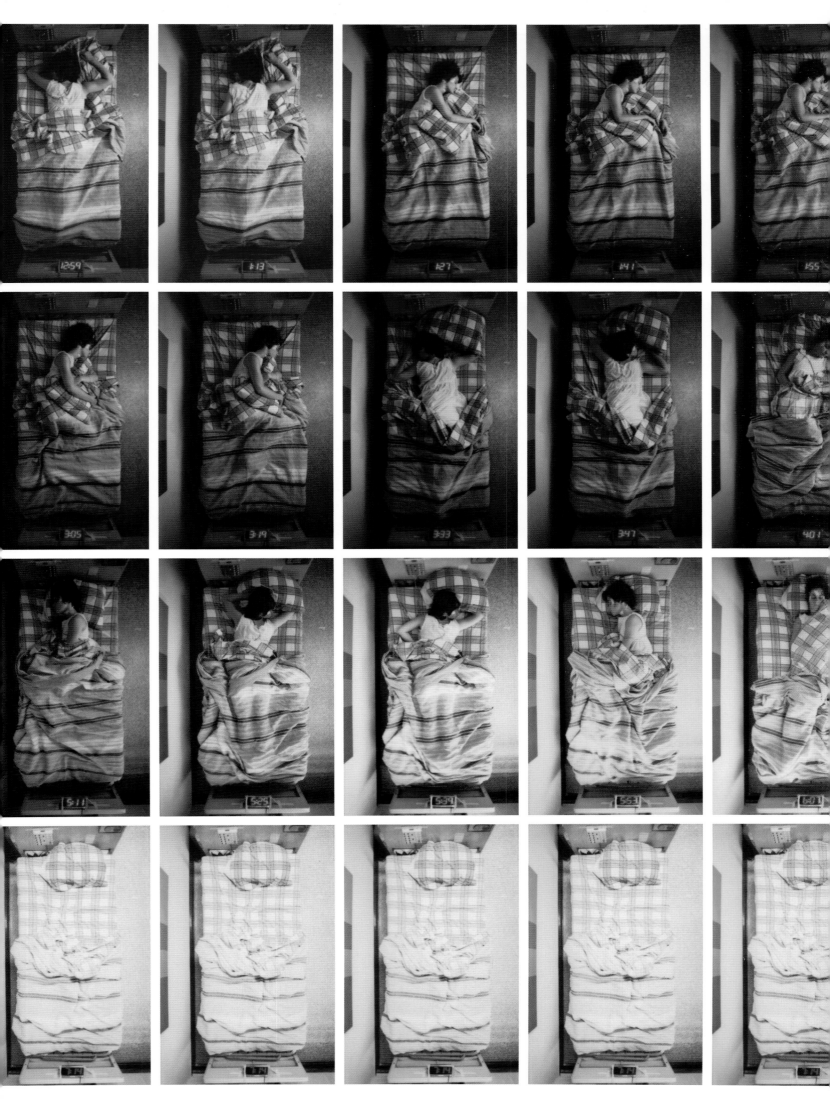

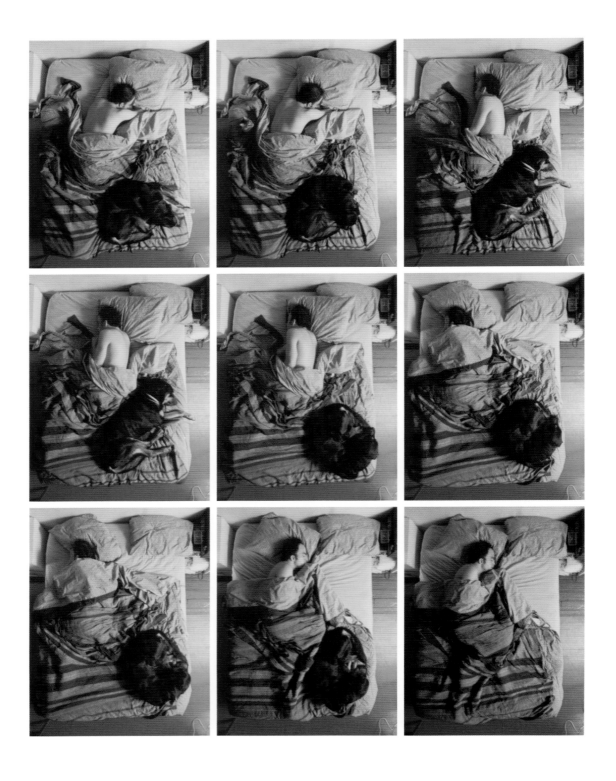

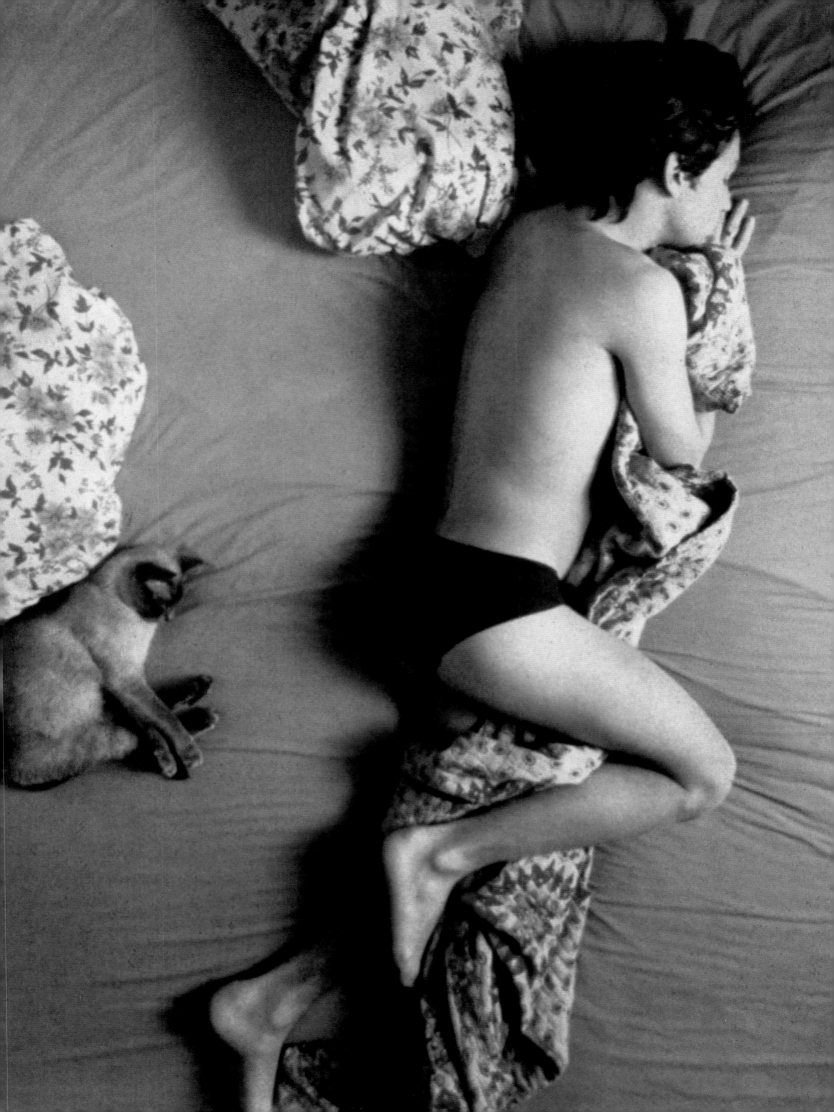

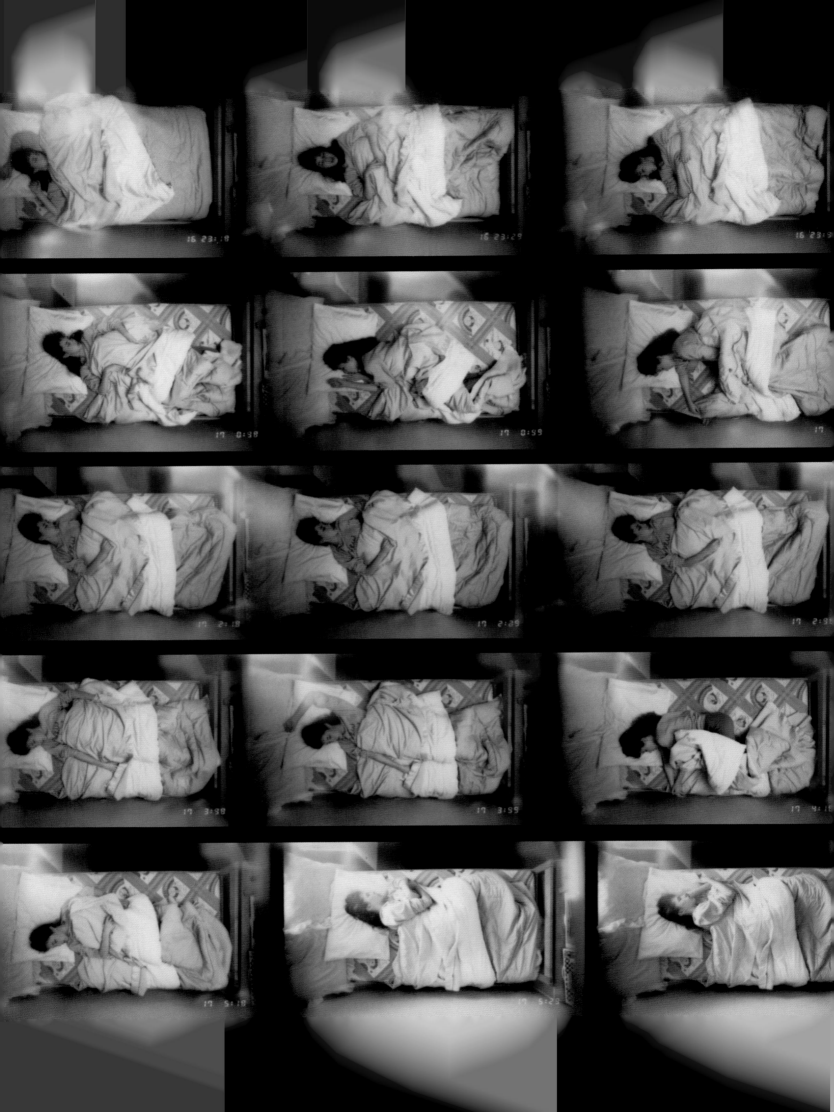

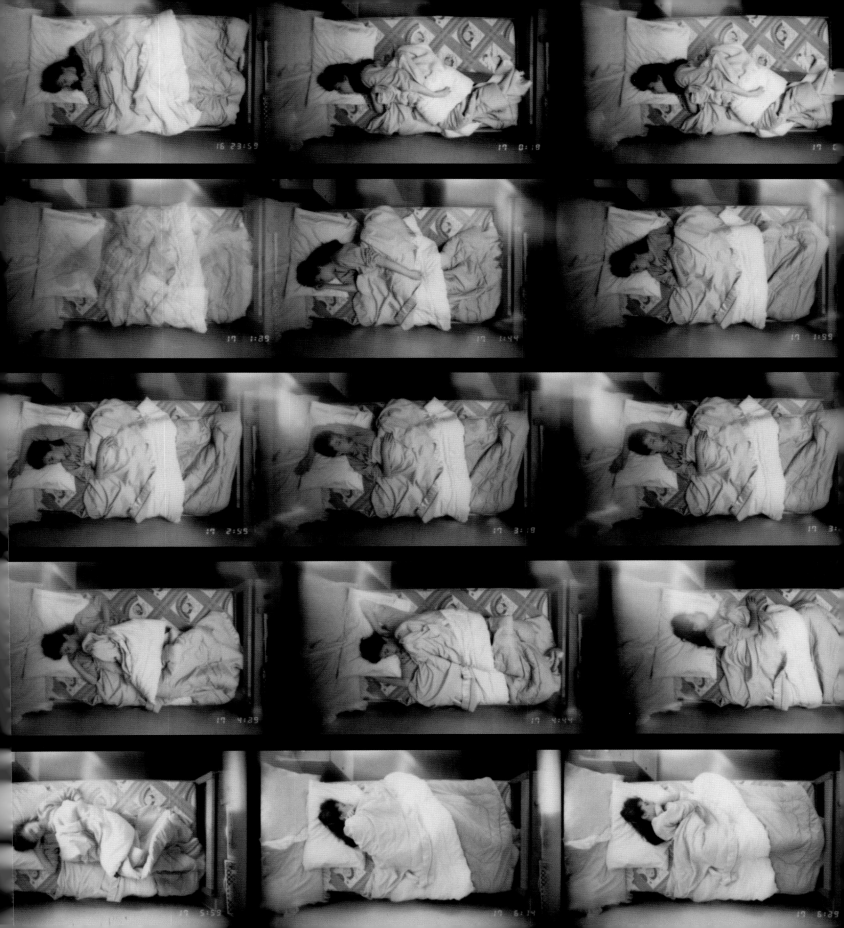

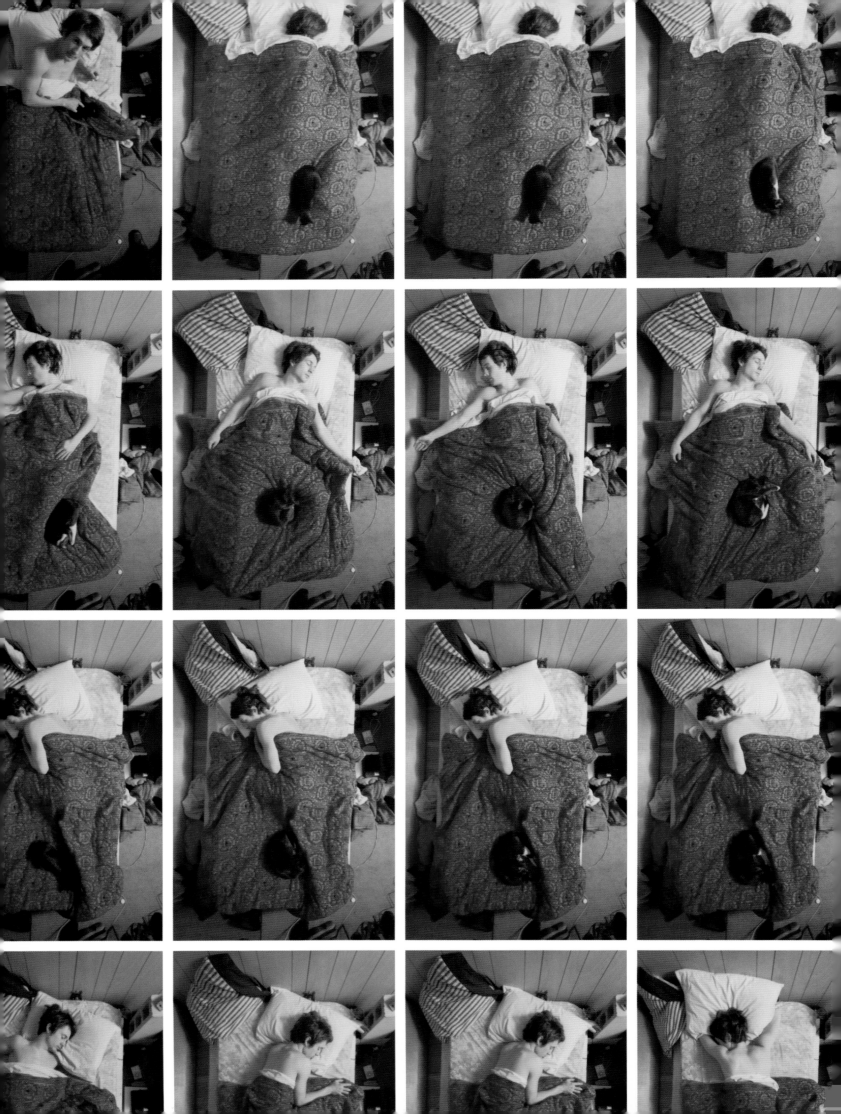

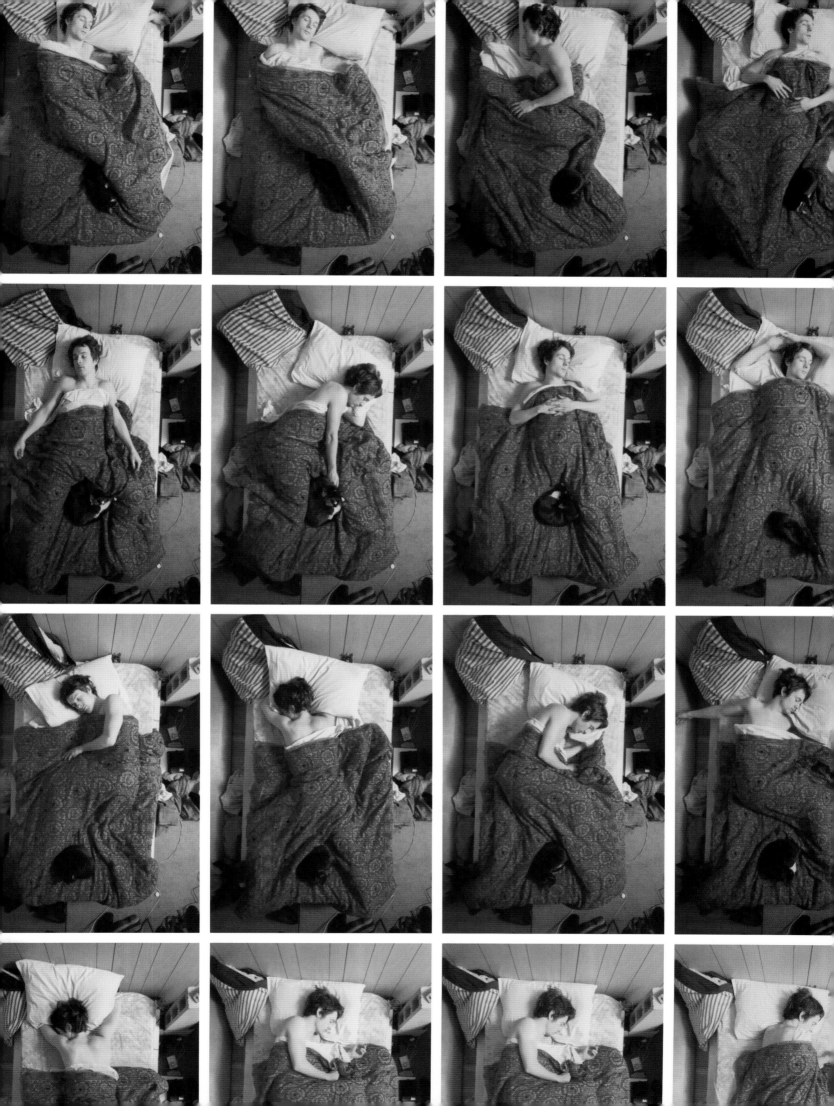

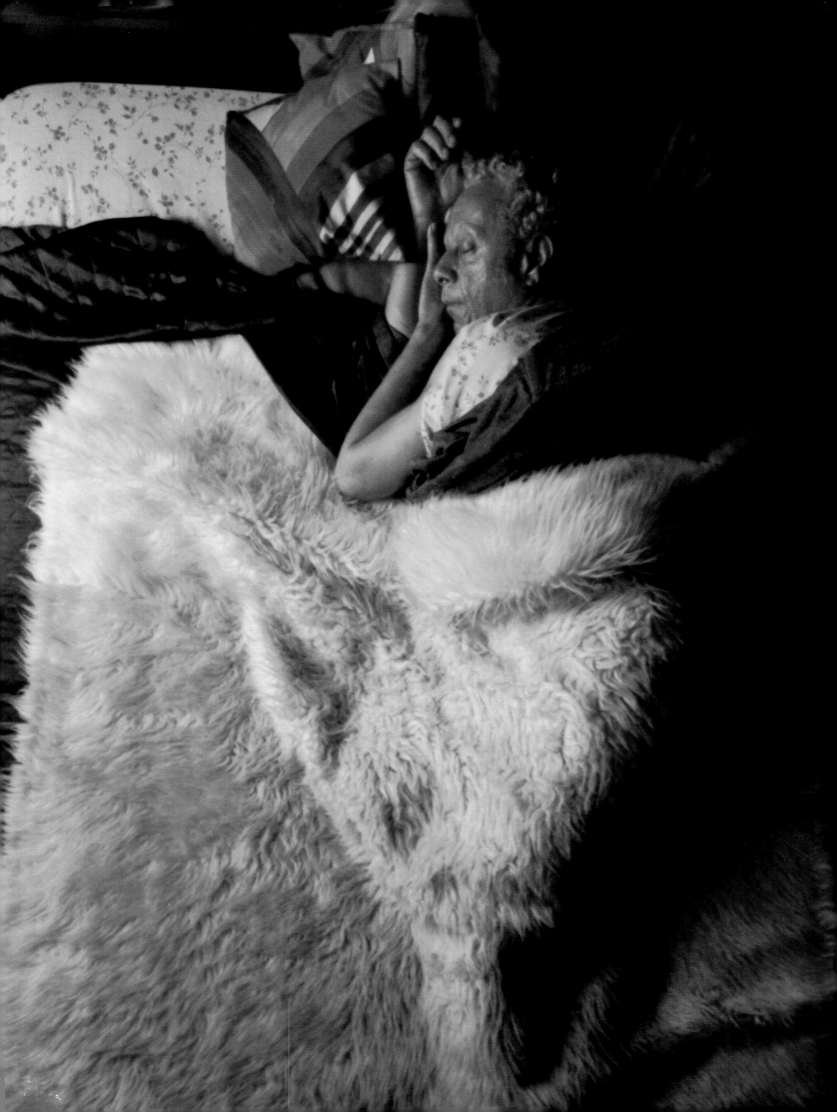

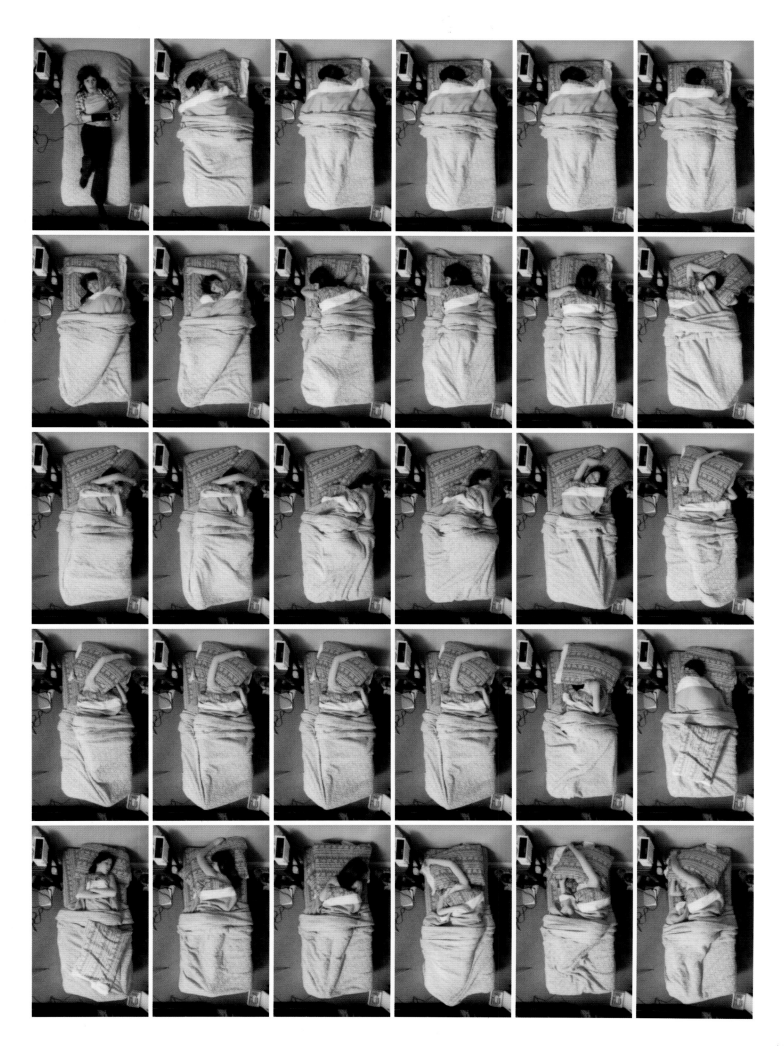

103

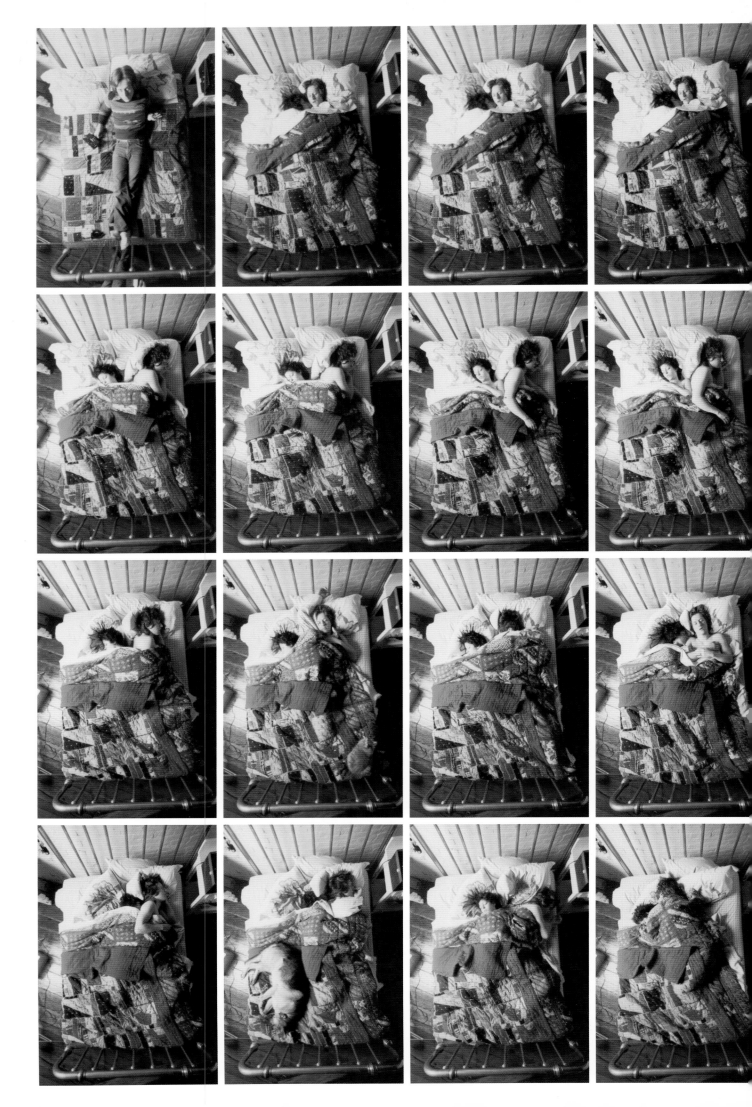

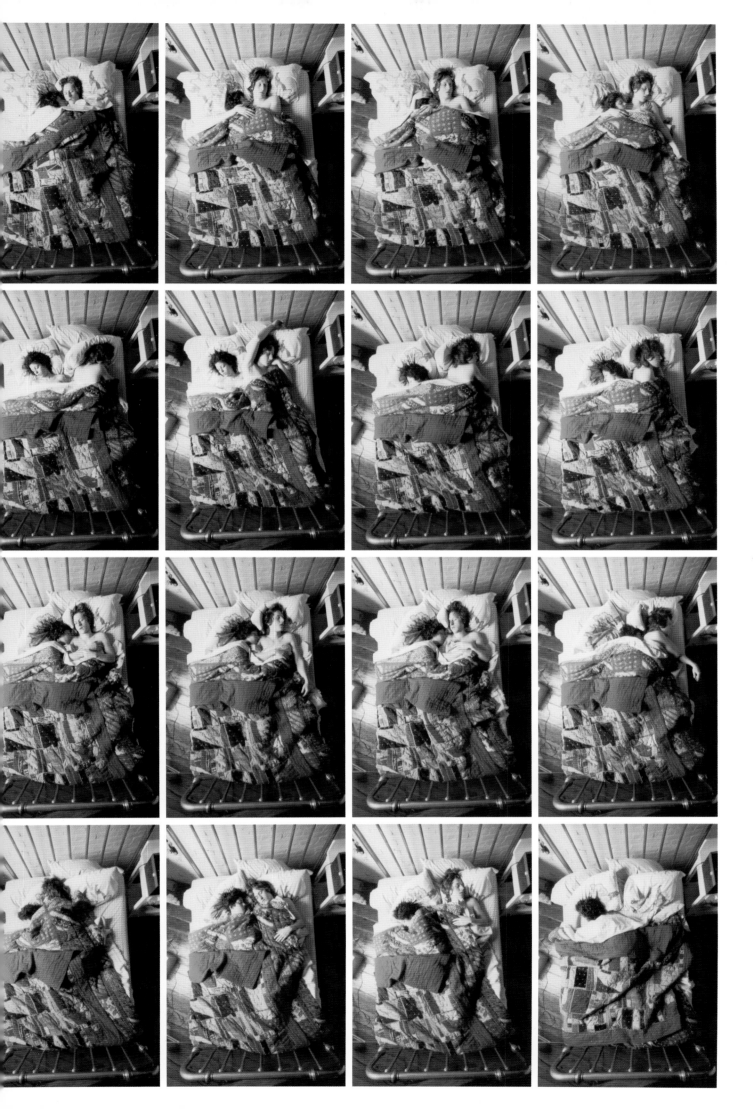

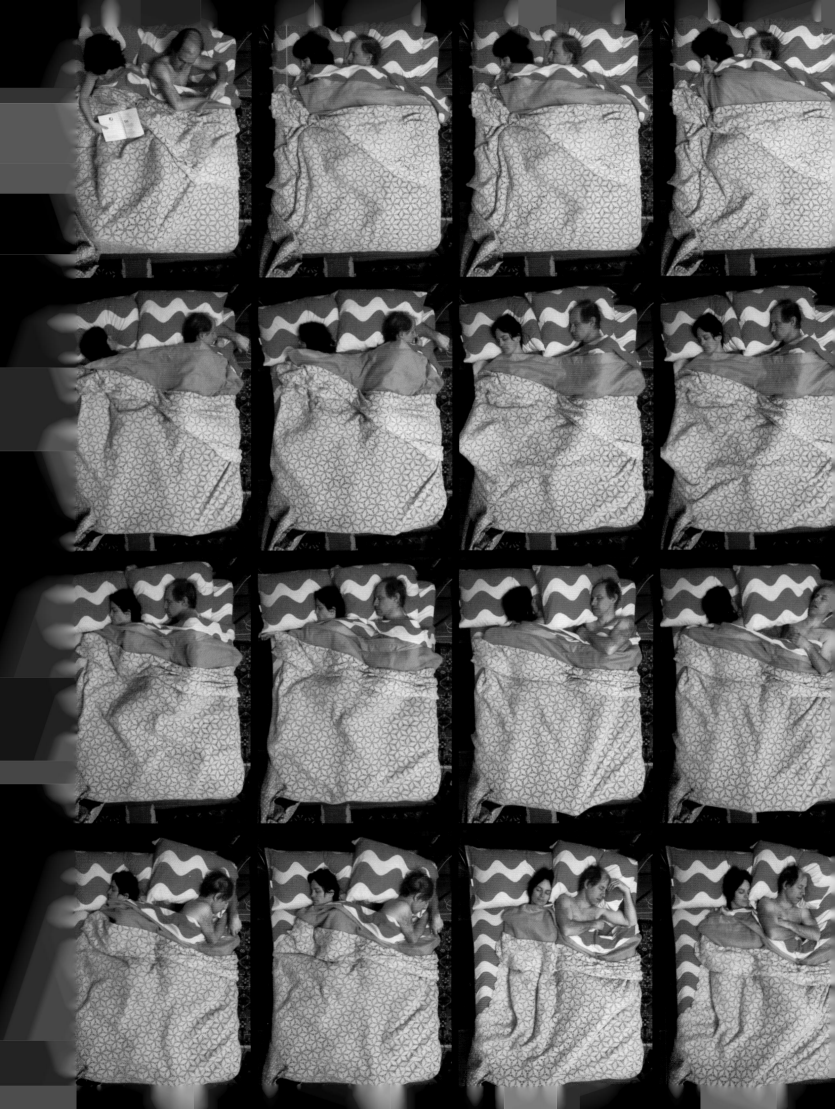

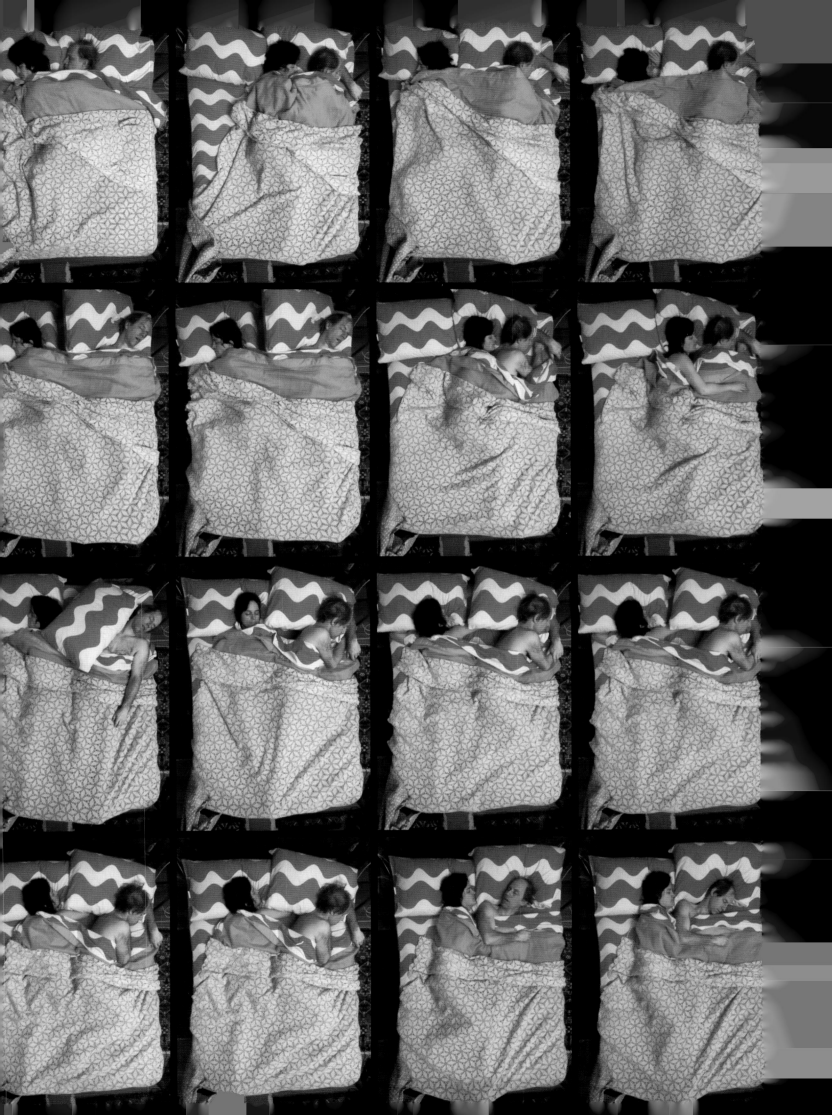

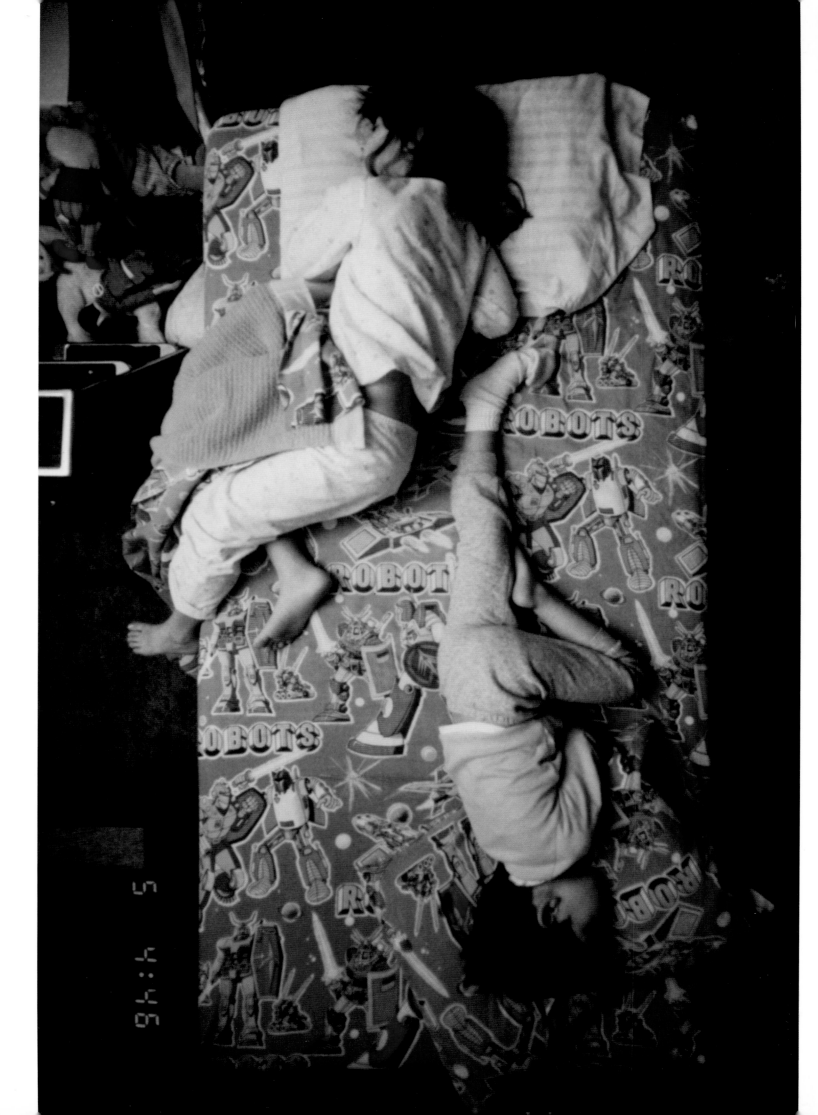

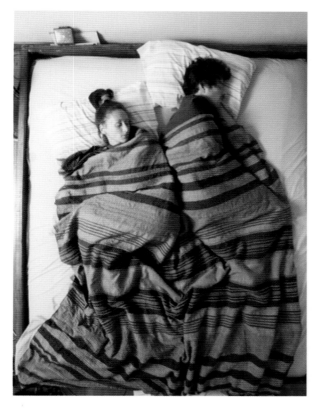
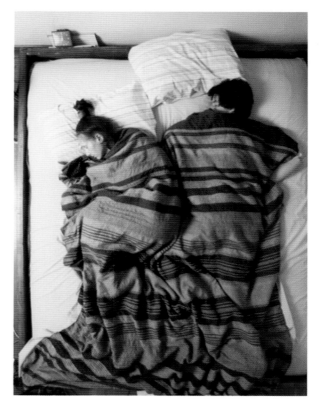
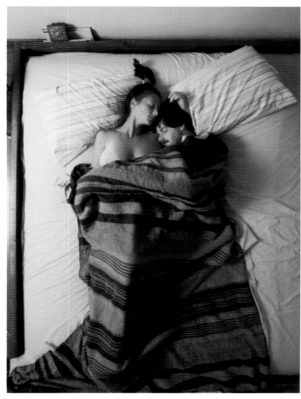
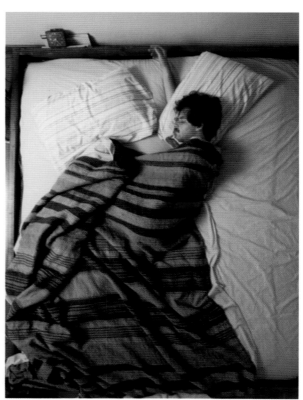

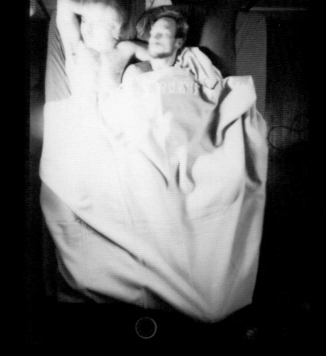

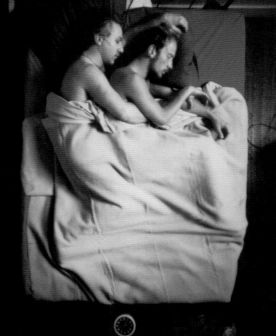

CM▷3

CM▷4

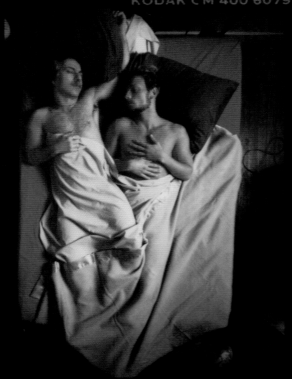

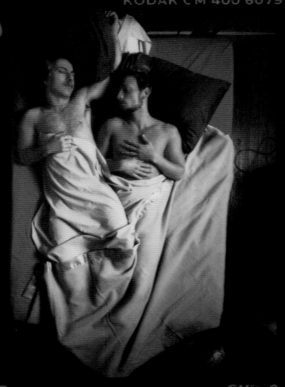

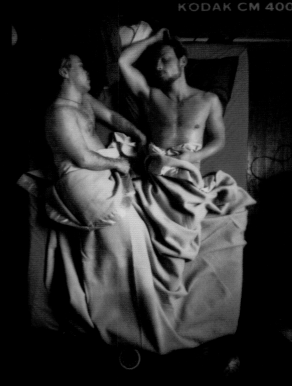

▷8

CM▷9

CM▷10

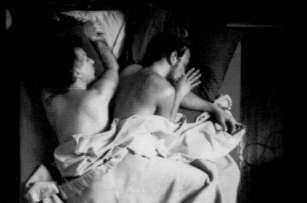

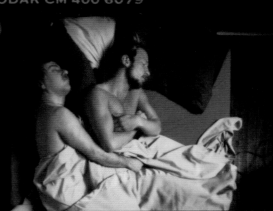

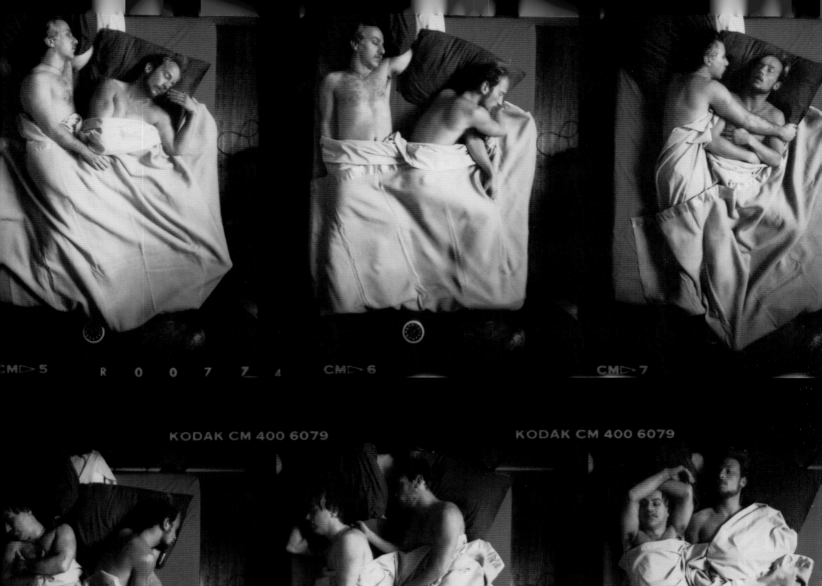

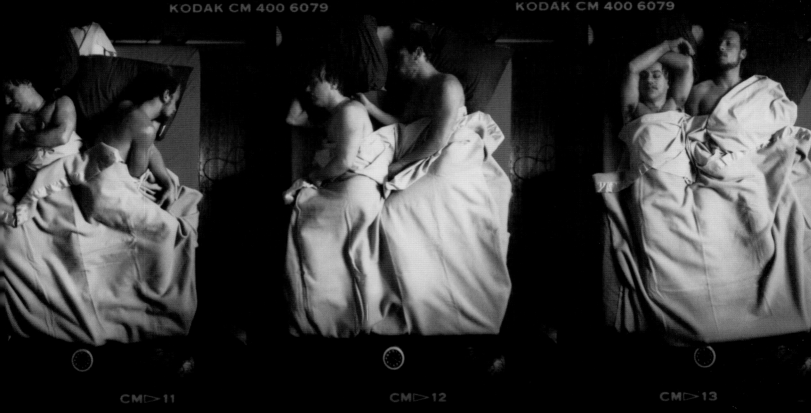

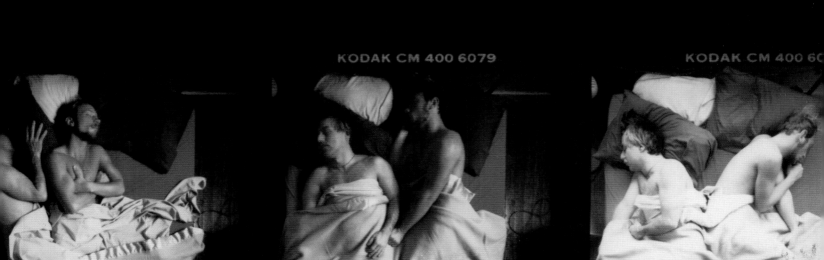

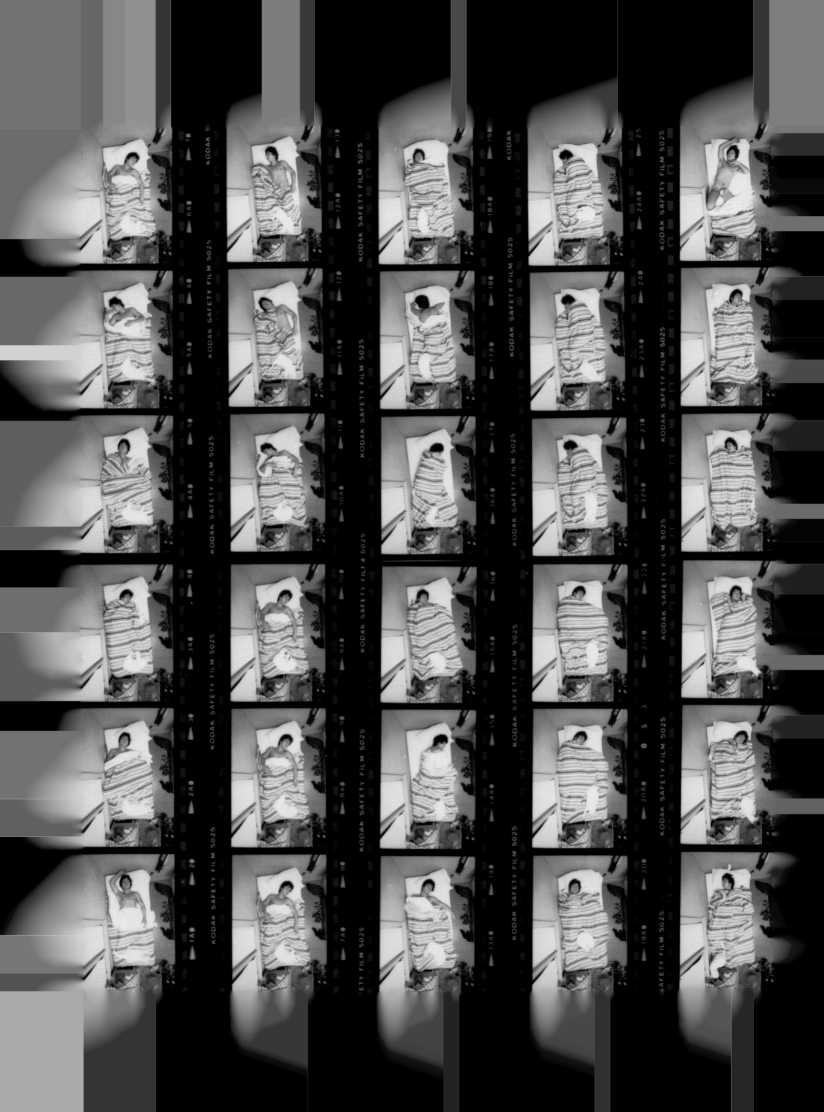

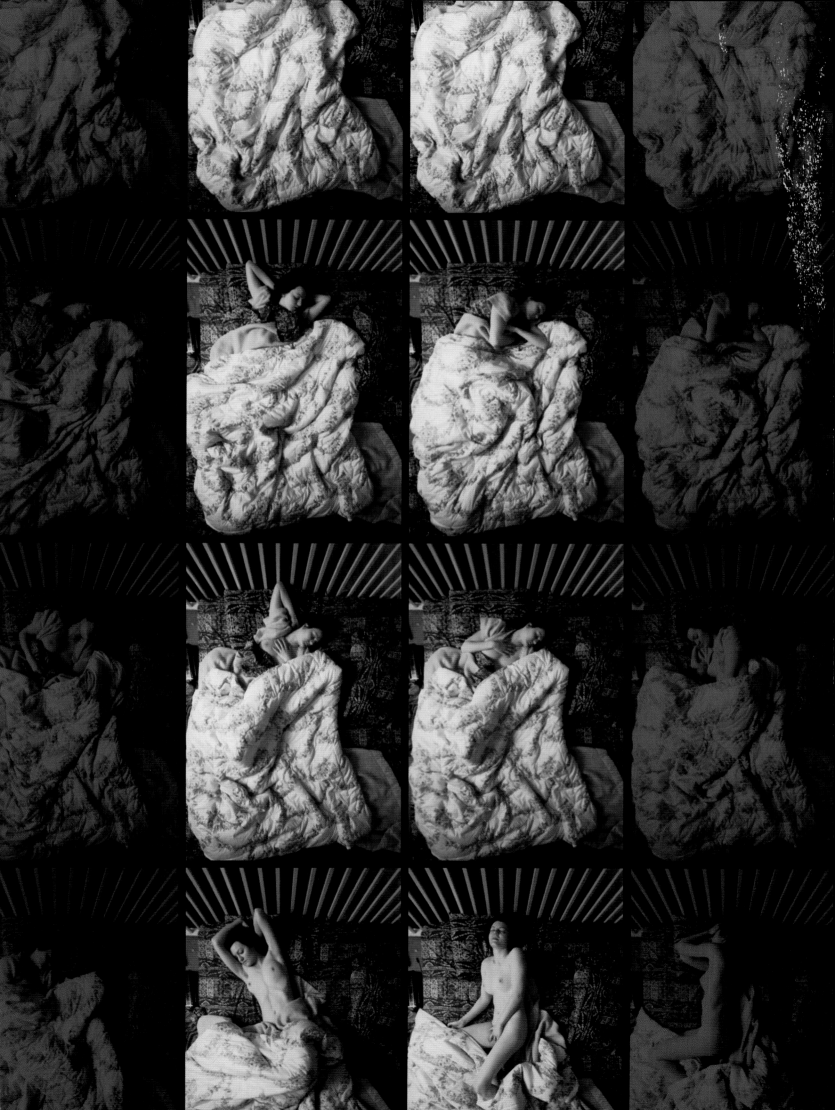

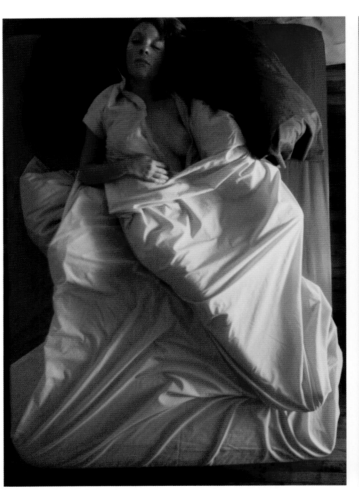
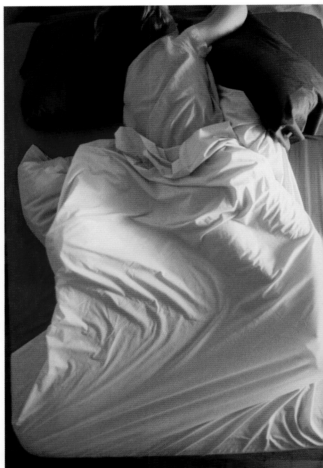

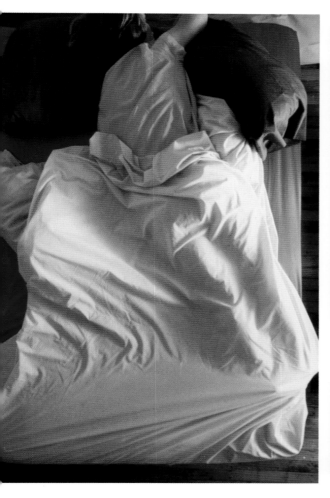
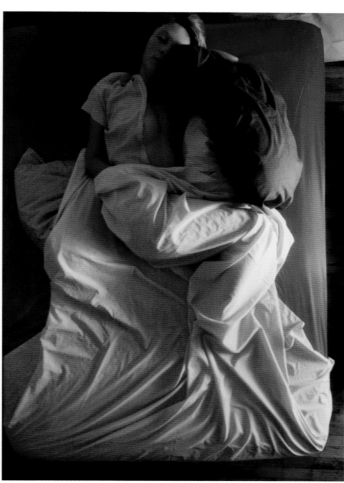

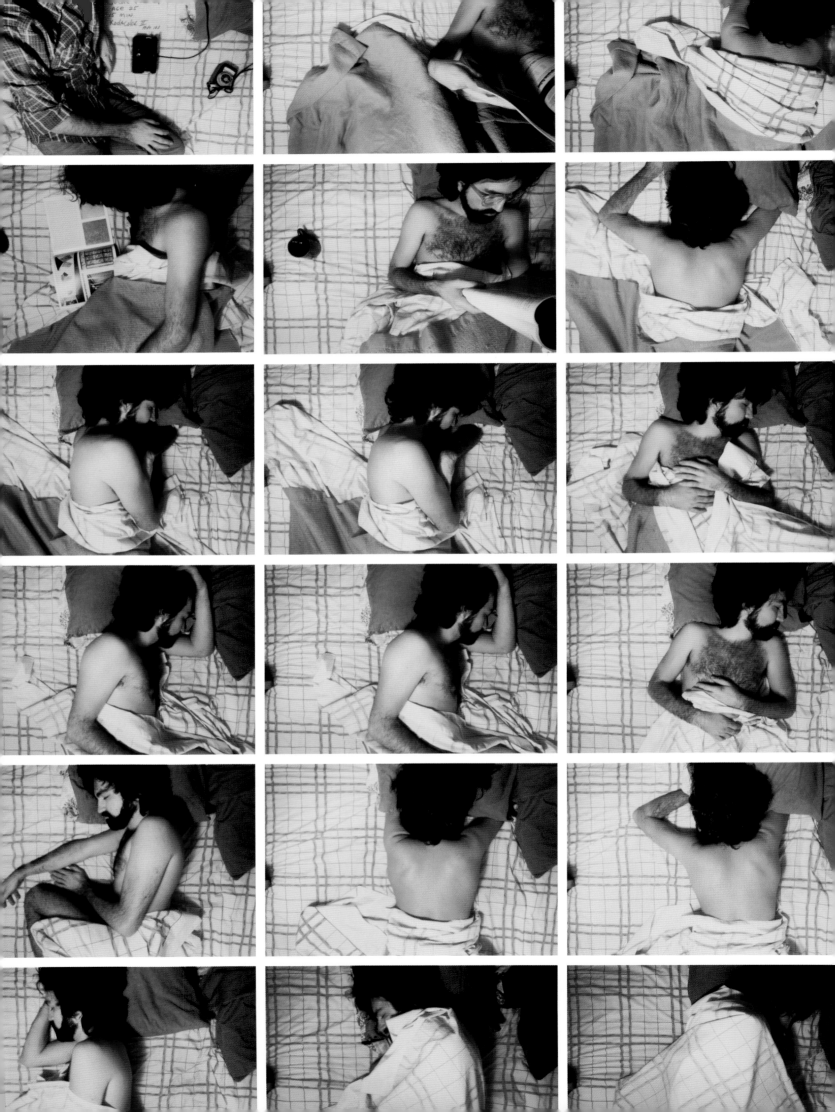

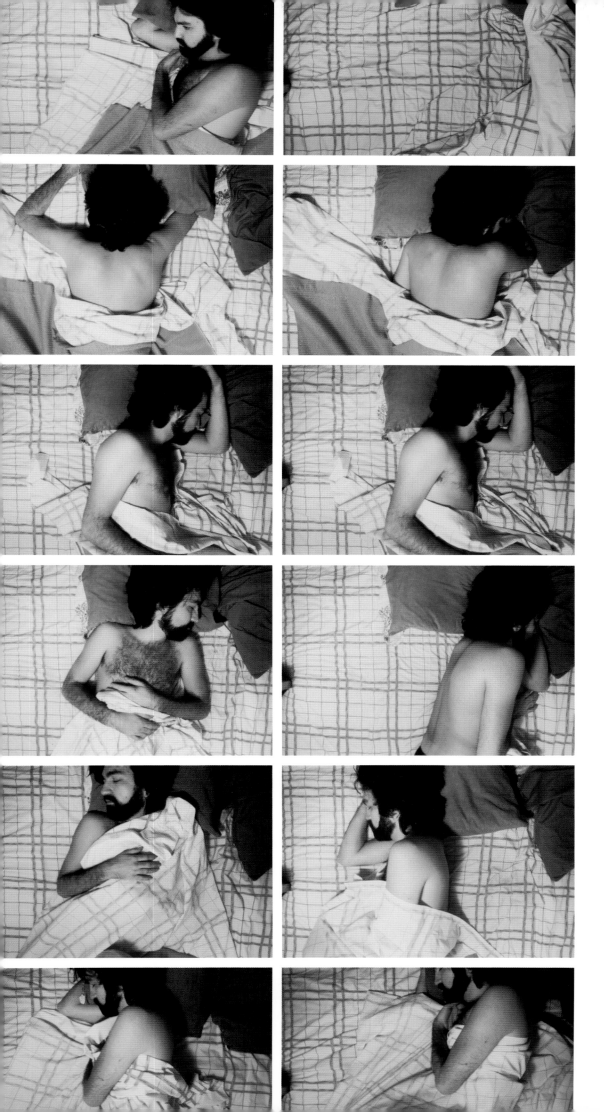

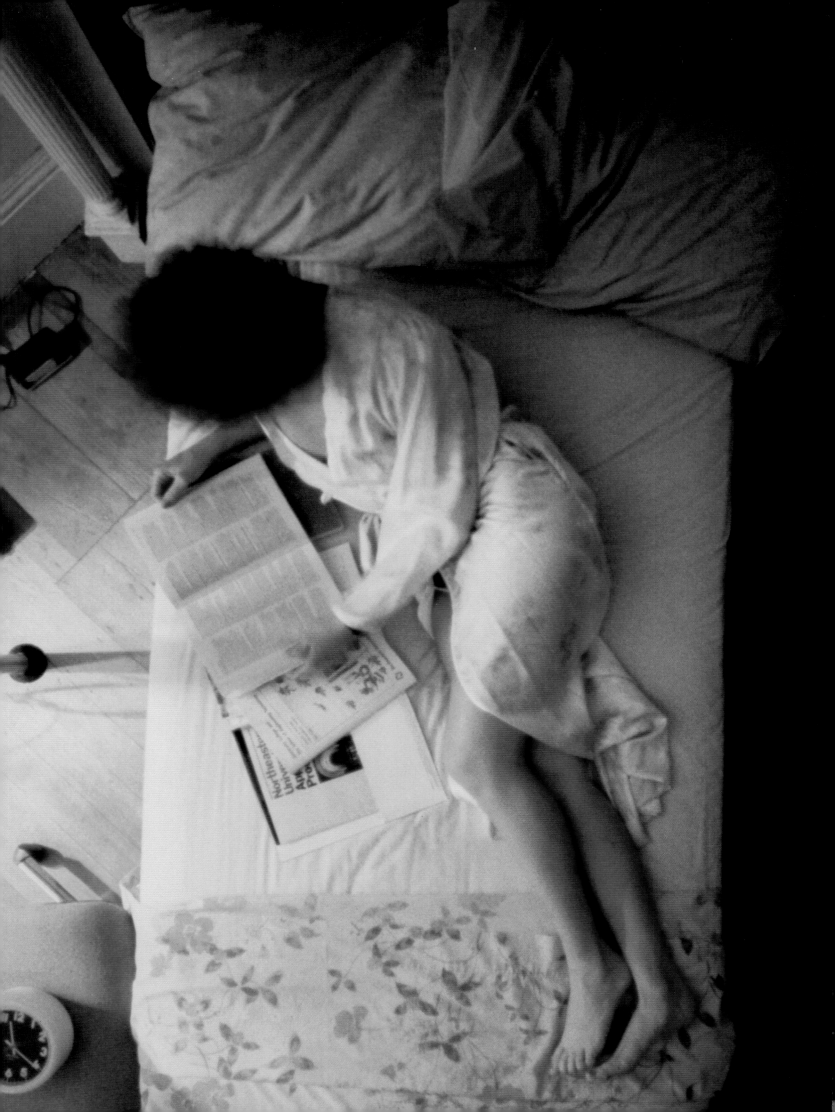

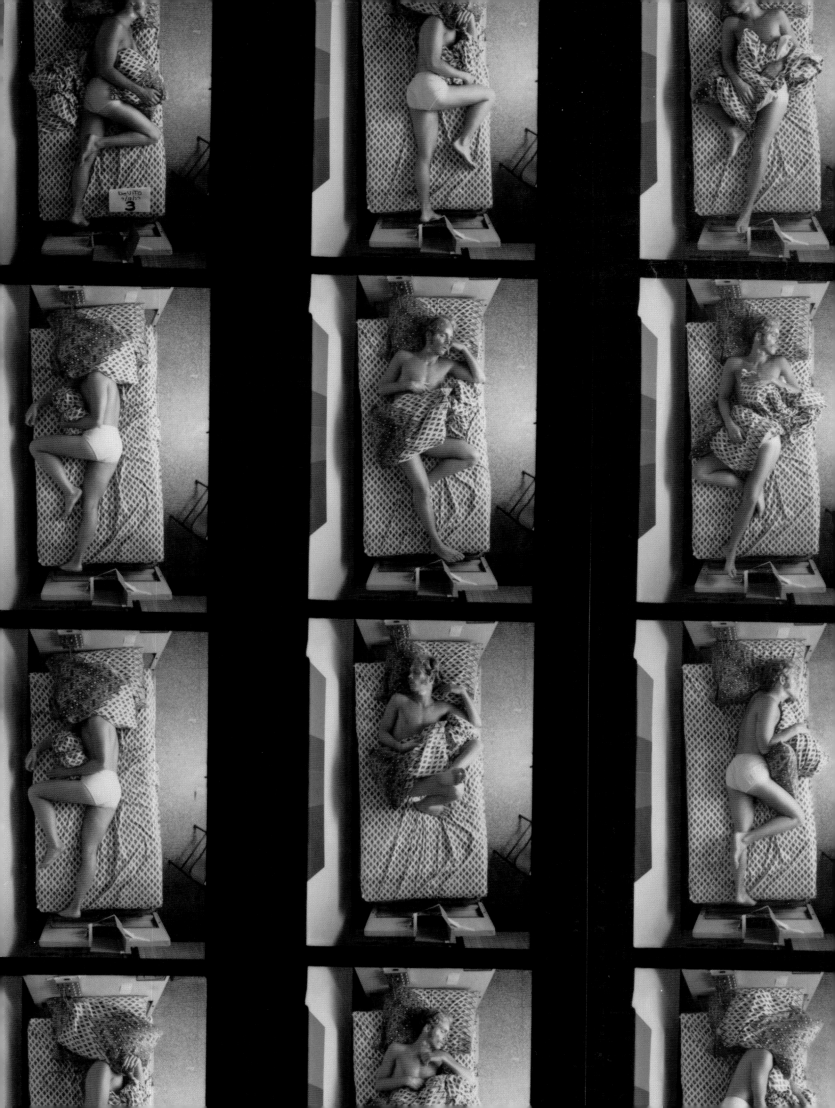

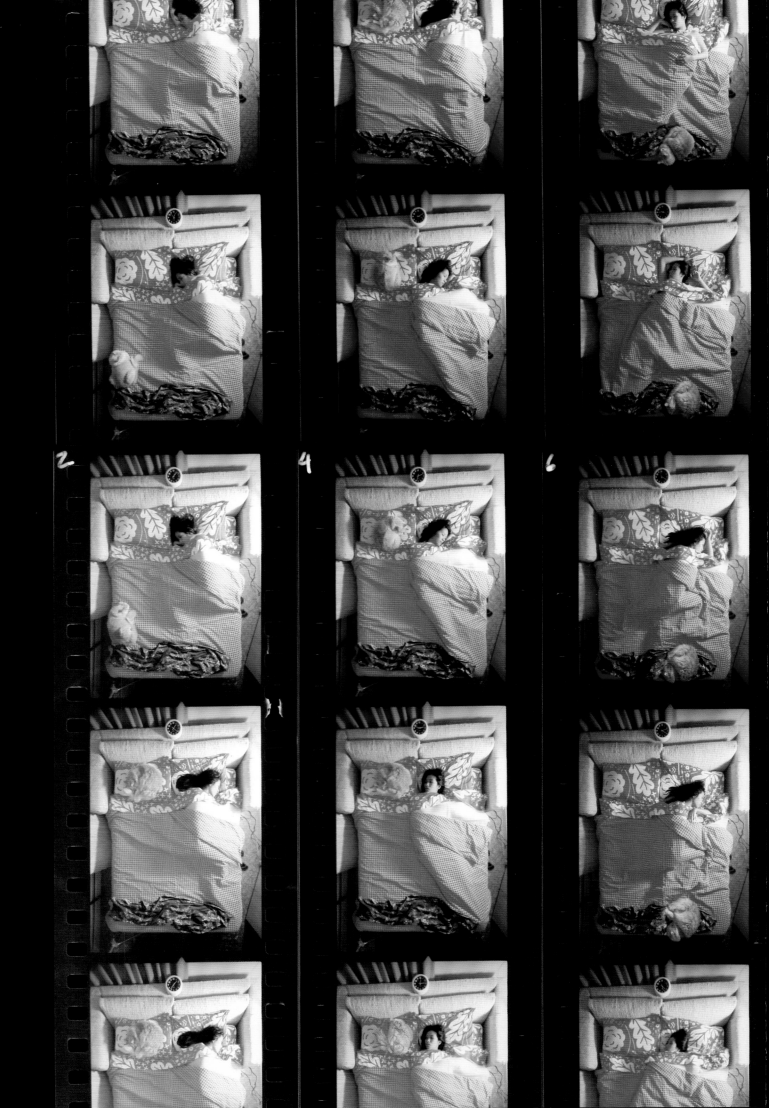

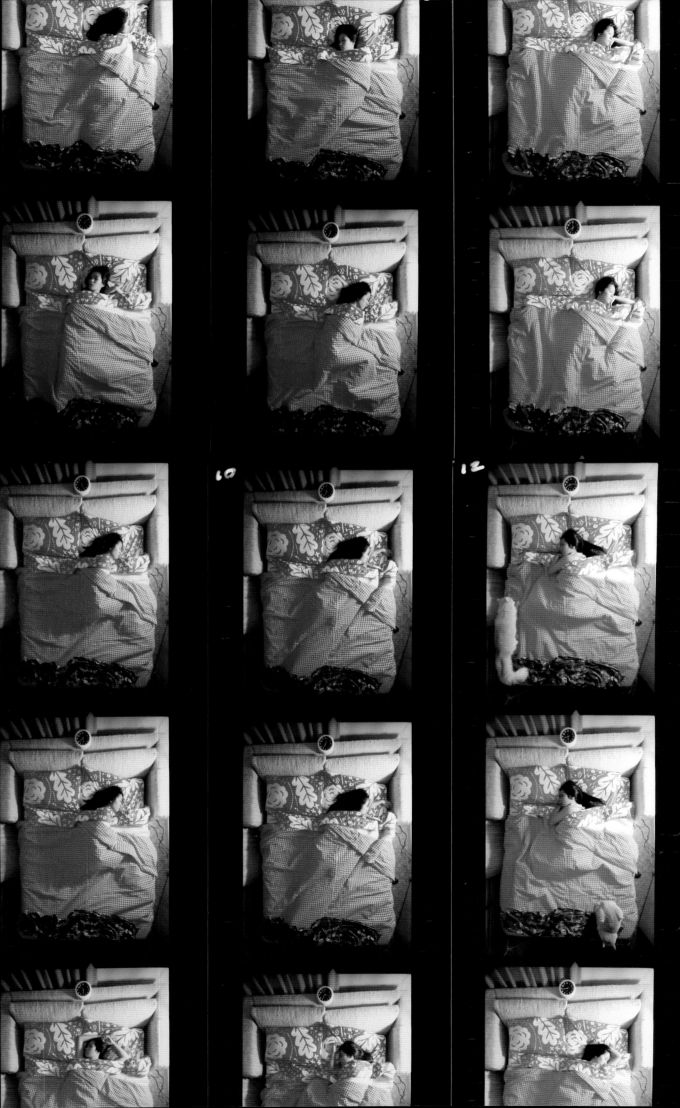

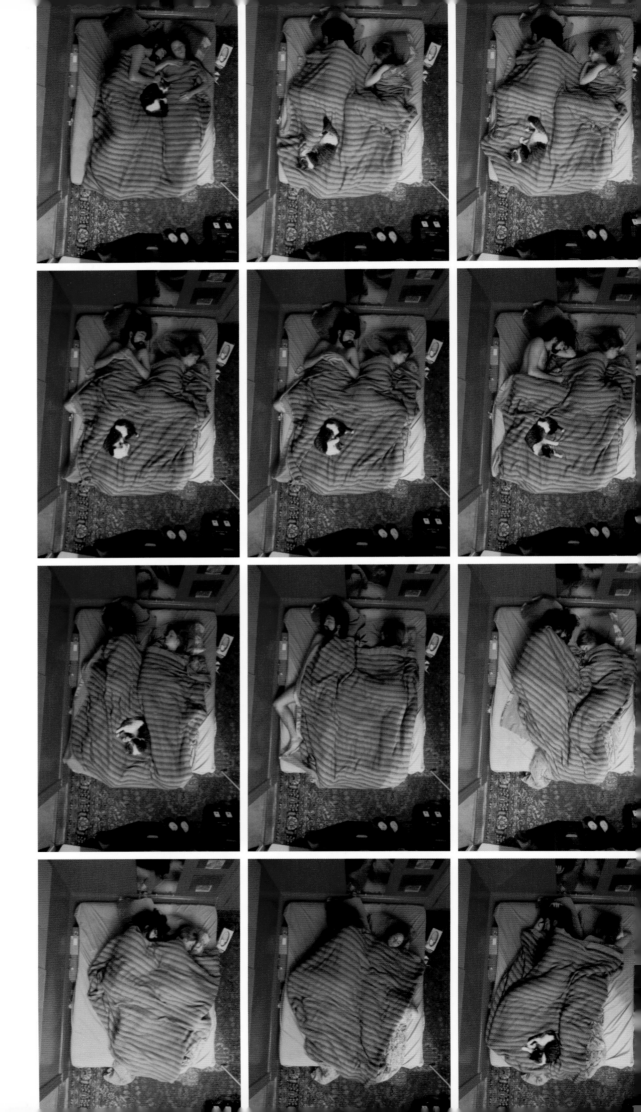

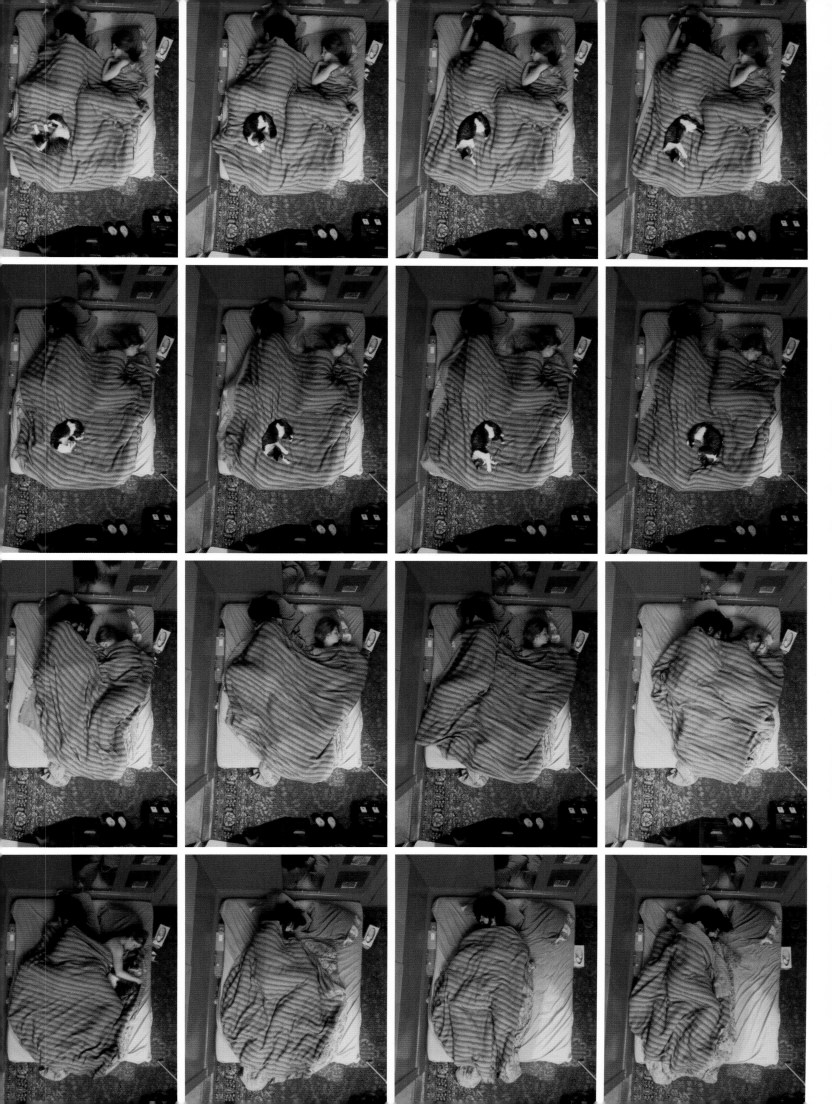

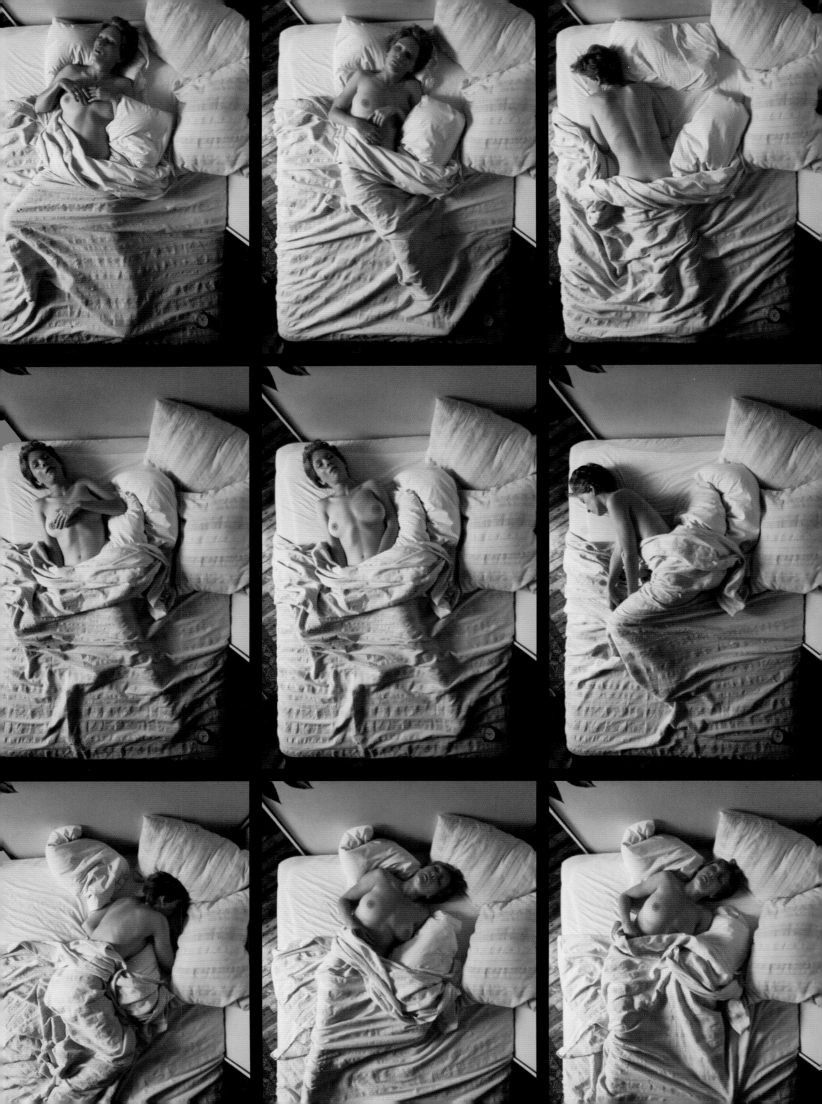

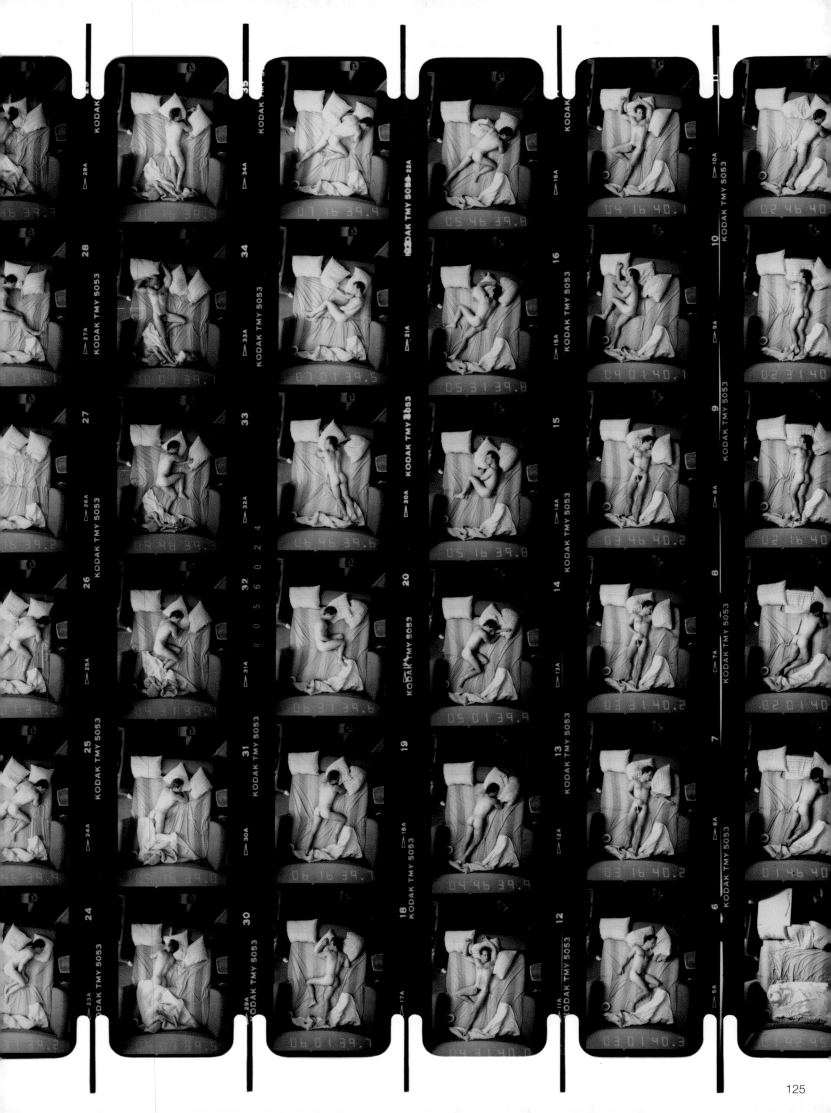

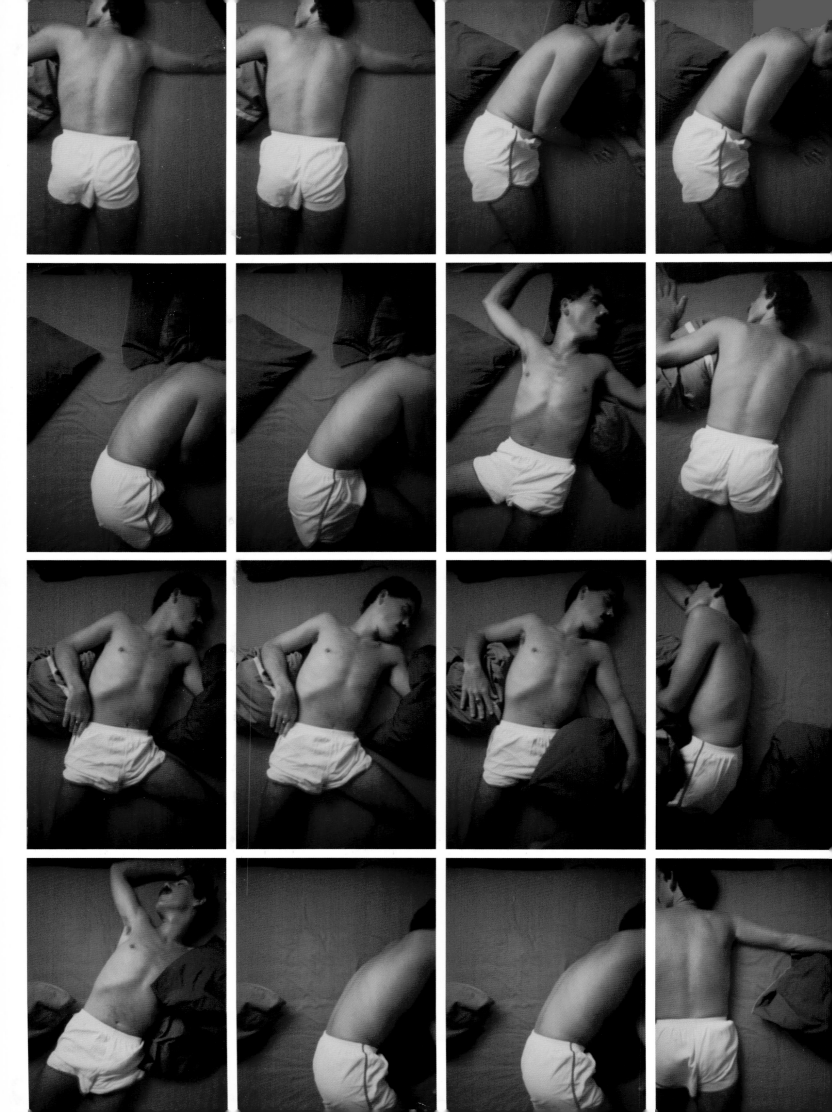

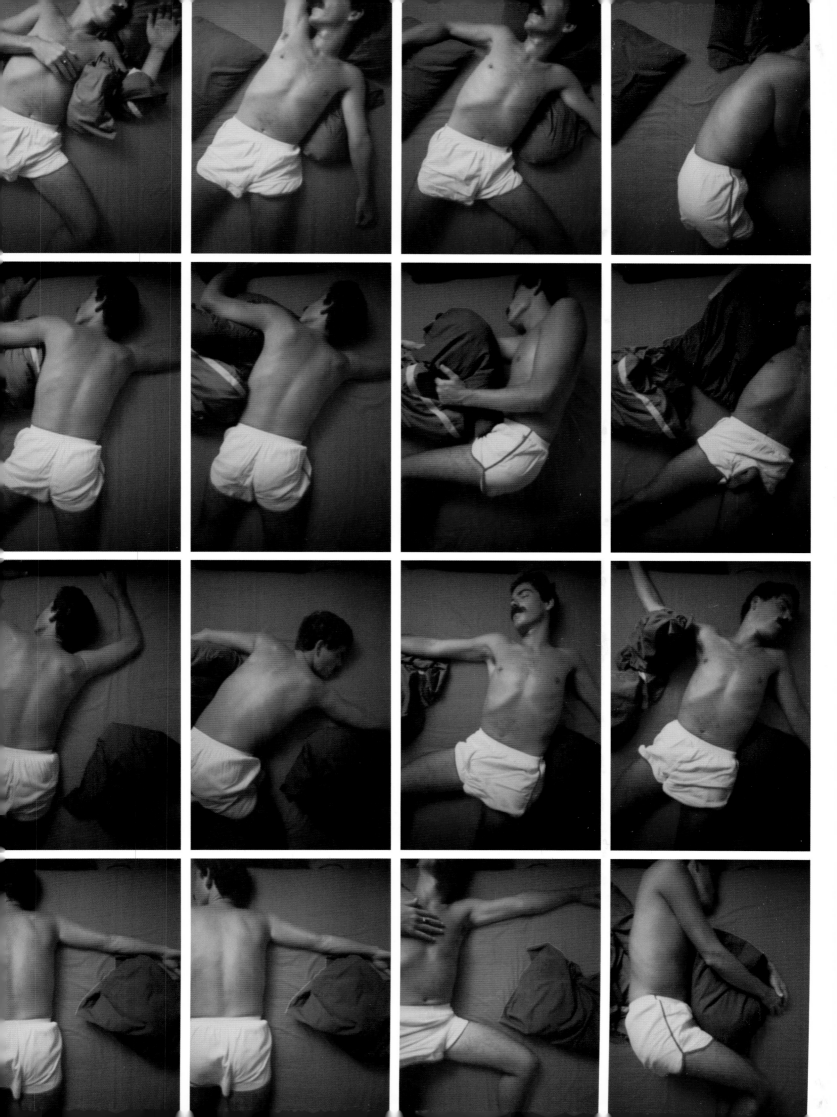

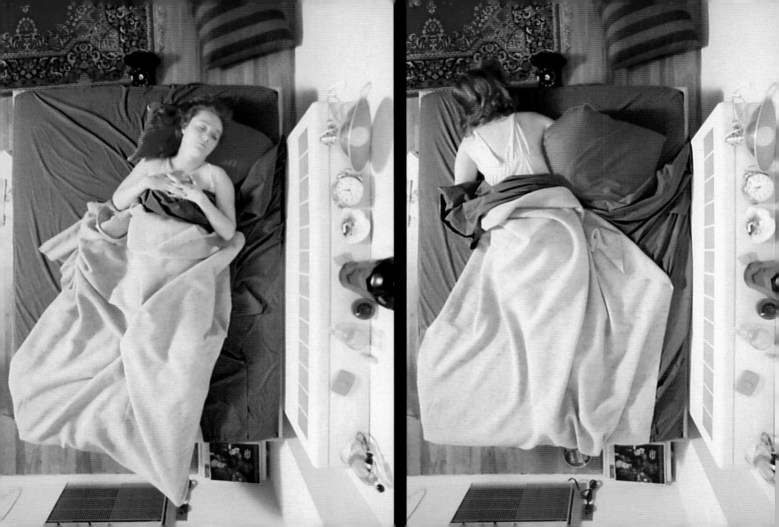

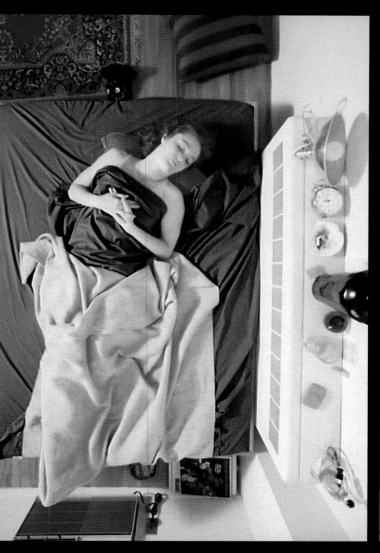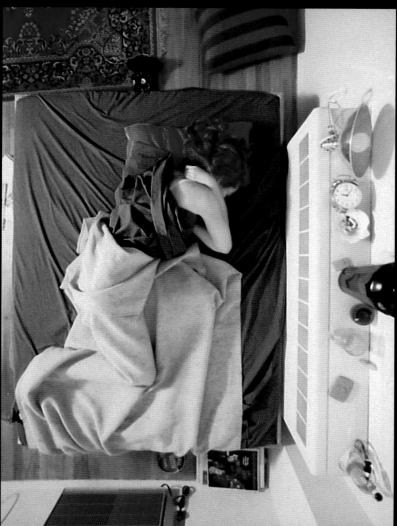

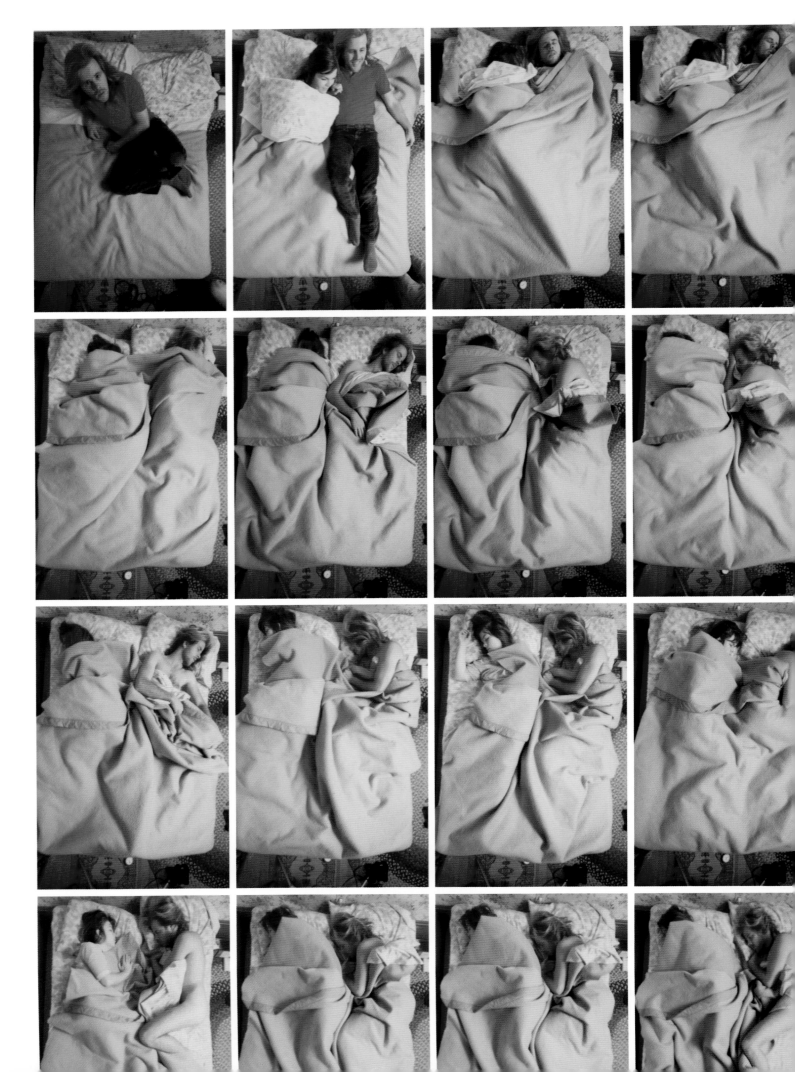

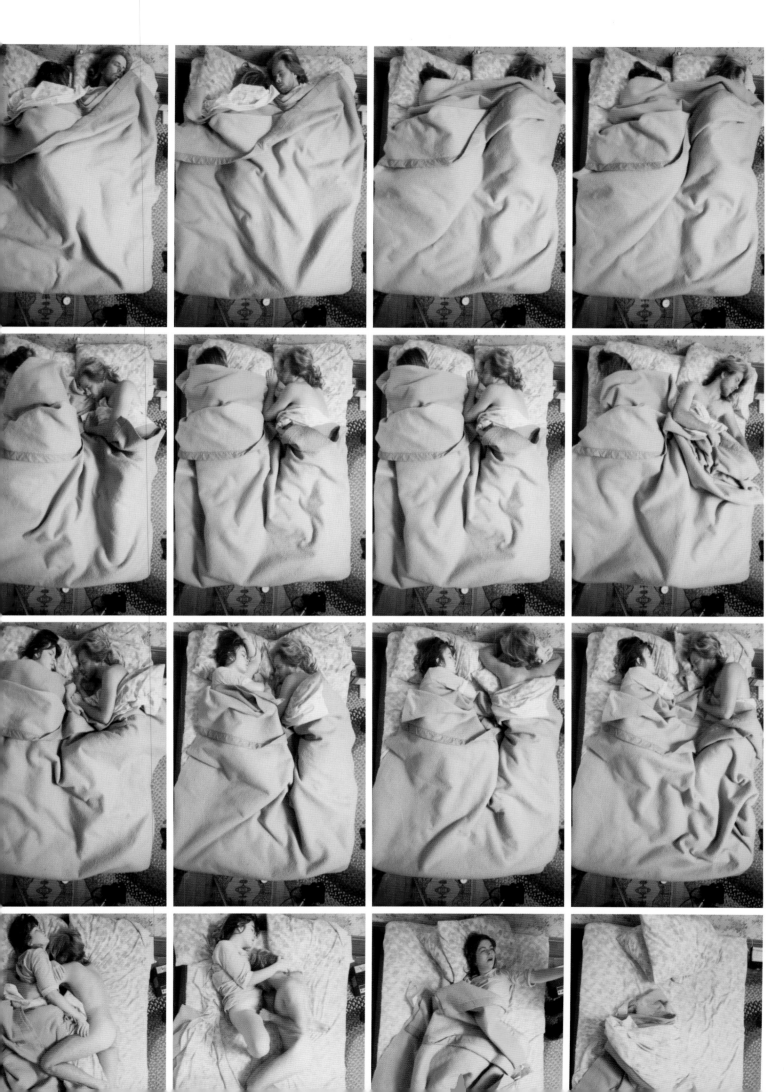

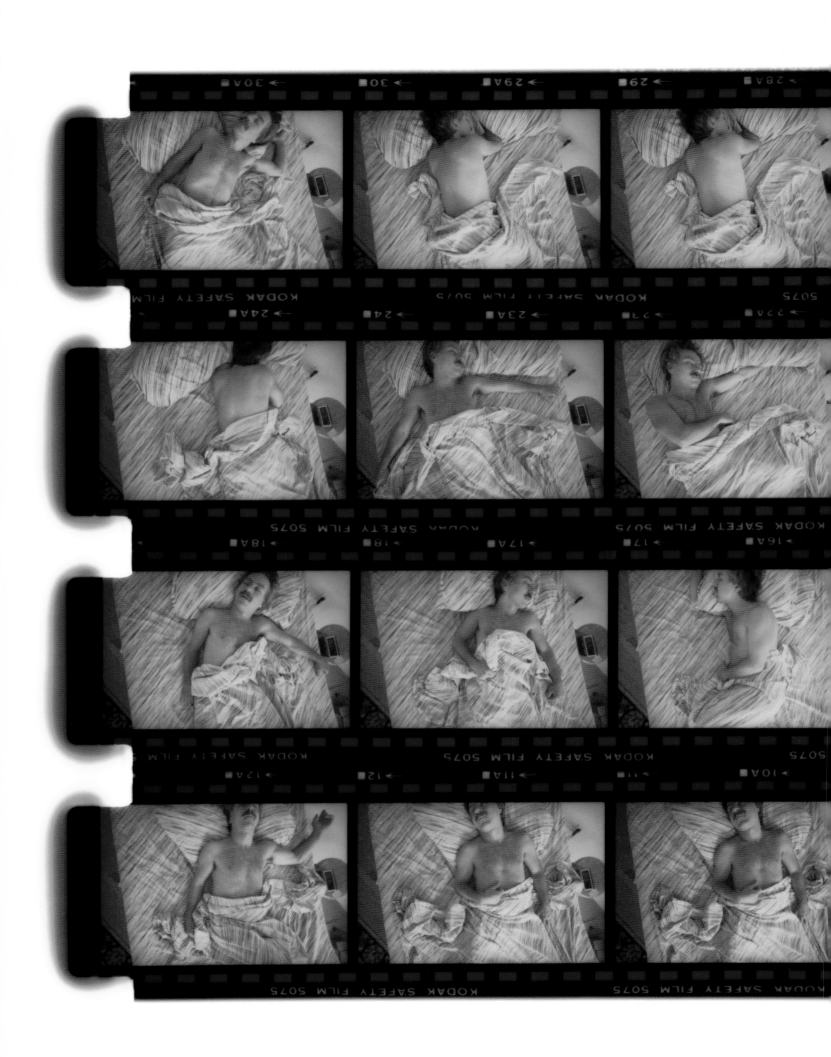

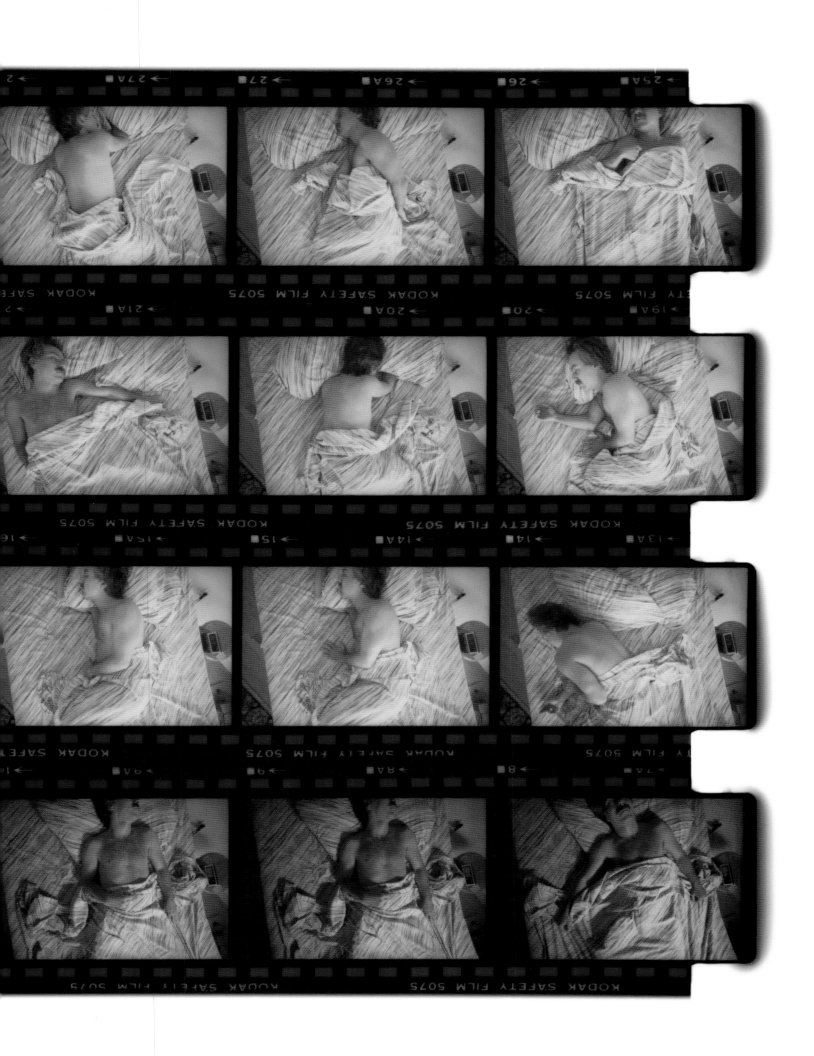

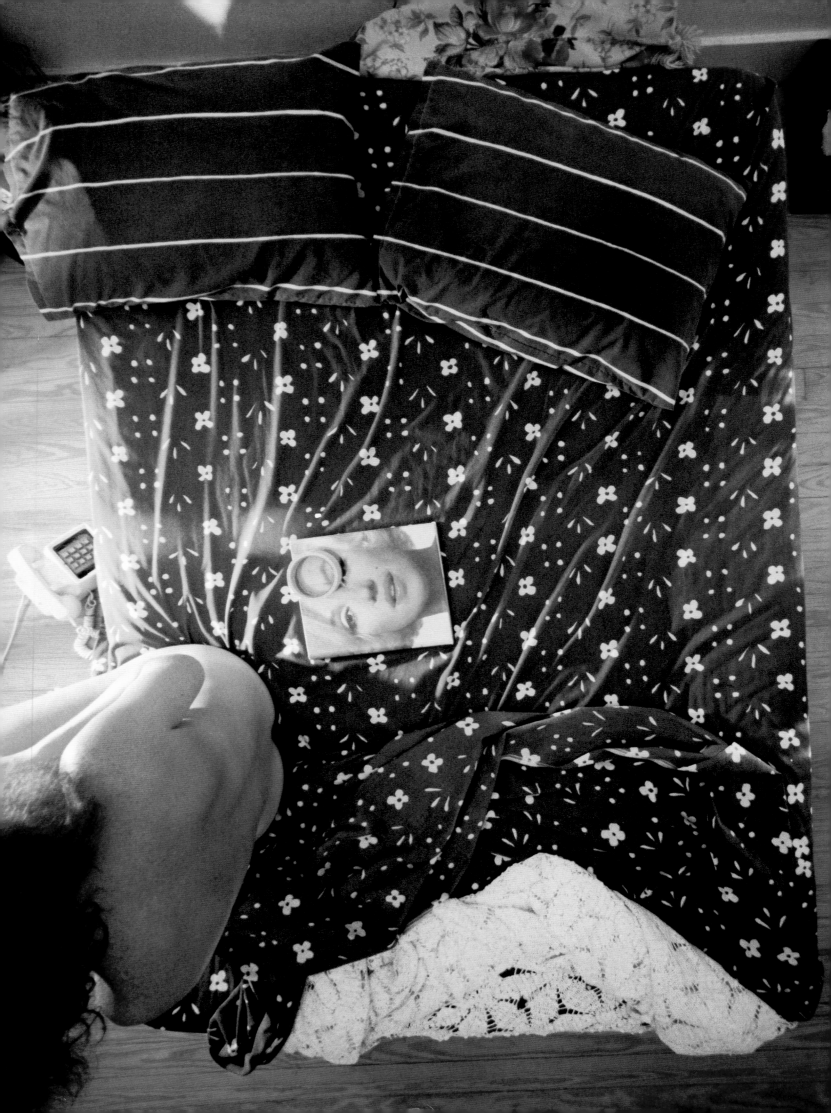

EPILOGUE

BY DELIA BONFILIO & RON ELDRIDGE

Ted Spagna was an influential photographer, filmmaker, artist, researcher, and passionate teacher who made history with his pioneering work in sleep photography. Born on October 11, 1943 to first-generation Italian Americans, Ted Spagna grew up in Queens, New York. Guided by his experience in watching his father build the family house, Spagna earned his degree in architecture from the prestigious Cooper Union.

Throughout architecture school, Spagna nurtured a secret desire to make films. His obsession first revealed itself when he did his thesis project on "cinematic architecture." He designed a residential space whose plan and form was dictated in terms of film. A CUT was a door, a DISSOLVE was a ramp, a FADE was an ending of space, and a SUPERIMPOSE was a space that opened up vertically or a contiguous space above. Spagna followed his interest in film with a master's degree from Boston University in 1972, completing his first major film, *It Is There and We Are Here This Is Some Time Ago,* a documentary-style film whose visuals and masterly editing make a profound statement on love, family, friends, time, space, and cinematic architecture. This film exhibits the ways in which Spagna was influenced by architecture in his use of the camera, experimenting with its placement in plan, elevation, and orthogonal views. Though his style choices were mostly unconscious, the film proved to set the stage for exploration in the next ten years of his work.

By 1975, Spagna had begun taking automatic time-lapse images using an intervalometer. Drawing on his experience with cinematic architecture, he set out to capture his sleep portraits throughout the night from above the bed. When he looked at the images for the first time, he was surprised to discover another "self" in those images, one that apparently existed only in sleep. Having never known that part of himself, he became fascinated with and obsessed by these sleep portraits. He perfected his technique and set out to work on photographing everyone he knew, starting with his parents and then moving on to photograph anyone who was willing to pose for him. His subjects, who ranged in age from a few months old to a ninety-two-year-old man, were single sleepers, couples, people with their pets, parents with their babies, and six people sleeping together. Each sleep portrait is a collection of twenty to thirty images taken at fifteen-minute intervals during the night.

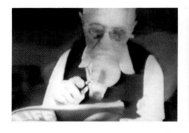 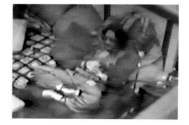

Spagna thought of his sleep portraits as a contemporary link to Eadweard Muybridge's studies of animal locomotion. Muybridge used the camera to take a fraction of time and extend it into space. Spagna took the events of an entire night and condensed them to a point where patterns can be detected. In this way, time itself becomes both a formal element and subject in the work. By photographing his subjects in floorplan view—bird's-eye view—there is a spatial tension created, much like what the Cubist painters did with their canvases. In another sense, the sleeper in the throes of twisting and turning with his bedclothes creates a kind of narrative tableau reminiscent of Tiepolo's baroque paintings of floating Madonnas and saints swathed in flowing drapes. This activity draws the viewer into the work, baiting him or her to examine and study the individual frames, even the sleeper's expressions.

The chronologically arranged time-lapsed photographs depict the sleeper in both time and space, and reveal what Spagna called "the architecture of sleep." We experience the subject's night of sleep much in the same way we experience architecture in both time and space. We approach a building, enter, and walk through it, all the while experiencing its structure moment after moment (sequentially) and as space connected to space (shifts in structure). In these photographic ensembles, we enter and move sequentially through a subject's night of sleep, observing his or her shifts in posture.

While teaching at Harvard's Carpenter Center for the Visual Arts, Spagna discovered that his sleep photographs had scientific relevance when he shared them with Allan Hobson, a well-known neurophysiologist at Harvard University. What they discovered with Spagna's sleep portraits was the definitive proof of the existence of natural biological rhythms within sleep—the ninety-minute sleep/dream cycle. Human sleep characteristically descends in stages from wakefulness to deep sleep, then ascends back through the stages to dreaming, or REM sleep. This cycle may repeat as many as four to six times in a single night. Within each series of photographs, it becomes clear not only how far into sleep the sleeper is, but also how deep. The relationship of sequential frames without movement to those with movement can indicate to the viewer when the sleeper is dreaming or in deep sleep.

Ted Spagna had bridged a gap between art and science with this pioneering work in sleep photography. He went on to collaborate with Allan Hobson and Paul Earls (a composer from M.I.T.) on a major exhibition entitled *Dreamstage: An Experimental Portrait of the Sleeping Brain,* which attempted to unravel the mysteries of how we sleep. Central to the show was a person asleep whose brain was monitored by an encephalograph that drove a ten-color laser and polyphonic synthesizer, providing dramatic visual and aural real-time readouts of the

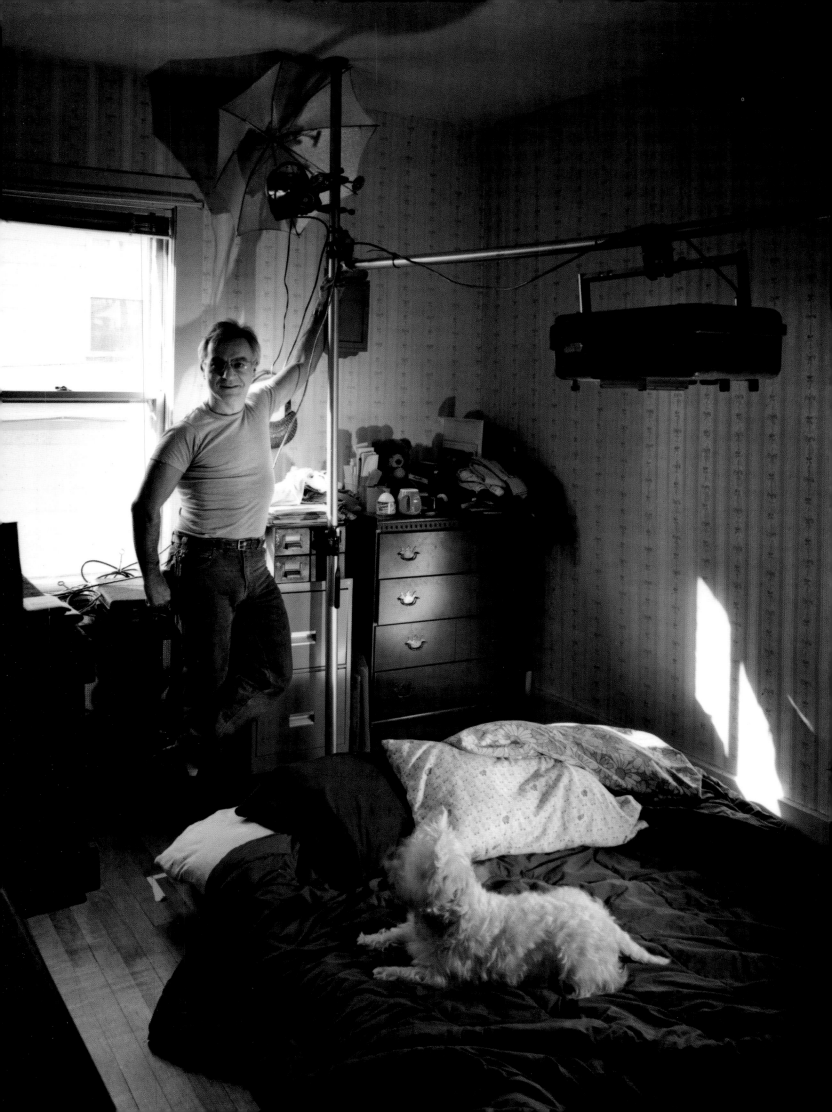

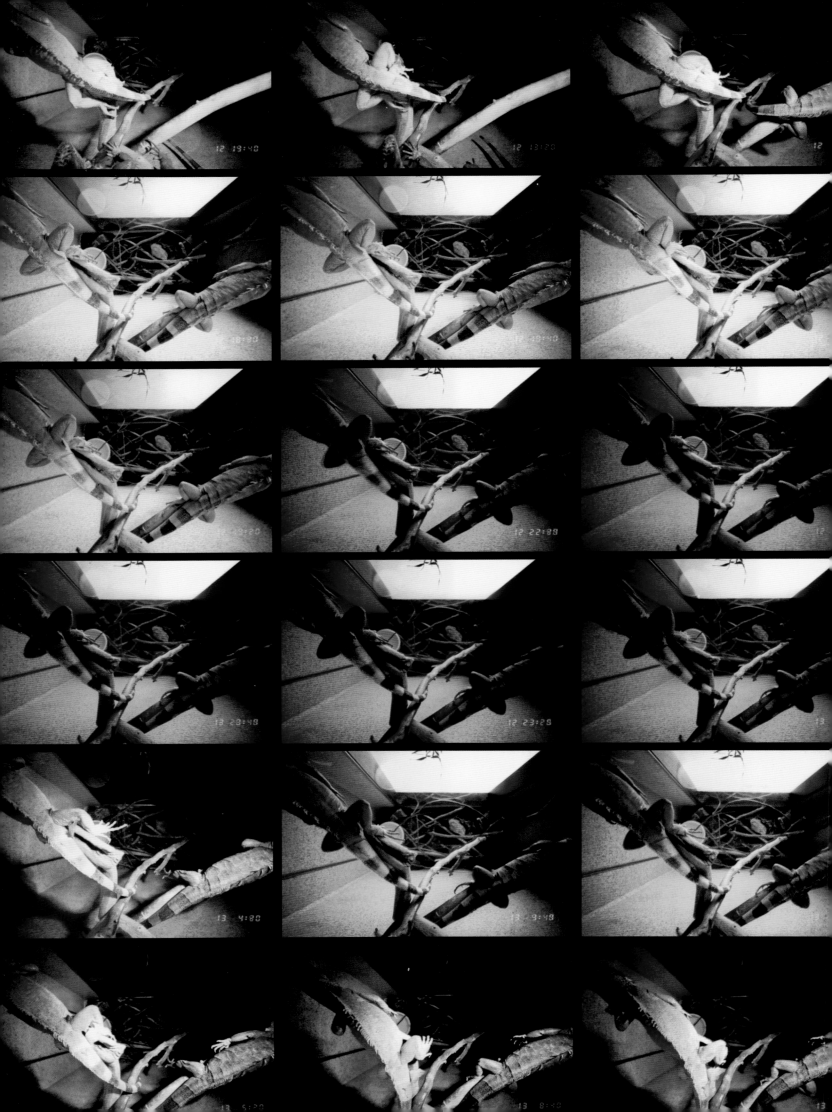

subject's brain. The show traveled all over the United States and to France, and Spagna's sleep portraits went on to be featured on *60 Minutes,* the *Today Show,* the cover of *New York Times Magazine, People,* and *Art in America.*

Spagna eventually achieved the capability of harnessing moonlight as his only source of illumination, allowing him to fulfill his wish to photograph exotic wild animals in sleep with a noninvasive method. He dedicated two years to animal-sleep photography, working primarily at the metropolitan Boston zoos and the Miami Metrozoo. These moonlight shots of animals, full of color, texture, and detail that belie our usual perception of night, proved invaluable to zoologists and animal keepers, allowing them to study the effects of stress as well as environment on the sleeping subjects. In these photographs, Spagna found that the usual notions about animals, obtained from the way animals are traditionally represented—in nature, alert, in motion, and displaying physical power and energy—are replaced by something very different.

He planned to continue his work with animals at places where they are allowed to roam free. He had also hoped to photograph the sleep of schizophrenics, sleepwalkers, and astronauts in the zero gravity of an orbiting space shuttle. The possibilities were endless, but those plans fell short on June 21, 1989, when Spagna succumbed to AIDS-related lymphoma. The art and science communities lost a pioneer and a great contributor. People who knew Ted lost a bright light and guiding force in their lives. He positively impacted everyone he met and challenged them to be open to new ideas. A student of life, Ted believed there was something valuable and beautiful to discover in every moment he captured.

A chance reconnection between Spagna's nephew and goddaughter has led to the resurrection of Ted's work with this book of his human sleep studies. Their goal with this project is to carry out Spagna's mission in life—to inspire exploration, discovery, and learning.

*Eadweard J. Muybridge (1830-1904) *Turning around in surprise and running away*
ca. 1884-1887, collotype print, Courtesy George Eastman House Collection.

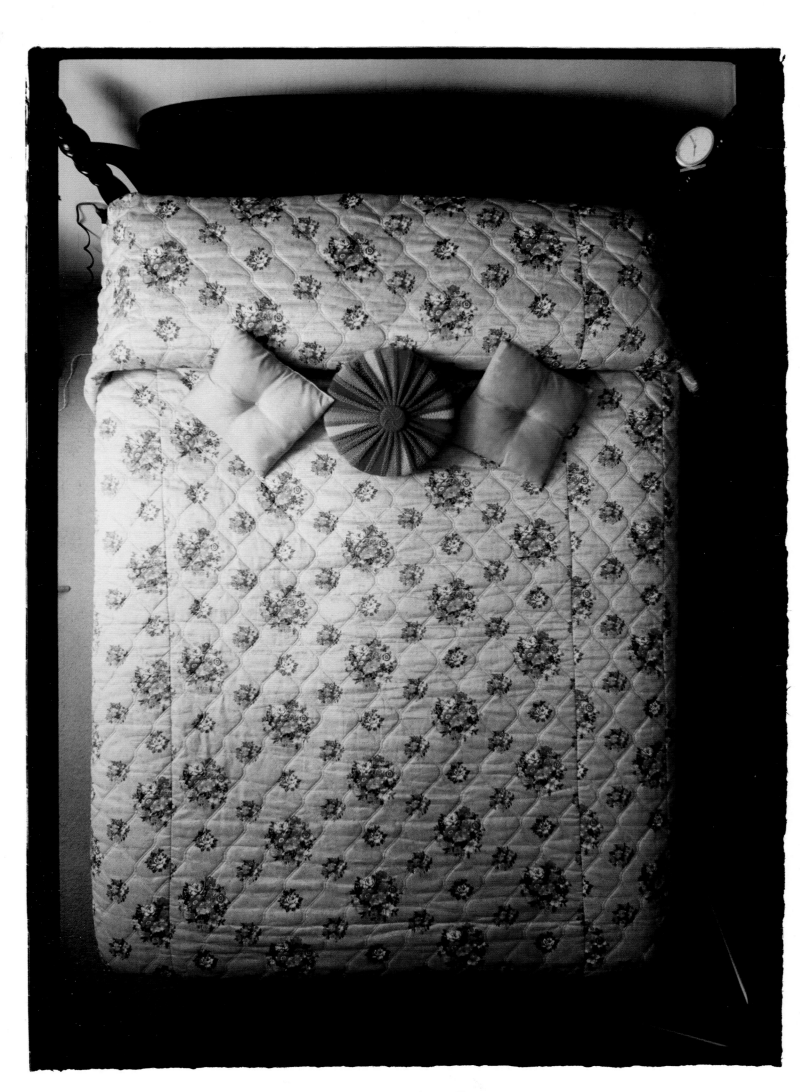

ACKNOWLEDGEMENTS

This book is dedicated to Uncle Teddy, who continues to inspire us.

We'd like to express our sincere gratitude to a few people for their contributions to this project. Without their support and encouragement, this book would not have been possible: Carol Eldridge, Ann McQueen, Robert Rindler, James Connors, Josh Prokop, Dr. Allan Hobson, Mary Ellen Mark, Michael Cobb, Paul Bonfilio, Alba Bonfilio, Stephen Jennings, Robert Van Petten, Charles Miers, and Martynka Wawrzyniak.

We'd also like to thank the George Eastman House International Museum of Photography and Film and the Harry Ransom Center at the University of Texas at Austin.

"I have been photographing sleep for more than ten years. Colleagues ask me if I ever tire from having made the same photographs for so long. I have done thousands of sleep portraits: infants, couples, elderly people, elephants, hatching ostrich chicks, gorillas, giraffes, and numerous other species. My excitement and interest in the work has increased rather than waned. I never tire at looking at the work. Each portrait is an entirely new exploration, and the information it contains completely unique. The interaction of the sleep/dream cycles between infant and parent(s) or between a pet and a person, or the relationship between the inner and outer states of the sleeper vary greatly from portrait to portrait, and I am intrigued by these differences. Visually, I am attracted to the decorative richness and variety of sleepers, their beds, and their sleeping environments. These all-night portraits reveal strikingly the inherent beauty, rhythm, and organization of natural behavior."

—Ted Spagna (November 1986)

First published in the United States of America in 2013
by Rizzoli International Publications, Inc.
300 Park Avenue South
New York, NY 10010
www.rizzoliusa.com

Edited by Delia Bonfilio and Ronald Eldridge, with Martynka Wawrzyniak

Designed by Bonfilio Design

Introduction © 1989 Dr. Allan Hobson. Adapted from an article previously published in the
Association of Professional Sleep Societies' APSS Newsletter 4, no. 4 (December 1989).

20013 2014 2015 2016 / 10 9 8 7 6 5 4 3 2 1

Distributed in the U.S. trade by Random House, New York

Printed in China

ISBN: 978-0-8478-4098-4

Library of Congress Control Number: 2013931308

A collection of Spagna's work is preserved at George Eastman House International Museum
of Photography and Film in Rochester, New York (www.eastmanhouse.org). Images on
pages 2, 5, 9, 12-17, 22-23, 30-31, 36-37, 40, 42-43, 48, 52-61, 64-67, 69, 70-71, 75-77,
82-83, 90-91, 96, 100-101, 104-107, 109, 113, 114-118, 122-124, 126-127, 130-131, and
138 are courtesy of George Eastman House Collection.

A collection of Spagna's work is preserved at Harry Ransom Center at the University of
Texas at Austin (www.hrc.utexas.edu). Images on pages 10, 18-21, 24-27, 32-33, 38-39,
41, 49-51, 62-63, 72-74, 80, 84-85, 88-89, 92-95, 98-99, 102-103, 108, 110-112, 119,
125, 132-133, and 137 are courtesy of Harry Ransom Center Collection.

The Estate of Ted Spagna and its private collection is managed by Bonfilio Design,
Carpinteria, California (www.tedspagna.com). Images on pages 1, 6, 28-29, 34-35, 44-47,
68, 78-79, 81, 86-87, 97, 120-121, 128-129, 134, and 142 are courtesy of the Estate of
Ted Spagna's Private Collection.